THE NEW 35MM
PHOTOGRAPHER'S
HANDBOOK

THIRD REVISED EDITION

THE NEW 35MM PHOTOGRAPHER'S HANDBOOK

EVERYTHING YOU NEED TO GET THE MOST OUT OF YOUR CAMERA, INCLUDING:

JULIAN CALDER & JOHN GARRETT

THREE RIVERS PRESS
NEW YORK

A Marshall Edition
Conceived, edited, and designed by
Marshall Editions, Ltd.
The Orangery, 161 New Bond Street
London W1Y 9PA

Project Manager: Jinny Johnson
Editor: Rebecca Clunes
Managing Art Editor: Patrick Carpenter
Managing Editor: Clare Currie
Editorial Director: Ellen Dupont
Proof Reader: Mike Stocks
Production: Nikki Ingram, Sarah Hinks

Published by Three Rivers Press, 201 East 50th Street,
New York, New York, 10022.
Member of the Crown Publishing Group.

Random House, Inc. New York, Toronto,
London, Sydney, Auckland
www.randomhouse.com

Three Rivers Press is a registered trademark of
Random House, Inc.

This edition originally published in Great Britain by
Marshall Publishing, Ltd., in 1999.

Printed in Milan, Italy

Library of Congress Cataloging-in-Publication Data

Calder, Julian.
The new 35mm photographer's handbook / by Julian
Calder, John Garrett. — Rev. ed.
Rev. ed. of: The 35mm photographer's handbook. 1986.
1. 35mm cameras. 2. Photography—Handbooks, manuals,
etc. I. Garrett, John.
II. Calder,
Julian. III. Title: 35mm photographer's handbook. IV.
Title: New thirty-five mm photographer's handbook.
TR262.C26 1990 771.3'2 dc20 90-1760

ISBN 0-609-80422-7

10 9 8 7 6 5 4 3 2 1

First American Edition

Julian Calder's early inspiration came from the great photo stories in *Life Magazine*. He acquired his photographic education at art college and as an assistant to several London photographers. For him, the still photograph has the essential quality of being tangible, involving the viewer in a way that the ephemeral images on television or cinema screen cannot.

Julian is an inveterate traveller, who enjoys the discipline of working on assignment for companies and magazines. He utilizes all the technical gadgetry available in order to realize the full potential of a picture, stretching the versatility of his camera system to the utmost to capture the picture he wants.

John Garrett was a photographer in his native Australia before settling in England in 1966. He has worked on assignment for most of the world's top magazines, including *Time*, *Paris Match*, *Stern* and *The Sunday Times*, and has contributed photographs to several books including volumes in the Time-Life series *Cities of the World*.

An experienced photographer, John also directs television commercials and has written seven books, including *The Art of Black and White Photography*. He now spends much of his time working on his own photographic projects.

Contents

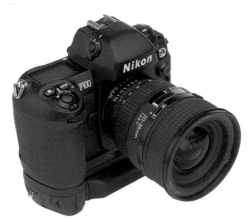

© JULIAN CALDER

Introduction

Since this book was first published, I have traveled round the world 15 times. Assignments have taken me to places such as the North Pole, Central China, and the waterways of Botswana, and with every trip I have learned more about photography, about ways of getting the pictures I want.

There have been tremendous advances in all aspects of camera technology. Electronics, microprocessors, printed circuitry, advanced lightweight plastics, new film emulsions, flash, and zoom lens design – all these developments have made the world of photography more exciting and more accessible than ever before. The same photographic problems are always there, but there are new ways of solving them. There is now something for almost every occasion – a film for every picture, a lens for every situation – the only limit is your own imagination.

There has been a steady rise in interest in all areas of photography, such as black and white and different printing effects, as well as in the use of computer technology to manipulate and enhance images to create "the perfect picture." Today's photographers split into two groups – the traditionalists and the image makers, for whom the camera is only part of the process.

As a professional photographer, I have a keen interest in this technology, and in updating The 35mm Photographer's Handbook, I have looked at what it can do for you – and what it sometimes can't. The text has been completely revised to cover working with the latest equipment and there are more than 150 new pictures, whose merit is often enhanced by the technology behind them.

But every photographer or image maker still needs to know the basics; the camera doesn't take the picture for you. Photography is one of those activities that can only be learned by experience. The more you do it the more you find out, and by understanding what went wrong, the bad pictures can teach you as much as the good.

This book aims to help you to understand the creative potential of cameras from the simplest to the most advanced electronic models. It assumes that you wish to take photography seriously; that professional standards of work are what you are after; and that, like a professional, you will want to take pictures every day.

That is why the book has a shape and size to suit the camera bag or a pocket in the car rather than the coffee table. It is meant to be of daily use to people such as teachers, students, and architects, as well as photographers, and to serve myriad other occupations where a picture can speak so much more persuasively than words. Photography is a world of its own – and a visual access to every other world. It should enhance the recollected pleasures of everyday life as well as travel, parenthood, and hobbies.

Most of the pictures in this book were taken on Nikon equipment. Nikon makes one of the most comprehensive 35mm camera systems, but there are a number of other systems which are broadly similar. The electronic cameras now available are the most advanced ever, but to take great pictures you don't have to have the most up-to-date equipment. Never forget that some of the greatest masterpieces of photography have been taken on the simplest cameras.

Julian Calder

SLR cameras

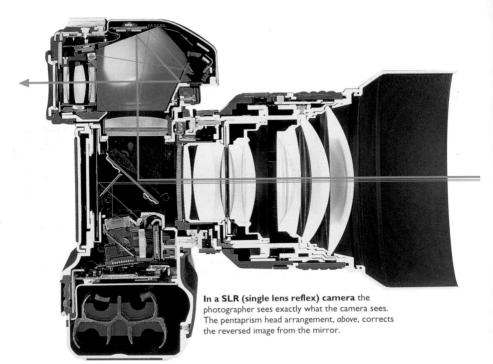

In a SLR (single lens reflex) camera the photographer sees exactly what the camera sees. The pentaprism head arrangement, *above*, corrects the reversed image from the mirror.

35mm cameras are compact, lightweight and capable of producing a high-quality image. Their 36mm ⌀ 24mm format is a pleasing shape in which to compose pictures, echoing the age-old golden section theory of design. SLR stands for single lens reflex. Through this viewing system, the photographer sees the exact image that the camera sees. The photographer also benefits from camera metering and can control shutter, aperture, and winder without having to remove the eye from the viewfinder.

35mm SLR users have at their disposal the most comprehensive range of interchangeable lenses and accessories, and these allow extra versatility and creativity. Modern 35mm systems are made of plastic and metal alloys and are lighter than ever before.

The latest generation of SLR cameras incorporates the electronic expertise to make them the most sophisticated yet. Built-in microcomputers control camera

functions, process data, and evaluate all aspects of your picture. But all the technology does make cameras harder to fix if anything goes wrong.

There are many types of SLR camera on the market, but only a few complete system manufacturers – Nikon, Canon, Olympus, Minolta, Pentax, Contax, and Leica. The highly versatile Nikon F-100, shown here, makes full use of micro-electronics, microprocessor circuitry, and toughened plastics. It is light, fully automatic and can be used with all Nikon lenses, both autofocus and older models.

Don't be put off by the sophistication of the new camera technology. It is there to help take good pictures – not just as a gimmick. The new cameras are immensely versatile, but in order to realize their full potential, a new owner must do two things. First, read the instruction manual thoroughly and, second, use the camera extensively and analyse the results.

Nikon F 100

1 Exposure compensation button
2 Shutter release button
3 Exposure mode button
4 Depth-of-field preview button
5 Metering system selector lock
6 Lens release button
7 Sync terminal
8 Self-timer indicator LED
9 Sub-command dial
10 Focus mode selector
11 10-pin remote terminal
12 Film advance mode selector lock release
13 Flash sync mode button
14 Auto exposure/flash exposure bracketing (film rewind) button
15 ISO film speed button
16 Accessory shoe
17 Diopter adjustment knob
18 Metering system selector
19 Film plane indicator
20 AF start (AF-ON) button
21 Power switch
22 Camera strap eyelet
23 Custom setting button
24 Film confirmation window
25 Film advance mode selector
26 Shutter speed/ aperture lock button
27 Viewfinder eyepiece
28 AF area mode selector
29 AE-L/AF-L (Auto-exposure/Autofocus lock) button
30 Focus area selector
31 Focus area selector lock knob
32 LED panel
33 Main command dial

Electronic cameras |

Speedlight SB28 offers advanced features such as pre-flash, a repeating flash for dramatic strobe effects and high-speed sync, that allows the use of a shallow depth of field in bright sunlight.

Electronics have brought about a revolution in camera technology. The Nikon F90, for example, contains nearly 900 separate parts; these include two powerful microcomputers and eight ICs to process data and help the photographer make the creative decisions necessary to realize a picture.

The use of electronics in such cameras lets them do more than ever before – it would be impossible to produce mechanical equivalents of all the functions in the F90. And, despite the complexity of electronic cameras, they are now more reliable than their mechanical counterparts.

As with any machine, you need to become familiar with a new camera before you see an improvement in your pictures. Once you are used to the camera, you will find that features such as autofocus and the various types of programming can solve many photographic problems – even when you didn't know there was one.

And remember, autofocus and other such features are meant as an aid to, not a substitute for, creative skill. They do not have to be used all the time, only when needed – most of the features can still be manually controlled. To be in command of the medium, a knowledge of the relationship between the aperture and the shutter is vital, even when working with an electronic camera. But when automatic features are used, they let the photographer to concentrate on the picture, with the knowledge that other decisions are being taken care of.

All automatic functions rely on batteries and battery technology has greatly improved. Lithium batteries give better service than ordinary types.

More often than not, a particular light effect makes a picture. Nikon built-in light meters have always been capable of crictical exposure control, but the metering systems of the new generation of cameras – the F5 and F-100 plus D-type lenses – are even better. The ten-segment matrix sensor reads the brightness, contrast, and color of the subject and its distance from the camera. This information is processed by the camera's database to provide accurate automatic exposure. If there is any doubt, it is possible to custom set the meter to auto bracket.

Most major manufacturers produce a host of
accessories, ranging from simple items, such as
straps and filters, through to sophisticated timing
devices and super-telephoto lenses for the military
and security industries.

Electronic cameras 2

A central, battery-powered control unit operates all the functions of the electronic camera – shutter, exposure, flash, focusing, information on type of film, and number of exposures. Although the camera functions are automatic, the photographer must program in the picture requirements and choose which mode to shoot in, which metering system to use, and so on. All this information registers on the LCD screen, *right*.

The exact terminology used differs according to the camera make, but here are the basic terms in general use:

Mode
Electronic cameras have a variety of operating systems or modes from which the photographer can choose – manual, aperture, or shutter priority – and specific types of programming.

Programming
Set on programming, the camera selects what it considers to be the correct combination of shutter and aperture for the picture being taken.

High-speed programming
The camera automatically selects a fast shutter speed in order to freeze action.

Ordinary programming
The camera selects an aperture that ensures that the picture is sharp from foreground to background.

Shutter priority
You choose the shutter speed for the effect you want. The camera selects the appropriate aperture.

Aperture priority
You choose the aperture for the picture and the camera sets the shutter speed.

Manual
The photographer controls both shutter and aperture – when bracketing, for example. On some cameras there is an automatic bracketing programme.

Autofocus
The lens focuses automatically, but REMEMBER that you have to allow it time to focus before taking the picture.

Metering systems
Electronic cameras have three methods of taking the correct light reading:

Matrix or evaluated metering splits the screen into five or six sections and takes an average of them all.

Center-weighted takes the reading mainly from the center of the frame where the main interest is likely to be.

Spot metering takes the reading from a very small central area.

ISO
This is the internationally accepted rating system for film speeds, replacing ASA.

Control dial
This dial is used to select the camera's various functions. Commands are displayed in the viewfinder, *bottom right*, and on the LCD screen, *top right*.

LCD display
This window on the body of the camera displays all relevant camera information. It is usually displayed for 16 seconds at a time after lightly pressing the shutter button. The illustration, *top right*, shows all possible information on the screen, but this would never appear all at once; the screen, *center right*, shows the information for the normal program.

Balanced fill-in flash
This allows camera and flash unit to be programmed to take a picture in which the flash does not overpower the background light.

Dedicated flash
These flash units work in harmony with, and are controlled by, the camera, to take a properly exposed picture. Information is relayed between flash unit and camera via the hot shoe to produce the right amount of flash on the subject.

LCD panel on top of camera

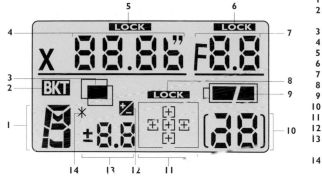

1 Exposure mode
2 Auto exposure/flash exposure bracketing
3 Multiple exposure
4 Shutter speed
5 Shutter speed lock
6 Aperture lock
7 Aperture
8 Focus area lock
9 Battery level
10 Frame counter
11 Focus area/AF area mode
12 Exposure compensation
13 Exposure compensation value
14 Flexible program

LCD panel

1 Film speed setting mode
2 Film speed/bracketing information/custom setting
3 Flash sync mode
4 PC link connection
5 Custom setting
6 Bracketing bar graphs
7 Auto exposure/flash exposure bracketing

Viewfinder display

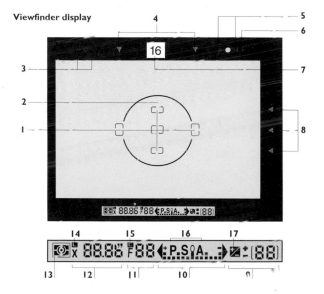

1 Focus brackets/spot metering (4mm dia) area
2 12mm dia reference circle for centre-weighted metering
3 Exposure level
4 Focus area indicators
5 Focus indicators
6 Ready light
7 Aperture direct readout
8 Focus area indicators
9 Frame counter/exposure compensation value
10 Electronic analog exposure display
11 Aperture
12 Shutter speed
13 Metering system
14 Shutter speed lock indicator
15 Aperture lock indicator
16 Exposure mode
17 Exposure compensation

Electronic cameras 3

The state-of-the-art electronic camera, the Nikon F5 is the ultimate professional body that offers everything technology can do. The latest in the line that includes the FM2, F2, F3, and F4, it incorporates all of their advantages as well as new features. Its sophisticated programming and flash system allow you to have complete confidence in its picture-taking abilities.

With a body made of solid, die-cast aluminum alloy, the F5 is rugged and built to withstand the toughest conditions. The body has a rubberized outer skin to make it shower-safe, and the external levers and dials have been designed to keep out moisture and dust.

At the camera's heart are five microcomputers that control systems such as metering and focusing. While the F5 does have autofocus, this is just one of many important features; a tool to be used when required, and overridden when not. It alsohas computerized focus tracking for subjects moving in a consistent manner. It can track the moving subject, anticipate where it will be at the time of exposure, and preset the focus accordingly.

The F5 has three metering systems – spot, center-weighted, and 3D color matrix metering – for which the information from 100,000 images has been programmed into the camera (see pp. 32–33). The motor drive is built in and operates at a speed of 5.7 frames a second. A silent, but slower, speed can also be selected.

Canon, Minolta, and other makers also offer top-of-the-range professional cameras with similar features.

Remember, though, that technology doesn't guarantee a good picture unless the user knows how to handle it.

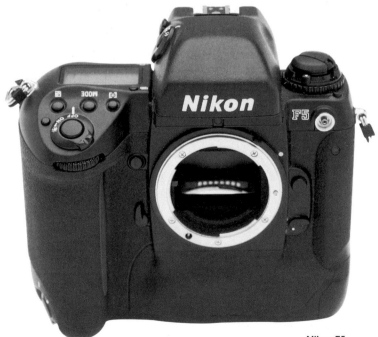

Nikon F5

The Nikon Zoom 800 is a sophisticated compact with a 38–130 mm power zoom lens. Features include an advanced autofocus system that measures focusing data in seven zones, and a selection of shooting modes, including portrait mode, action mode, and landscape mode, to take care of nearly every picture-taking situation. A sophisticated flash system includes zoom flash, which adjusts automatically to any setting in the range, auto flash, and slow sync.

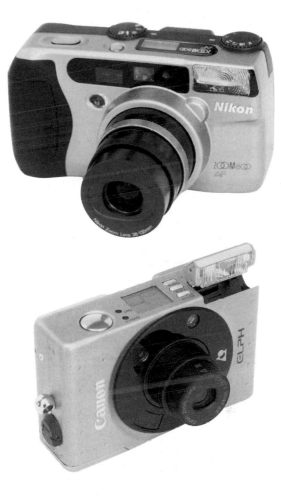

The Canon Elph is a popular APS camera that not only looks good but also takes good pictures. Its stainless-steel body feels great and many manufacturers have copied its look. The camera is equipped with a 24-48mm zoom lens, autofocus, detailed back printing, and built-in flash as well as APS features such as mid-roll exchange and a choice of print size. The size of a packet of cigarettes, this camera fits into a briefcase, purse, or pocket and is ideal for carrying with you at all times.

Compacts

Compact 35mm cameras are light, easy to carry, and offer a wide range of automatic features. They are simple to use and do not require the technological knowledge demanded by electronic SLRs. A compact is the ideal family camera, perfect for slipping in the bag when going on holiday or out for the day. It will record the moments you want to remember with the minimum of bother.

Top-of-the-range compacts are by no means cheap but they are good-quality cameras and give excellent results. Most professional photographers now carry a compact in the camera bag. Totally automatic and extremely reliable, a compact can is perfect for capturing that fleeting moment. Recently, several of the press pictures of the year have been taken on compact cameras.

The drawback is that although some compacts have their own integral zoom, this does not compete with the huge array of lens options in an SLR system, which gives the photographer so much more choice in picture-making. But, within their limits, they are good value.

Special purpose cameras

Although SLR camera systems fulfil most picture-taking needs, there are occasions when another type of camera might be necessary. While the studio cameraman might specify a different, larger format, there is also a range of 35mm cameras designed for particular situations or pictures. You might need a particularly rugged camera for working in the rain or a traditional, non-autofocus model, like the FM2. You may appreciate the quietness of a rangefinder camera or the precision of shooting without an automatic winder.

For your own creativity, it is sometimes good to be limited and not to have to make technical decisions about which camera body, lens, or program to use. Try going out with just one camera and lens, using black and white film, or try going on holiday with just a compact. You can still get great results.

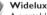

Nikonos

A rugged, all-purpose camera, the Nikonos can be taken underwater down to a depth of 165ft (50m). Its unique construction features an inner body that is sealed into the outer casing. Dustproof and virtually indestructible, it can be used in any environmen,t from desert to mountains, and in adverse conditions such as rain and sea spray. It can be fitted with any of five interchangeable lenses and has its own underwater flash.

Widelux

A portable camera designed for taking landscapes, the Widelux is also useful for taking portraits of large groups. During an exposure, the 26mm lens moves within its mount, describing an arc of 140°, and produces a sharp, panoramic image that occupies one-and-a-half times the width of a normal 35mm frame. It has a limited range of shutter speeds (1/15, 1/60, 1/250 second). Use a pistol grip with a Widelux to help stop your hands intruding into the picture.

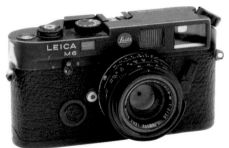

Leica

A reportage photographer's camera, the Leica M6 has a non-reflex design without the noise-making mirror action common to SLRs. It is the quietest full-size 35mm camera. An extensive range of high-quality interchangeable lenses allows exposures to be made under any conditions, particularly in low light levels. Ruggedly constructed and extremely versatile, its design has remained virtually unchanged since its introduction in 1984.

FM2

The FM2 is the traditionalist's choice. If you do want to work with non-autofocus lenses, it is best to use a manual body like this. Mechanically controlled, it works without batteries at all speeds. A motor drive can be attached but it is good to use for single-shot photography – the manual controls really make you think about the picture that you are taking.

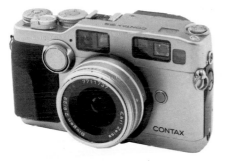

The Nikon Coolpix 900

This is a high-performance digital camera with all the advantages of Nikon technology in a compact design. Although you do need a lot of back-up equipment, digital photography is fast becoming more popular. The advantages are that there is no processing; once you have the whole system you can print the pictures;at home and get instant results.

The Contax G2

A superb rangefinder camera, that, although it does not have the capabilities of a full SLR system, is much more than a compact. It is quiet and well-designed, with manual and autofocus operation, and six interchangeable lenses. A good-general purpose camera, it is ideal for those days when you only want to carry one piece of serious equipment.

Disposable cameras

These come ready loaded with film and cannot be re-used. Different makes offer features such as flash and prints that are wider than usual. There is even an underwater version, which can be used in depths of up to 12ft (3.5m) of water.

Zoom lenses I

A zoom lens is several lenses in one. It gives you a choice of focal lengths, enabling variations of the same picture to be composed from the same position. The photographer can come in close or pull back for a wider shot without having to move. Once believed to be inferior to fixed focal length lenses, zoom lenses are now as good as ordinary lenses and cheaper to produce. Nearly all zooms are designed to work as autofocus lenses and do not operate well manually – the focusing ring is too small and can be irritating to use.

Zooms are now an ideal choice for every photographer. They increase your creative options, let you explore a range of focal lengths with ease, and change focal length quickly. Another point well worth remembering is that camera equipment is heavy, and carrying two zoom lenses is much easier than having seven or eight individual lenses weighing you down.

The majority of zooms do change aperture, but this is not really a problem when shooting with faster film. Constant maximum aperture lenses are more

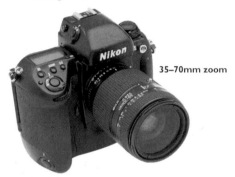

35–70mm zoom

35–70mm zoom f2.8 autofocus (angle of view 62°–34°) The versatile 35–70mm covers the "normal" lens range and is an excellent first lens. It is good for portraits and has a macro facility.

Both shots of the snake charmer were taken on a 35–70mm zoom. The 35mm shot, *below left*, sets the man in his location in front of the Red Fort, Delhi. Snake charmer and building are of equal importance. The 70mm shot, *below right*, was taken without moving position, but from a lower viewpoint, and is much more a portrait of the snake charmer. The zoom has let the photographer to get close to his subject – without getting too near the snake.

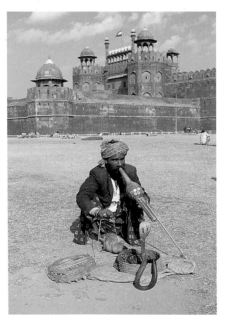

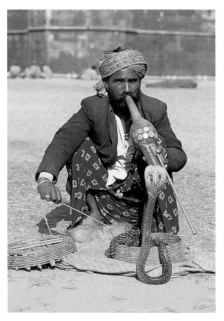

expensive but professional photographers prefer them because they like to use the whole aperture range of the lens.

80–200mm zoom

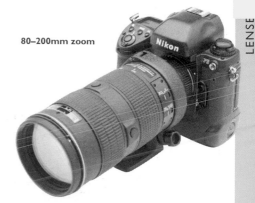

Use circular polarizing filters, not graduated filters, when working with an autofocus zoom – the front element of the lens turns as it goes through the zoom and will cause the grad filter to affect the wrong part of the picture.

80–200mm zoom f2.8 autofocus (angle of view 30°–12°) The most useful long zoom lens, the 80–200mm is extremely sharp and manageable, holding focus throughout the zoom. Contrast can be increased by using a longer lens hood than the one supplied.

The 80–200mm zoom is the ideal lens to carry when out for the day. Both these pictures were taken on the zoom during a trip to Oporto, Portugal.

The atmospheric portrait of the garlic seller was shot on 80mm, which works well for close-up detail.

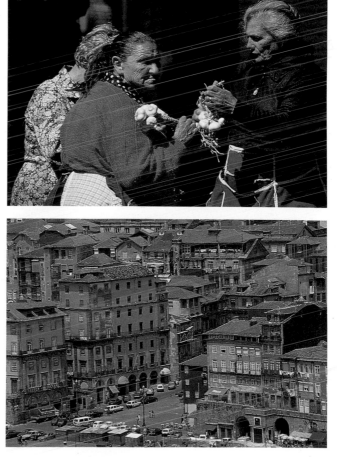

At the other end of its range, the lens is equally successful for this view of the city taken on 200mm. This focal length foreshortens the perspective and packs the buildings up to create a full frame. The wide aperture of this lens lets it to be hand held at fairly slow speeds when light conditions are not good.

Zoom lenses 2

There are now zoom lenses available that cover the range from ultra wide through to telephoto. The development of zoom technology is such that soon even a professional photographer will need only two general lenses. The zooms shown here all feature in the recommended selections given for a basic system on pages 88-89.

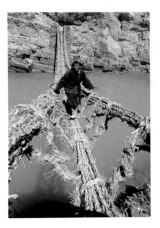

20-35 zoom f2.8 autofocus (angle of view 94°-62°) This lens, which has a constant maximum aperture, covers all the wide-angle options. The picture of a man crossing a rope bridge in India was taken at about 24mm. The lens keeps the foreground detail sharp, exaggerates the sweep of the bridge to highlight the drama of the picture, and includes enough background to set the subject in context. It was perfect for the shot.

28-200 zoom f3.5–5.6 autofocus (angle of view 74°-12°) The 28-200 is a high-power zoom, suitable for subjects such as landscapes, portraits and sports. A moving subject, like this young child, can be challenging, but the flexibility of the zoom lets you follow the action while keeping the subject the same size within the frame. This shot was taken at about 105mm.

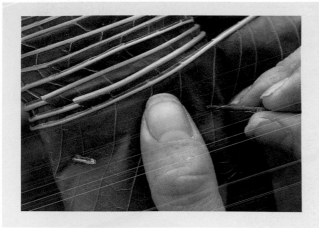

Macro setting Many zooms now have a macro or close-focusing facility, that lets you come right in on a subject. Although in some zooms the macro facility is only available at the widest zoom setting, others will close focus through the whole range. This detailed image of sculptor Andy Goldsworthy stitching a leaf in preparation for one of his works was taken on the macro setting of a 35-70 zoom.

70-300 zoom f4–5.6 autofocus (angle of view 34°-8°) The 70-300 is a powerful but lightweight telelens, ideal for wildlife photography or for taking candid shots of people. The flexibility of the zoom's range let the photographer to come in close on this rhino's head.

Fixed lenses I

Now that zooms are of such good quality, many photographers may wonder why they need fixed lenses. One advantage of fixed lenses is that they give you more involvement. You have to move to frame the picture rather than just stand still and use the zoom. With zooms, the photographer is an observer and less committed to the picture than when using a fixed lens. Also, if you don't like autofocus, fixed lenses are easier to use manually than zooms.

There are many lenses of fixed focal lengths available. The examples shown here are an indication of the optical properties and applications of a cross-section of useful lenses, not a catalogue of all available types.

Lenses are often considered as belonging to specific families, such as wide angle or telephoto, and useful for certain designated subjects. However, this is not necessarily always so. Good portraits can be taken on ultra-wide angle lenses; architectural subjects can be shot on telephoto lenses, as long as the photographer is aware of the level of distortion and the effect on perspective.

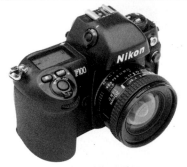

Get to know your lenses. It is as important to be familiar with a new lens as with a new car. The balance of a lens in the hand, the position and operation of its controls, and its optical characteristics are major factors.

There are big price differences between lens ranges but, as a rule, you get what you pay for. Some ranges, such as Vivitar Series 1, Tamron, and Sigma are excellent, but most cheap lenses are of poor quality. If the price of a new lens is beyond reach, secondhand lenses are often good value. Even if a used lens is out of adjustment, it can usually be reset.

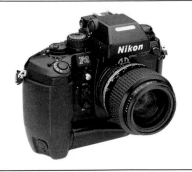

Always test a used lens before you buy it. Photograph a flat, textured surface, such as a brick wall, at various apertures. Project the picture or enlarge it as much as possible, and scrutinize the edges for fall-off or distortion. If the image appears sharp from edge to edge, the lens is in good condition.

15mm f5.6 (angle of view 110º)

An ultra-wide angle lens with little image distortion, the 15mm doesn't bend the vertical or horizontal lines. It has enormous depth of field capability and doesn't really need to be focused unless used close up. Because of its extreme exaggeration of perspective, spectacular pictures can be taken; a fine lens for interiors and sweeping landscapes. Filters must be used on the back of the lens.

20mm f2.8 (angle of view 94º)

The most popular ultra-wide angle lens with many professional photographers, the 20mm is extremely versatile. Like the 15mm, it is good for interiors and dynamic pictures, but comes into its own for landscapes when used with polarizing filters. Graphic compositions can be made that utilize exaggeration of perspective without appearing gimmicky.

35mm f1.4 (angle of view 62º)

Although a wide angle, the 35mm should be the 35mm photographer's standard lens. Its angle of view and minimal distortion allow more possibilities for composition than a normal lens. When shooting people, this lens emphasizes the relationship between subject and environment. The ability to get "inside" a picture creates an intimacy between photographer and subject.

105mm f1.8 (angle of view 23º)

One of the finest focal lengths for 35mm cameras, the 105mm is a favorite of all professionals. Photographers consider it an ideal portrait lens because, when fully framing a head, it photographs the face as the mind's eye sees it, with no distortion. The 85mm f1.4 is also a favorite – the lens of natural perspective. One of these "fast" lenses is still a must for photojournalists.

Fixed lenses 2

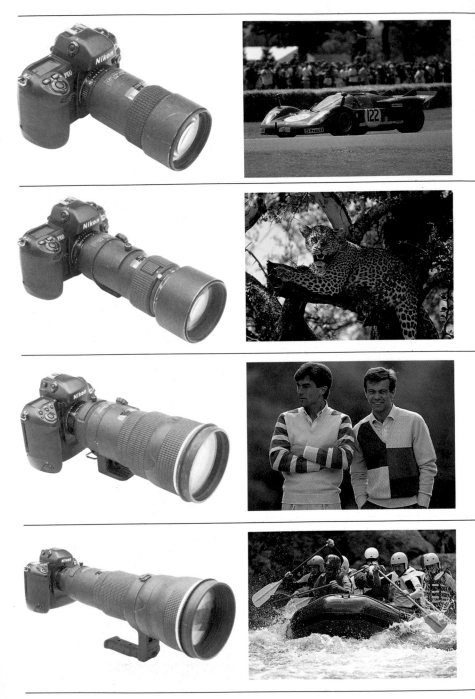

180mm f2.8 (angle of view 13º)

With its wide aperture, the 180mm was a popular semi-telelens but has now been superseded by zooms like the 80–200mm. The 180mm is still a useful and versatile focal length, however. It is excellent for color reportage work, presenting a good relationship between subject and background – a good lens for shooting people across the street.

300mm f4.5 autofocus (angle of view 8º)

This is the first of the real telephoto lenses; it sees closer than the human eye does. It compresses perspective with minimal depth of focus, providing exciting picture possibilities. Because of its light weight, it is the standard telephoto lens for press and sports work, allowing the photographer to stand well away from the subject.

300mm f2.8 IF ED autofocus (angle of view 8º)

A professional lens which gives excellent picture quality. "IF" means internal focus; "ED" refers to the front lens element that gives better color rendition and stops flare. This 300 is the standard press photographer's lens, heavy but manageable and usually used with a monopod. It is also popular for outdoor fashion photography.

600mm f4 (angle of view 4º)

Visual and technical precision are vital when using this lens. It must nearly always be used with a tripod or monopod for static pictures but "panning" is possible. The compression of perspective and shallow depth of field that it achieves can give extraordinary and exciting results. The lens also lets pictures be taken of subjects that are physically inaccessible.

The relationship of subject to background is illustrated in these pictures, taken on three different lenses. The couple were in the same positions for each picture.

The 20mm lens exaggerates the difference between the couple and background.

For this shot on a 135mm lens, the photographer moved back from the subjects, but the buildings appear to be closer to them.

For this 600mm lens shot the photographer moved still further back. The couple in the picture now appear to be sitting very close to the buildings behind them.

Specialist lenses

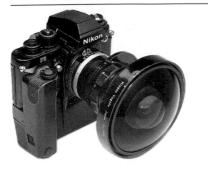

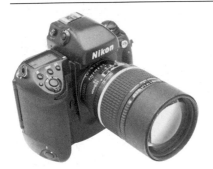

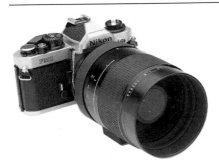

Fisheye 8mm f2.8 (angle of view 180°)

Fisheyes were originally designed to allow meteorologists to photograph cloud cover. The wide angle of view and circular frame can contain a complete horizontal plane when photographing directly upward or downward. The extreme distortion limits their usefulness and makes fisheyes unsuitable for most general photography.

Defocus lenses

Defocus lenses are used in fashion, portrait, and still-life photography to control the amount of sharpness in the picture. The subject is focused first. Then, by turning the dial on the lens you can "defocus" either the background or foreground – put it out of focus while keeping the subject sharp. The out-of-focus area in the picture can be increased or reduced.

Perspective correction lenses

These rectify the distortion of vertical or horizontal lines, important when photographing buildings to stop them appearing to fall over. A 28mm f3.5 lens is shown here. Take care when using these lenses with electronic cameras. Use center-weighted metering with the diaphragm set at the desired f-stop. Bracket at least three stops either side of what the meter says, especially if the lens

Mirror lenses

Light enters the lens and travels to the back, where it hits a mirror and is reflected back onto another mirror at the front of the lens; from there the light is reflected back to the shutter. Mirror lenses are about half the size and weight of other lenses and are `easier to carry. They make out-of-focus highlights appear like doughnuts.

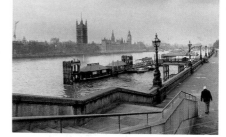

15mm lens (angle of view 110°)

50mm lens (angle of view 46°)

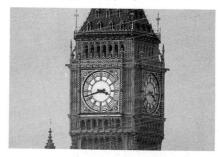

600mm lens (angle of view 4°)

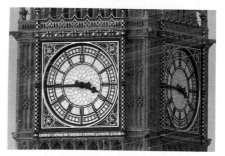

1200mm lens (angle of view 2°)

These views of Westminster, London, were all taken from the same point. Note the size of the clock: the longer the focal length, the greater its magnification. Focal length also controls the picture angle: the longer the focal length used, the narrower the picture angle.

Autofocus

Automatic focusing is improving all the time. Motors are much quicker, although you still sometimes miss a shot while waiting to focus. Some photographers love it; others are suspicious. Autofocus is best thought of as just another tool, something that can be extremely useful in certain situations but that should not be trusted implicitly.

One advantage of autofocus is that, with this important task taken care of automatically, the photographer can concentrate on the composition and framing of the picture. Autofocus is ideal for taking subjects that move around a lot, such as young children and animals, and for sport pictures and oncoming subjects. It is superior to manual focusing in low light levels and can even operate in semi-darkness.

Autofocus can take up to a couple of seconds to operate. In order not to lose your picture while waiting for autofocus, get into the habit of pushing the button in two stages. Press lightly to engage the autofocus and keep your finger on the button. Once the subject is sharp, wait for the shot you want before pressing down fully to take the picture.

The focusing brackets don't cover the entire picture area, so if the subject of the picture is on the edge of the viewfinder, autofocus may not succeed. Frame the subject of the photograph in the center, and operate the autofocus lock button, then reframe as required.

Autofocus usually operates in two modes: single and continuous. In the latter mode, you can use autofocus to follow a moving subject and keep it in focus by keeping the shutter button lightly depressed.

Sports photography has really benefited from autofocus, which works well with oncoming subjects. There was nothing else to focus on for this waterskiing picture. The subject was picked up when quite small and the focus held until the picture filled the frame.

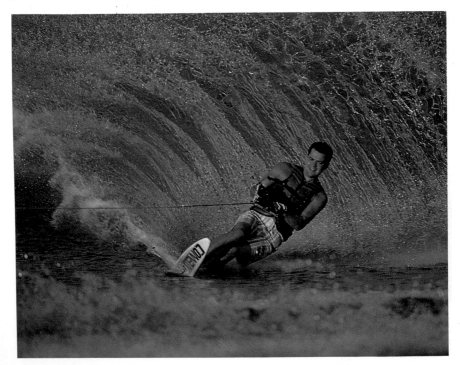

The constant bobbing movements of small animals such as marmosets make them difficult subjects to photograph, but autofocus eases the problem. For this picture, taken on an 80–200mm zoom at 1/500 second, the autofocus brackets on the viewing screen were centered on the animal's eyes. The focus held while the animal moved around. The fast shutter speed was necessary to freeze the action.

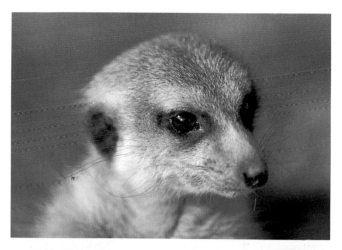

Young children can present much the same problem as the marmoset and are also good subjects for autofocus. This boy was so excited at getting out of school for the day that it was impossible to keep him still. Autofocus coped with his rapid movements and still held him sharp.

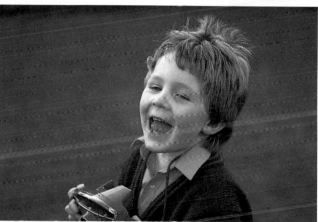

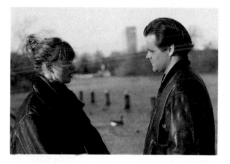

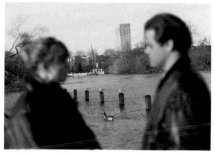

To focus on two subjects, each to one side of the frame, lock the autofocus, recompose, and shoot. Both the subjects of the picture then appear sharp against a blurred background.

Photographs taken without using this technique will focus the center of the picture. This can produce disappointing pictures, as above, where the focus is not on the people but on the irrelevant buildings.

Exposure I

Photography is to do with light – the understanding of it and its correct photographic use. The highly sophisticated metering systems of electronic cameras will solve most of the problems for you – and solve them well – but the photographer still needs to know the limitations of the camera's "expertise" and when and why to override it.

There are three basic types of metering in the camera – matrix, center-weighted and spot. You can switch to all three to make sure of the reading or you can take a reading with a hand-held meter.

The system known as matrix in Nikon cameras and evaluative in Canon is the most sophisticated. The picture is split into five or six segments. Each of these is then evaluated so the camera can decide on exposure. The metering computer has been programmed in such a way that it can make creative decisions; it recognizes if a subject is backlit, if there are strong highlights, or if the subject is a small, brightly lit area.

This is possible because the computer has been programmed with analyses of the subject matter and exposure levels of some 100,000 photographs. By using this stored experience, the camera can make a sound decision on the correct exposure for a given picture.

In the center-weighted system the meter concentrates 60 or 75 percent (depending on the camera model) of its sensitivity in the centre, "feathering out" toward the edges. The advantage of this method is that it gives more control and flexibility. The camera can be moved around to meter different areas of the picture and the photographer makes the final decision.

In spot metering, the reading is taken from a central circle about 0.1in (5mm) in diameter – about 2.5 percent of the viewfinder area. A precise reading can thus be taken off any area of the photograph. Spot metering is ideal in difficult light conditions or when the important element in the picture is small.

Matrix metering splits the picture into five segments in order to judge optimum overall exposure; generally the best reading for negative film.

Center-weighted metering concentrates the bulk of its sensitivity on a 12mm central area of the viewfinder; generally the best reading for transparency film.

Spot metering takes a precise reading of a detail of the scene. Take several readings and use them to find the average.

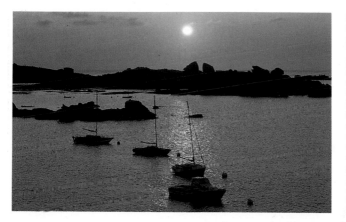

Sunset pictures are ideal candidates for matrix metering. Using its stored "experience" of such pictures, the camera can recognize that the sun is not important and expose for the general scene. Each section is evaluated separately so that the sun does not disrupt the reading. Without matrix, the meter would have exposed for the bright sun, the rest of the picture would have been underexposed, and the foreground would have been too dark.

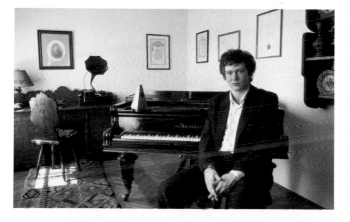

In this daylight portrait of a pianist in a room that once belonged to the composer Bartók, the subject is surrounded by dark furniture and white walls, making correct exposure problematic. Using center-weighted metering, the reading was taken from the central dark areas, ignoring the white walls. Both the key elements, face and piano, are perfectly exposed in the resulting picture.

A shaft of very strong daylight lit this monk standing inside a dark monastery. In order to expose for the brightly lit face, spot metering was used to take a precise reading from an area of the face. The dramatic effect of this photograph could only have been achieved with the pinpoint accuracy of spot metering, and emphasizes the importance of choosing the correct metering mode for the picture.

Exposure 2

There is really no such thing as correct exposure – only the exposure for the picture you want to take. The camera is just a tool in the photographer's hands; despite all the technology, it has no taste.

Exposure can make or break a picture, but the right level for the picture is not always what the meter says. Older cameras without sophisticated metering systems often give too general a reading. This is fine for evenly lit subjects, but may cause problems when there is a great difference in light levels. Even when using electronic metering systems, there are situations which require bracketing:

1 With wide angle lenses or in landscape photography, when the amount of sky may have too much influence on the reading.

2 When using two or more filters, especially polarizing filters.

3 With high speed film such as 1600 ISO and above; the film can be underexposed.

4 When taking pictures with high contrast and subjects not in center, *right*.

5 When using a perspective control lens.

Bracketing

Using bracketing as a technique enables a photographer to explore all exposure possibilities and make certain of getting the desired shot. Pictures may be taken that even the most experienced photographer might not have expected. There are five ways of bracketing:

Varying the f-stop

The first method, above, is to change the f-stop from the one indicated by the meter. Under most light conditions this means taking a frame at the metered aperture, then one at a half stop under, and another at a half stop over. In low light levels or when using slow shutter speeds, try going as much as two stops each side of the indicated aperture. This

can also be useful when working in unfamiliar light conditions.

Some electronic cameras make a mechanical exposure at about 1/100 second when the batteries are run down. In this instance, f-stop bracketing is the only way to alter exposure. The new electronic cameras do not work at all if the batteries are exhausted.

Shutter speed

If aperture priority is critical to maintain depth of field, bracket by varying the shutter speed. At a fixed f-stop, one frame is taken at the indicated shutter speed, then one above, and one below that. On electronic cameras, shutters work at speeds between those shown on the dial.

An off-center black cat in snow presents an extreme exposure problem. Take an incident light reading or a camera reading off neutral grey, such as your hand, and bracket to overexpose. Alternatively, take a spot reading from the cat and bracket.

For a light subject on a dark background – a white cat on a pile of coal – do exactly the same but bracket to underexpose. On automatic, the result would probably be a ghostly cat, with no detail, among overexposed coal.

On the bracketed frames, *above*, exposure was varied by two stops: from f5.6 for the face and coat, to f1, for the building. Of the resulting pictures. the girl appears at her best in frame 22, the buildings in frame 25. Frame 25 is a perfect example of when to use matrix-metered fill flash. The final choice of frame must depend on what was important in the picture.

Fill flash

The third method uses fill flash. Set the exposure for the background – see frame 25 – and bracket with the power of the flash. This is a manual operation – set the flash half a stop over and half a stop under and keep it on all the time. You are looking for a combination of frames 22 and 25 to give the perfect picture. News photographers use this method all the time – it is foolproof when shooting with negative film.

Neutral density filters

New technology has made neutral density filters less important but the fourth method of bracketing uses these filters to cut down the light. Bracket with different strengths of neutral density filter to let you use a particular shutter/aperture combination with an uncontrollable light source, like sunlight.

ISO setting

A fifth method of bracketing is by changing the film speed setting. When using 200 ISO film, for example, shoot one frame at the correct setting; change the dial to 150 ISO (half a stop over) for the second, and then to 300 ISO (half a stop under) for the third.

Aperture and shutter

A camera is a box with a lens at one side and a film holder at the other. The camera contains a shutter; the lens has an iris. Light enters the camera through the lens and exposes the film when the shutter is opened.

The iris is a system of metal leaves that can open and close. The space in the middle is the aperture, the size of which is measured in f-stops. The aperture governs the volume of light landing on the film; the shutter controls the length of time that light is allowed to land on the film. If the shutter speed is doubled, the amount of light is halved. This is also the effect if the size of the aperture is decreased by one stop. Conversely, a wider aperture or slower shutter lets more light through.

Correct exposure is obtained when the aperture and shutter speed are in the right relationship, governed by what speed of film is being used. The exposure meter needle moves with fluctuations of

Stopped down – a small aperture holds focus from foreground to background. Bracket shutter speeds. The picture, *below*, was taken with an exposure of f22 at ¼ second on a 35mm lens.

A wide-open aperture creates an out-of-focus background with no unnecessary detail intruding on the flower subject, *above*. Shot on an 85mm lens at f2, with an exposure of 1/1000 second.

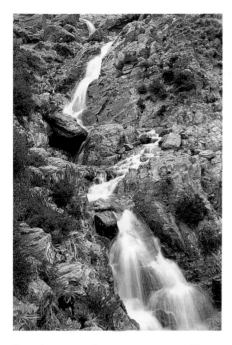

light and indicates a range of shutter/aperture combinations, any of which are technically correct.

Aperture determines the depth of field – how sharp the picture is in front and behind the point on which the lens is focused; the smaller the aperture, the greater the depth of field. With the lens wide open, only the point of focus is sharp. A scale on the lens barrel indicates the extent of the area in focus at each aperture. The effects of aperture control are most visible on long lenses.

The preview button on the camera enables the stopped-down image to be seen. Make it a habit to use this to check sharpness. If more depth of field is wanted, use a slower shutter and a tripod.

The shutter controls the effect of movement by the subject in the picture. It will either freeze the action or give the impression of movement. With modern electronic cameras, there is an infinitely variable range of shutter speeds.

Slow shutter speeds can convey movement. The tumbling waterfall, *above*, was photographed at a shutter speed of about one second with the camera securely mounted on a tripod.

Fast shutter speeds freeze action to make a dramatic picture. The horse, *below*, was captured, in mid-air as it completed a jump, using a shutter speed of 1/2000 second.

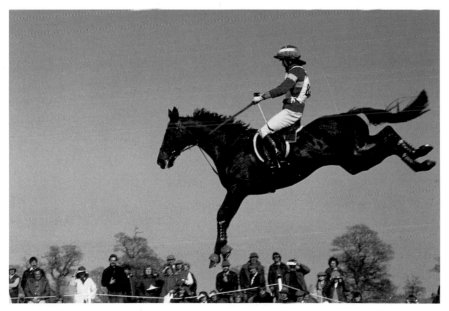

Exposure meters

Although camera metering is now highly sophisticated, the serious photographer should not be without an independent meter. With this, the level of light in every relevant area of the picture can be ascertained – this is often difficult and slow to work out with built-in meters.

As with camera meters, the hand meter only provides basic information; the photographer then has to apply this to the individual picture requirements.

There is no guarantee that any meter will give the exposure for the perfect picture, but intelligent use of the camera meter and the hand meter, combined with bracketing, should result in correct exposures for the picture.

Study any mistakes. If a note is kept of exposure details, much can be learned from bad pictures.

The Sekonik L-508 is a compact, versatile, zoom spot meter. It switches easily from spot to incident and measures both reflected ambient light and reflected flash as well as mixed lighting. It can memorize up to three readings and then automatically work out an average exposure for the picture, so there is no excuse for getting it wrong. The memory function even allows the photographer to compare spot and incident readings of the same scene.

GRAY CARD READINGS

When reduced to monotones, most scenes represent about 18 percent gray. Film speeds and meters are calibrated for this average tone (reproduced on p.240).

18 percent gray areas are grass, trees, tarmac, neutral clothing, and dull brickwork. For correct exposure in non-average conditions, measure something that represents this gray tone. With ultra wide-angle lenses, determine the exposure off the ground, then recompose the picture using that reading. In snow, take a reading from gray card and stick to it no matter what the camera says.

Color temperature meters measure the "color" of light and indicate the type of filtration required to achieve a correct color balance for the film in use. Mainly used when taking pictures in mixed light conditions with transparency film, a color temperature meter is also useful at the beginning and end of the day. Use it to check early morning light, which can look very blue, or late afternoon light, which can appear yellow.

Sekonic L-308 E11 **Sekonic L-508 zoom master** **Minolta colour meter**

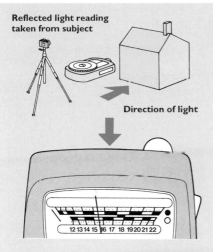

Reflected light reading taken from subject

Direction of light

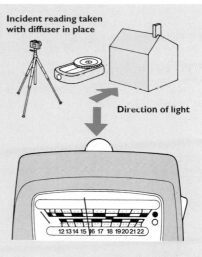

Incident reading taken with diffuser in place

Direction of light

USING HAND-HELD METERS

Hand-held meters can be used in two different ways to measure either reflected or incident light:

Reflected light readings are taken from the light which bounces off the subject in the direction of the lens. This is much the same as taking a reading with the camera meter, but the hand meter is more versatile.

Incident light readings are those where the meter is held in front of the subject but facing the light source, so measuring the amount of light falling on it. To take these readings, the meter needs a light diffuser, which nearly all meters now have. Incident readings give a more accurate idea of the light falling on a subject without being affected by the brightness of a subject.

Once the film speed has been set and an exposure value indicated on the scale, the complete range of relevant shutter/aperture combinations becomes evident.

The Weston Euro-Master is a selenium meter and useful for most general purposes. Since it is not battery powered, it is good for use in extreme cold or high humidity, where batteries are unreliable. It is less sensitive in low-lit areas.

Spot meters are used for precision work. They have a reflex viewing system with a spot in the middle of the screen that takes a one-degree measurement. Readings can be taken of all areas for the picture from a considerable distance, providing the photographer with sufficient information to make the correct exposure for any part of the picture. Spot meters are ideal for photographing backlit subjects and pictures of sport and stage performers.

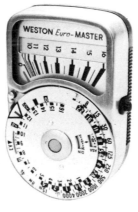

Weston Euro-Master

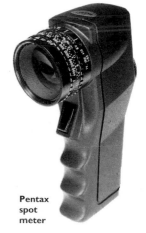

Pentax spot meter

Film color negative

Color negative films range in speed from 50–3200 ISO, and use the Kodak C41 processing system or equivalent. Universal in balance, they can be used in all types of lighting and color-corrected at printing stage.

More people use color negative than transparency, particularly if they want to scan pictures into a computer and manipulate them on screen. Negative film has a greater exposure latitude – you can keep detail in the blackest shadows and the lightest highlights. Many types have benefited from the development of APS and use the same technology.

Like transparency film, color negative needs careful handling. Good prints will only come from good quality negatives.

Agfa Ultra 50. Ultra-fine grain; this film gives hard-edged sharpness and good rich colors, even on a dull day.

Kodak Portra 160NC. Gives natural or neutral colors and flattering flesh tones in controlled lighting conditions. Has a wide exposure latitude.

Fujicolor NPS 160. A professional film designed for wedding photography. It gives good skin tones and can handle the full tonal range in daylight and with flash.

Fujicolor Reala 100. Colors are extremely realistic if printed well; excellent for skin tones and for use in mixed light.

Agfa Portrait 160. Good film for photographing people and for beauty pictures; gives smooth skin tones and soft pastel colors. Has very fine grain for an ISO 160 film.

Fujicolor Superia 200. The Superia range has benefited from APS technology and has highly uniform fine grain. Its sharpness makes it a good film for compact and travel photography.

Agfacolor CTX 200. Good neutral color film with satisfactory shadow detail and vibrant primary colors. Extremely wide latitude.

Fujicolor Superia 400. Good film for use in low light or mixed light conditions; uses the same technology as the ISO 100 and 200 varieties and has good color and grain. Use with fill flash.

Kodak Portra VC 400. Has enhanced or vivid color but gives good skin tones with on-camera flash. Ideal for use in mixed lighting.

Konica 400. Good grain and saturation for an ISO 400 film. Has a six-stop exposure latitude.

Agfa Opima 400. Pushes well. Gives clean, well-saturated colors and smooth skin tones in daylight, flash, and tungsten light.

Kodak Portra 800. Designed for newspaper photography and can be processed and scanned very quickly. Good highlights and mid-tones.

Fujicolor 800. A great film, this can be pushed to ISO 1600. The grain is not too big and it has good color in both low light and mixed lighting conditions.

Konica 3200. Has a grainy look which adds to the overall effect. Shadow detail is weak but this film allows you to roam in dim light without a tripod.

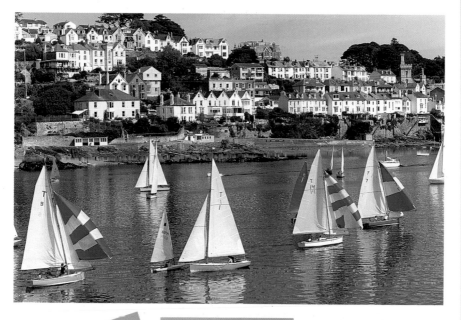

One-hour processing

One-hour processing labs are in nearly every shopping mall and railstation. While results are generally good, remember that prints do not receive individual attention. Film is batched, put through a film processor and printed onto a continuous roll of paper. Prints are then cut by machine and sorted. Ask for prints to be done again if you are not happy and take any very special pictures to a professional laboratory for hand printing.

Of these test prints shown, the harbor scene (*top*) has been well reproduced and the colors are natural and bright. This was a good negative, shot in bright, even light and with no one dominant color; there was no reason for it to present any problems to a processing lab.

The portrait results are more variable. Skin tones are much too magenta in the print (**1**) and too green in (**2**); only print (**3**) is acceptable.

Film black and white

Black and white photography is a medium in its own right – it is not just taking color subjects in monochrome. Reportage and fine art photographers often find shooting with color distracting and prefer the tonal subtlety and directness of black and white.

There are two approaches to using black and white. Either shoot a perfect negative from which to obtain a great print, or just shoot to get the picture and adjust the result in the processing. In both instances, the initial exposure dictates how the film should be developed and what type of print is best.

To get the best from black and white, a photographer needs a darkroom and some specialist knowledge of developing processes, which can only be touched on here. When choosing black and white film, be sure to select the right film for the intended picture.

Slow film (25–50 ISO)
These films have extremely fine grain, but must be developed accurately to obtain optimum quality. Good definition is achieved either when shooting in bright light or when long exposures can be made. Their ability to record a wide range of tones is useful with subjects such as architecture.

Medium film (100–200 ISO)
This range of films has a fair amount of latitude – the ability to cope with many different light conditions – and can be pushed if required. At its normal speed rating, it is best used when the light level is bright – in summer sunshine, or under studio lighting. Its slower speed allows the photographer to vary the f-stops to a greater degree than with fast film.

Fast film (400–3200 ISO)
News photographers use fast black and white film for its wide latitude. When shot at its normal rated speed, it has good grain structure. It can be pushed three f-stops or more and processed in many types of developer, depending on the negative quality required.

Black and white portraits are preferred by many photographers. The perfect print with the full tonal range from black through to white is what "real" photography is all about.

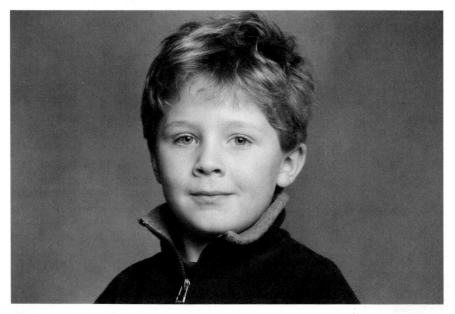

 Agfapan APX25. Professional film; fine grain and good definition, but it is slower than some comparable types without excessive contrast.

 Ilford Pan F. Extremely fine grain, high contrast, and very sharp; this is an excellent choice of slow film for general photography.

 Kodak T-Max 100. Very sharp general purpose film with fine, uniform grain; for best results, process in T-Max developer – one time use only. Don't over develop.

 Agfapan APX100. Professional film; almost as sharp as Agfapan 25 despite speed increase, but has coarser grain.

 Delta 100. Extremely fine grain and with a smooth tonal range, this is best with good light and is ideal for fashion, portraits, and still life. It is compatible with all developers and papers.

 Kodak Plus-X. Tried and tested for many years and still a favorite because of its reliability, its flexibility indoors and out, and its wide processing latitude.

 Ilford FP4. Considered by many darkrooms as the best medium-speed film. It has fine grain and a true tonal range, giving a roundness to the image. Good for head shots.

 Ilford HP5. Good shadow and contrast, it handles darkly lit subjects well and performs well at ISO 800/1000. A flexible film for general photography.

 Tri-X 400. The black and white film that all others are judged by. Incredibly adaptable, it can be pushed, made grainy, flat, soft, or hard.

 Polargraphic ISO 400. Instant, fine-grained film; used for copying, but has many creative applications.

 Kodak T-Max 400. The film for the careful photographer; obey the T-Max developing instructions for exquisite images. It is less tolerant of exposure and developing errors than Tri-X.

 Agfapan APX400. Best rated at ISO 320; when carefully processed, this produces pleasing rich blacks as well as good grain, sharpness, and contrast.

 Fuji Neopan 400. Fine grain; good for shadow detail without losing highlight detail. It performs best between ISO 400 and 800.

 Fuji Neopan 1600. Like the 400, this is popular for newspaper work because of its high contrasts and short development time.

 Kodak T-Max 3200. Better grain at 800 ISO than pushed Tri-X. Designed for artificial light and for processing in T-Max developer. Take shadow reading when pushing this film.

 Ilford SFX 200. Medium-speed film which produces pictures like infrared film when used with red, yellow, or orange filters. Easier to handle and print than infrared.

 Ilford XP2 400. Very fine grain with excellent highlight definition and tonal rendition. When everything is against you, this film gives you a picture. C41 process.

 Kodak Technical Pan IS0 25. High-resolution film for scientific and medical use. Very contrasty negatives that can be enlarged up to 60 times. Process in Technidol LC developer.

 Kodak High Speed Infrared Film. For pictorial work, use a red filter and rate 50 ISO. Set lens by IR index. Coarse grain and high contrast. Read instructions!

 Polarpan. An instant positive black and white film with good contrast and grain. Print on color paper.

Film transparency

There are many types of transparency (slide) film on the market, most available all over the world.

Daylight film is color balanced for noon/daylight, electronic flash, and blue flashbulbs. Other films are balanced for tungsten (inside light) of various types.

Film is available in various speeds, rated from 25 to 3200. The rating refers to the sensitivity of the film to light: the higher the rating, the faster or more sensitive the film. The faster films are inevitably coarser in grain and less sharp. Most transparency film is now processed by the E6 system. All E6 films are best

processed as soon as possible after exposure. Kodachrome films have a different processing system (K14), which only a few specialist professional labs can deal with. This inconvenience has led to the films falling out of favor, but they do scan well for Photoshop use.

Saturation is a term used to describe density and strength of color. With many films, slight underexposure will increase saturation. Many professionals overrate transparency film. A 25 ISO, for example, can be shot at 32; 64 ISO at 80. The slightly underexposed transparency ensures saturated color.

Kodachrome 25. One of the sharpest, least grainy films; limited exposure latitude so needs careful handling and bracketing. Good neutral colors.

E100S/E100SW/E100VS. Fine smooth-grained film; E100S is neutral, E100SW is saturated, warm color, and E100VS is hyper color. Elite II is the name of the consumer version.

Velvia 50. A very sharp and fine-grained film with vibrant "commercial" color. Good in clean light, a perfect choice for an overcast day. Rate at ISO 32 and push to "open the film up."

Agfachrome 100. Sharp, neutrally balanced film, it records true color and has average contrast and saturation. Pushes well, especially with flash indoors.

Agfa 50. Fine grained and sharp. Likes pastel and warm colors; good for natural-looking portraits. Can be pushed and pulled with confidence.

Fujichrome Astia 100. Smooth fine grain; faithfully records pastels and delicate hues. Holds detail through the shadows to the highlights. Very good for beauty photography in good, clean light.

Kodachrome 64. The constant and hard-edged sharpness give the Kodachrome look. Bracket half a stop either side of "correct." Increase the color saturation by using 81B filter.

Fujichrome Provia 100. Bright rich colors, both in daylight and with flash; clean whites and greys. Can be contrasty in bright light so expose for the darker areas. Pushes one stop well. A good general film.

Ektachrome 64. A favorite because of its true colors and sharpness; performs well in most situations, especially with skin tones. The standard Ektachrome film by which others are judged.

Elite Chrome 200. Increase in grain size from the 100 range but otherwise has the same color and tonal range. Can be pushed four stops. The ideal film to carry when travelling.

Ektachrome 100 Professional (EPN 100). Designed to make a faithful record of artificially produced colors in a studio or in good daylight conditions. Rate normally. Doesn't push well.

Kodachrome 200. Fast, sharp film with fine visible "gritty grain," which gives an industrial look when shot on location in overcast, dull conditions. Gives excellent shadow detail.

Fuji Provia 400. The best image quality in this ISO range; pushes two stops. The film to use when you would rather use a tripod than fill flash. Sensia 400 is the consumer version.

Kodak 320T. The same emulsion technology as 400X but for tungsten light; excellent grain and color. Can be pushed to ISO 640. Use 81A filter to give the look of interior lighting.

Kodak Ektachrome 400x. Warmer than Provia; use when the light is less than perfect – in stadiums, night-time streets, or on dull winter days. Works well with long or wide aperture lenses.

Kodak 64T. Tungsten-balanced film that records interiors and chemical dyes and colors well. Kodak 64T is an excellent film for cross processing.

Fujichrome MS 100/1000. Little loss of color or saturation or increase in grain when pushed makes this a good film for shooting in ever-changing light. Rate at 400 when using flash.

Ektachrome Infrared. Used for creative and special effect pictures – vegetation appears red, for example. Bracket exposures and take care with focusing. Experiment with filtration.

Agfa Scala 200. Black and white film for positive transparencies; requires special processing but has a beautiful tonal range – sometimes better than conventional black and white film.

Ektachrome P1600. Good in mixed light conditions; expose for the darker areas and clip process. The noticeably tight, even grain adds to the artistic effect.

PolaChrome. Instant pictures if you carry the autoprocessor, its quality is unlike any other transparency film; a very useful aid.

PolaChrome HCP. A high-contrast color film with medium grain and high resolution, it is ideal for use in computer graphics, copy stand work, and photomicrographs.

Film handling

All film materials deteriorate with time. Color film is especially affected by temperature and humidity. If changes in climatic conditions occur, the speed and color balance of film is likely to undergo some alteration.

There are two types of color film; one is designed for professional use, the other for amateurs. Professional film is of extremely high quality and is more consistent roll for roll than amateur, but it has a shorter shelf life. For best results, manufacturers advise that professional film should be stored in stable conditions at temperatures of 55°F (13°C) or below and processed soon after use.

Film intended for extremely critical color reproduction should be kept in a freezer at even lower temperatures, around –4°F (–20°C). Before use, allow the film to return to room temperature slowly in order to avoid condensation inside the cassette. Process film as soon as possible after use.

Amateur film has a longer shelf life, remains more stable under varying conditions, and has a more general application than professional film. It is designed for less critical applications. Manufacturers assume that amateur film will be stored at room temperature and the length of time between purchase and process will be longer than with professional film.

Adverse conditions

When travelling in hot countries, use amateur film for its greater stability. If it is possible to keep it under controlled conditions like professional film, the consistency of amateur film batches can be maintained.

Film is packaged in sealed foil and airtight cans to protect it from humidity. In humid conditions, process exposed film as quickly as possible. On location, keep any exposed film separate from unexposed rolls and protect it just as carefully. Once packs are opened, they must be protected from light. Never open a film pack until it is to be loaded.

Insulated bags (see pp. 74–75) are useful for carrying film; in hot weather, put a freezer sachet inside the bag to keep temperatures low. However, extremely cold conditions are as bad as exceptional heat. Film is likely to crack or snap and may also cut the fingers when being handled.

Chemicals and radiation are other dangers from which film must be protected. Generally, the X-ray scanners used in airports shouldn't affect film, but avoid letting it go through more than a couple of times. Very fast film of ISO 2000 and over may be affected by the scanners, causing the film to fog. In North America, you can always ask for a hand check, but carry the film in a clear container so it is easy for the airport officials to see.

The range and availability of films changes rapidly. Plan ahead and try to

An ordinary plastic food storage box makes an ideal see-through container for carrying film through customs. Keep rolls of film in their cans.

Use of a bulk loader lets photographers save on the cost of film. Available in 100ft (30.5m) lengths, the film is wound onto used cassettes. Bulk loaders are essential for use with motor drive back units.

FILM CHECKPOINTS

- Push (overrate the speed) to increase grain or when it is the only way to make the exposure. Pushing can also be used to reduce contrast – underrate the film and push the processing.
- Rate film slower than indicated in tungsten or low light levels.
- Even under low light levels, an image usually registers on black and white film. If a scene is visible, it can be photographed, but it may need an exposure of 30 minutes or more.
- Expose for shadow details – never starve a negative film of light. Even when film is pushed, shadow detail will not improve. A flat light on a subject enables detail to be extracted from pushed film.
- Orthochromatic films are blind to red and yellow. Use them for copying when no mid-tones are required.
- To see how color tones convert to monochrome, adjust the controls of a color TV to black and white.
- Modern film emulsions have a long life. Manufacturers claim that, when properly stored, transparencies and negatives should remain in good condition for a hundred years.

ensure that you have the right film for the task in hand. There is now a film for every possible picture situation, whether you are using transparency, negative or black and white.

Remember the affect of exposure; in long exposures under dim light, or very short ones under bright light, films can appear underexposed; with color film, the balance of one of the three emulsions might be altered. This effect is known as reciprocity failure: the normal reciprocal relationship between exposure and light intensity does not apply.

Each type of film is identified by a bar code system known as DX coding. Modern electronic cameras can recognize these codes, and from them register the speed of the film and the number of exposures on the LCD panel.

Times of day

Dawn

Morning

Midday

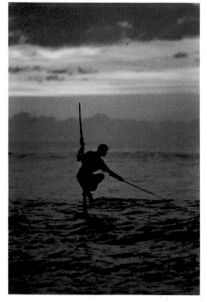

Sunrise

The quality of daylight varies in different parts of the world and at different times of the year, depending on the angle of the sun in the sky. Just after the sun rises and immediately before it sets are the magic moments of the day, with a light that can make the most mundane subjects worth photographing.

Dawn has wonderful photographic properties. The light is clean, clear, and cold. Many car advertising pictures are shot at this time because the modeling effect of the light is so good. It is shadowless, with little difference between the highlights and shadows. It is well worth getting up at this time of day – many of the best pictures are taken at dawn when most people are still in bed.

Sunrise brings a warm, romantic light, containing more red than blue tones. The sun's rays are sharper than at sunset. There is high definition on directly lit subjects but, as the sun rises in the sky, the quality of light changes quickly, leaving very little time to shoot.

Morning. The fine, bright light that lasts until about ten o'clock is popular with professional photographers shooting fashion or travel assignments on location. The sun climbing in a blue sky provides a clean, almost colorless light. Visibility is good and shadows are clearly defined, although they are not yet totally black.

Afternoon

Midday is not the best time for general photography since the sun is too directly overhead. There is a tremendous difference in exposure between shadows and highlight areas. The light is usually too hazy for landscape shots, although it can be suitable in the winter or after rain. In portraiture, eye sockets tend to fill in with hard shadows. This hard light with its black shadow areas can be used to advantage with a polarizing filter.

Afternoon. As the sun gets lower in the sky, modeling comes back into the landscape, and the warm quality of the light is good for skin tones. This diffused light is best for backlighting. Water sparkles and the long shadows are blue. Afternoons are a good time for photographing from the air, from a helicopter or a balloon, as the light gives shape to the landscape.

Sunset

Sunsets can never be chased so a prior knowledge of where the sun is going to drop is vital for a successful picture. Take meter readings from one side of the sun and bracket exposures. With automatic cameras, matrix metering works well for sunset pictures. The computerized metering system can recognize a sunset and expose for the whole picture, not just for the bright sun.

Dusk. After the sun has set, the glow that remains provides a light that is similar to that of pre-dawn but softer and full of color. As the light level decreases, longer exposures are necessary. The indirect light softens hard surfaces.

Dusk

Daylight

Natural light is best: daylight is the raw material of photography and has an infinite range of effects of which the serious photographer must be aware.

One of the old laws of photography was that the sun should always be on the photographer's back, but this no longer applies. With modern lenses, pictures can be taken irrespective of the position of the sun. Window light is excellent for portraiture and enables good interior shots to be taken without flash if the subject is positioned with care, *right*.

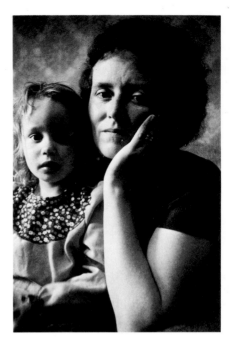

At midday, the light is usually hard and bright, so position subjects with their back to the sun for a more flattering effect. When working with backlighting, take the reading from the face and ignore all other readings. *Below*, the hair and shoulders are backlit, holding the figure off the background and making a pleasing picture.

Shade is flattering to people because it is diffused, shadowless, and flat. At midday, when direct light is too harsh, shade can be used to good effect, *below right*. Be careful when using color film: shade can lend a blue or greenish cast to the picture.

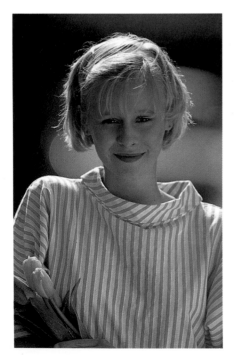

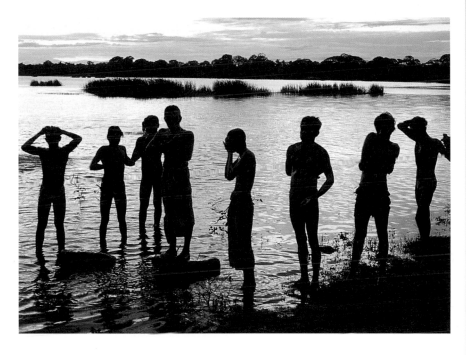

For a dramatic silhouette effect, expose for the highlights, allowing the subject to become just a shape. On automatic cameras, use the manual override and set the exposure yourself – the automatic metering system will expose for the whole picture, not just the highlights.

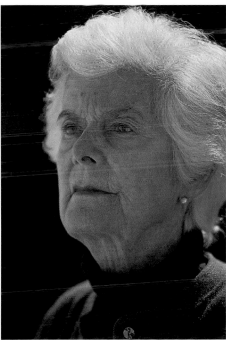

Light is immovable, but the position of the subject of the picture, and the angle of the camera to it, can be adjusted in relation to the light source. The light on a bright, sunny day was too harsh for this portrait, *left*, so the subject was positioned facing a white wall. She was lit by the sun bouncing off the wall, a softer, kinder light. The photographer stood at an angle of 45° to the subject and the wall.

Weather

Bad weather has as dramatic an effect on the quality of light as the changing angle of the sun. Don't be afraid of the wet or cold. Prepare the camera properly and shoot in the conditions from which most people shelter.

Look after yourself, too. On a cold, wet day, a warm anorak and good boots may contribute more to the success of a picture than a fancy lens.

Snow scenes like this Scottish landscape, *above*, have a blue cast that can be corrected with 81 series filters. Snow reflects light, so be extra careful with exposures.

Fog gives muted colors, allowing key images to be picked out from the background, as in this London park scene, *left*. Bracket exposures to be sure of obtaining the picture you want in difficult conditions.

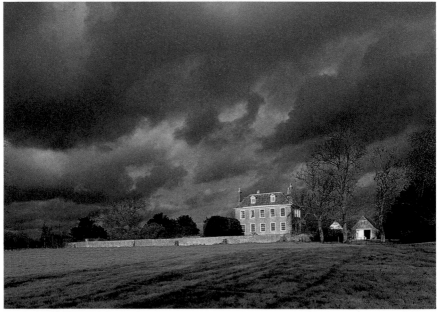

After wet weather, the clearing sky provides a clean, soft light as if the air has been washed, as in this shot of London's old Covent Garden market, *above*.

Rain makes surfaces glossy and highlights sparkle. This shot, *left*, was taken in Sri Lanka during the monsoon season.

Gaps in storm clouds let through bursts of strong light. In this picture, *left*, taken in the Cotswolds, England, drama is increased by exposing for the highlights on the house at just the right moment, so making the sky seem even darker and stormier than it was.

Long exposure by moonlight can produce color changes, such as the purple cast on this Zanzibar mosque, *above*. On exposures over 30 seconds, movement of the moon will also be registered. Some film is not designed for long exposure use, so check before you try such a shot.

After sunset, daylight or tungsten transparency film can be used when photographing artificially lit subjects. Tungsten film gave the correct color of this floodlit Portuguese cathedral, *left*.

Filters black and white

The use of filters can be divided into three categories: black and white filtration, color compensation filters, and special effects (see pp.186-89). Each involves different principles, but filters are simple to use once the basic ways that they work in are understood.

When using filters for black and white photography, there is just one basic principle to understand. Filters lighten their own color (and those in that area of the spectrum) and darken the complementary (opposite) color.

A yellow filter, for example, holds the tone in a blue sky, while giving separation from the clouds. An orange filter darkens the sky, and red has a spectacular effect on the blue, turning it almost black in contrast to bright white clouds. Any element of red in the picture would lighten with each of these filters.

Take care with exposure when using filters with black and white film – they can increase the contrast in the negative.

Remember to expose for the shadows (especially in landscapes), otherwise the picture will include only highlight detail, with no detail in the shadows.

Professional photographers often use filters with black and white film to increase the tonal separation of pictures for press reproduction. For example, in a photograph of an orange car against a background of blue sea, the tone of the car and the sea would appear too similar in black and white for the car to stand out sufficiently. If a yellow filter is used, however, the tone of the car would be lightened and the sea darkened without any loss of detail.

In black and white portraiture, the use of an orange filter can improve the appearance of spotty skin by lightening the tone of the spots. For smooth, white skin tones, use red filters.

Polarizing filters are used to control reflections and also as neutral density filters in black and white photography.

Filters for use with black and white films in daylight

Subject	Effect	Filter
Blue sky	Natural	No 8 Yellow
	Darkened	No 15 Orange
	Dark	No 25 Red
	Almost black	No 29 Deep Red
	Day for night	No 25 Red plus Polarizing
Seascape with blue sky	Natural	No 8 Yellow
	Dark water	No 15 Orange
Sunsets	Natural	No 8 Yellow or none
	Increased contrast	No 15 Orange or No 25 Red
Distant landscapes	Natural	No 8 Yellow
	Haze reduction	No 15 Orange
	Greater reduction of haze	No 25 Red or No 29 Deep Red
Dominant foliage	Natural	No 8 Yellow or No 11 Yellow-Green
	Light	No 58 Green
Outdoor portraiture with sky background	Natural	No 11 Yellow-Green No 8 Yellow or Polarizing No 25 Red
Flowers and foliage	Natural	No 8 Yellow or No 11 Yellow-Green
Red and orange colors	Lighten for greater detail	No 25 Red
Dark blue and purple colors	Lighten for greater detail	None or No 47 Blue
Foliage	Lighten for greater detail	No 58 Green
Stone, wood, sand, snow etc, in sunlight, blue sky	Natural	No 8 Yellow
	Increased texture	No 15 Orange or No 25 Red

A 15 Orange filter gives increased contrast, separating areas of similar tone in the sky and the water. It is more effective than the yellow types sold to non-professionals as "cloud filters."

A 25 Red can be used in portraiture to make skin tones appear smooth and white. Backgrounds are also darkened, giving greater prominence to the subject.

A 29 Red is the most dramatic filter for use with black and white film. It turns the sky almost black, while keeping the clouds white. As the blue is filtered out, the effect of haze is also reduced.

Filters color

Color compensating filters are used to change the color temperature of the light falling on the subject. They can only be used with color transparency film. If possible, buy glass filters as they have the best optical quality.

Compensating filters increase their own color in the picture by filtering out the complementary colors. When shooting a portrait of someone sitting under a tree, for example, skin tones take on an unpleasant green cast from the leaves. By using a 10 Magenta (the complementary color to green), the skin tone is brought back to normal without upsetting the greens of the background.

When skin tones are particularly important, as when shooting color portraits and beauty, glamor, or nude shots, they can be enhanced by use of the 81 series filters. These add warmth to skin tones, giving a richer, suntanned appearance. Care should be taken when shooting on Fuji film, which is browner in tone than Ektachrome films. The 81 series are useful on dull, overcast days as they increase the saturation of all colors in the shot.

Also useful as "cosmetic" filters are the 1A and 2A – like the 81 they warm and intensify colors, but they give a pink hue rather than the brownish tint of the 81 series.

Other filters correct the color temperature of light to match the film being used. An 80B is used to balance daylight film for use in tungsten light. An 85B enables tungsten film to be used in daylight. (See also p. 59 for the use of filtration when working with florescent and mixed light sources.)

Polarizing filters

The polarizing filters are used for holding the saturation in directly lit subjects; for controlling reflective surfaces, such as painted metal, glass, leaves, and water; and for penetrating the reflections on transparent materials. They also increase color saturation – they make blues bluer, for example. These filters act in the same

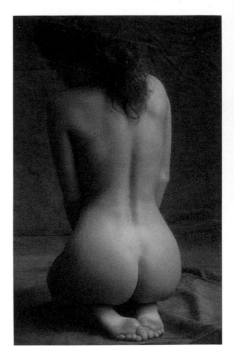

way as Polaroid sunglasses, which can be used over the camera lens if you do not have a polarizing filter available.

Polarizing filters are most often used to bring out the blue sky and cloud effects – the job done by red filters with black and white film. They also hold highlight detail and reproduce saturated "hard edge" colors on the beach, in sunny snow scenes, or anywhere there is a lot of light bouncing around. When used with slow film and exposures made for the highlights, the shadows will drop out to black, creating a simple graphic effect. They are not effective on backlit subjects, sunsets, or sunrises.

Polarizing filters are adjustable and when there is a chance of obtaining a good shot, take several frames, each with a different degree of polarization.

UV (ultraviolet) and L39 filters, much used in the past, have virtually no effect on modern coated lenses. However, it is still advisable to use them since they help protect the lens.

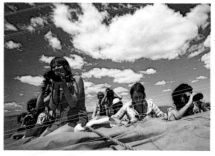

By using an 81EF filter for the nude, *left*, the skin tones are warmed and enhanced. A Softar filter softens the overall effect. Florescent lighting would have made the faces look green, *above*, but a 15 Magenta was used to balance the color. Two uses of polarizing filters are illustrated. Reflections are cut out, *above right*, with the effect of seeing through the water. The sky in the picture, *right*, is made more dramatic – clouds are whitened and the blue made darker.

Absorbs green

Absorbs blue and red

Absorbs red

Absorbs blue and green

Absorbs blue

Absorbs red and green

Color filtration with florescent light

Film type	Type of florescent lamp (written on tube)*					
	Daylight	White	Warm white	Warm white Deluxe	Cool white	Cool white Deluxe
Daylight	40M+30Y +1 stop	20C+30M +1 stop	40C+40M +1⅓ stop	60C+30M +1⅔ stop	30M +⅔ stop	30C+20M +1 stop
Tungsten and Type L	85B+30M +10Y +1⅔ stop	40M+20Y +1 stop	10Y +1 stop	50M+60Y +⅓ stop	10M+30Y +1⅓ stop	+⅔ stop
Type A	85B+30M +10Y +1⅔ stop	40M+30Y +1 stop	30M+10Y +1 stop	None	50M+50Y +1⅓ stop	10M+20Y +⅔ stop

*Beware – color balance alters with age

Color compensating filters are essential when shooting in florescent light or everything will turn out green. If you do not have a color temperature meter, use the chart above as a rough guide to which filters to use in different lighting and by how much to increase exposure. (See also p. 59.)

Compact flash units I

Many photographers automatically turn to flash because the subject is too dark to shoot with a hand-held camera. But before introducing a new light source, consider if use of a tripod and long exposure might better retain the mood of the photograph. A particular effect of light can often be the stimulus for a picture and that effect can easily be lost by using additional lighting.

When additional lighting really is necessary, the latest technology takes the uncertainty out of flash photography. TTL (through the lens) flash metering is particularly effective when flash is used in conjunction with ambient daylight. A sensor in the camera measures the amount of light reflected on the film surface and determines the flash output, taking account of the existing light so that it appears natural.

Even in darkness, built-in illuminators on some electronic flash units allow autofocus cameras to function perfectly. Below certain light levels, the illuminator automatically turns on to allow the autofocus to operate.

Electronic compact flash units also offer features such as adjustable heads so that the angle of flash can be varied.

The Metz 45CT-4 has long been the wedding and press photographer's flash because it has a fast recycle time when set on automatic. It is powered by either rechargeable nickel cadmium or ordinary batteries.

The Invacone helps to soften flash on camera, which can produce a hard light. It is mainly used when photographing skin or flowers and when you want to avoid hard shadows.

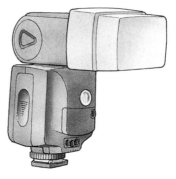

The Turbopack is powered by quantum turbobatteries and can run two flashes. Its advantage is that it recycles so fast that it can be used when shooting with a camera set on motordrive. The unit can be carried in a pocket or clipped to your belt.

The Q flash is powered by a quantum battery and is a useful piece of equipment, because it produces a strong light but does not have to plugged into to mains power. It is not automatic – you have to dial in the amount of light you require – but it is extremely reliable.

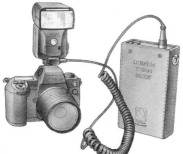

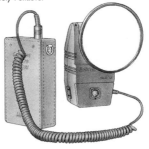

The **Sunpak** is a cheap but reliable two battery unit. It is powerful at close range, but falls off rapidly and is often used as second "fill" light.

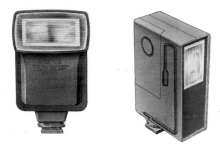

The Nikon Speedlight SB-28, *(below)* a powerful electronic flash unit, offers automatic TTL flash output control with all modern Nikon SLR cameras. The built-in autofocus illuminator comes into operation in low light conditions, and allows correctly focused pictures to be taken, even in darkness. The SB-28 also has an adjustable head that can be tilted to the required angle. All information relevant to the exposure is displayed on an LCD panel. The Speedlight is powered by ordinary penlight batteries.

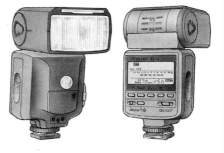

Slave unit SU4.
This enables you to use two flashes, one on the camera and one away from it. Once the first flash fires, the slave unit picks it up and triggers the second, signaling the correct information on the duration and power of the flash required.

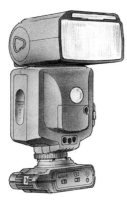

Extension lead SC17 is a remote cord that connects camera and flash. It allows you to take the flash off the camera and place it where you want it (see p. 63). Moving the flash can also help to reduce red eye when taking portraits.

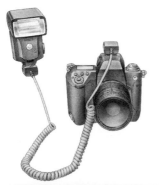

FLORESCENT LIGHT

Florescent light is good for black and white photography but can be disastrous in color – everything takes on a strong, green hue. Imagine you are taking a picture of a grey-haired man in a supermarket. Without filter or flash, there will be an overall green look to the picture, especially on the hair, because of the directional nature of the florescent light.

To solve the problem, use fill flash and make it the same color as the florescent light by putting a 30 green filter over the flash. Magenta is opposite to green, so put a 30 magenta filter on the camera. If, for example, the ambient reading with the magenta filter is 1/15 second at 5.6, set camera and flash to that, and the flash to f8 to compensate for the strength of the filter on the flash.

Compact flash units 2

A naturalist and his pet owl were photographed at sunset, using matrix-metered fill flash balanced to the natural light. The flash was off the camera, but connected by a speedlight cord. An infrared beam from the flash head calculated both the amount of flash needed to light the man and a suitable aperture, and relayed this information to the camera. The drama of the shot is enhanced as the flash was fired just as the owl landed on the man's hand.

The fish market, *below,* was lit by dedicated manual flash balanced to the ambient light. A reading of the level of background light was taken first and the flash was set to give a similar reading. The picture was shot at 1/15 second to let the natural light register. Because there was too much movement for such a long exposure, the use of flash was essential to freeze the action as well as to light the subjects in the foreground of the picture.

Two compact flashes – one mounted on the camera hot shoe and the other positioned in the background – were used to light this elegant, reconstructed drawing room at the Burrell Museum, Glasgow, *above*. The two were balanced to make the foreground and background light the same. While the camera flash brought out the detail in the foreground chair, the second flash was necessary to illuminate the rest of the room.

Rear curtain sync has enabled the photographer to freeze the action in this go-kart picture while keeping an impression of movement, *below*. Normally, the flash fires at the beginning of an exposure. If you are using a slow shutter speed with a moving subject, the result is a streaking light pattern in front of the subject, not behind. With rear curtain sync, the flash fires at the end of the exposure, turning available light into streaks that follow the subject, giving a feeling of movement.

Using compact flash

Compact flash units give reliable results on normal lenses, but all have their idiosyncrasies. Shoot several rolls of film to discover how your unit works. Vary the position of the flash and its angle in relation to the subject to produce different effects. Before taking a picture, try the torch test: put a handkerchief over a torch and position the beam to get an idea of the effect the flash will have.

Two compact flashes lit this portrait of the head chef of the Drake Hotel, Chicago, but with a shutter speed of 25 seconds so that the candlelight also registered. A more natural look is often achieved by using a slower than indicated shutter speed, allowing ambient light to register, in conjunction with flash.

Painting with light is a creative flash technique. The first picture, *below left*, was taken with a 20 second exposure, using only the natural light in the church. It is too dark, and reveals little detail. For the second picture, *below right*, the camera was on open shutter with a black card held over the lens. An assistant walked around the church, keeping the same distance from the walls, and fired a series of 15 flashes. With each flash, the photographer removed the card to allow light to reach the film. The process took several minutes, but the camera shutter was only open for about 15 seconds.

Hold flash at arm's length above camera on extension cable. More modeling, less contrast makes this a flattering light. No "red eye" with color.

Flash at 45° from camera, held about 12in (30cm) above height of model. Use another lamp to test positioning of flash.

Flash at 90° to the model and about 12in (30cm) in front at face height. Be careful not to fill in the right eye with a black shadow.

Flash held 12–24in (30–60cm) above model and aimed directly at her face. Subject should look upward in order to achieve a flattering chin line.

Flash aimed from the feet of the photographer. This gives a spooky effect and is not a flattering light.

Flash bounced off a side wall. A soft, flattering light. Electric eye picks up off subject. Overexpose one stop to give shadow detail with negative film.

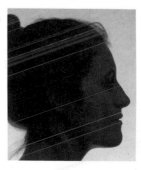

Top bounce is soft light but can make bags under eyes prominent. Overexpose one stop to minimize bags. A low ceiling is needed for this to work.

Flash behind the head against a dark background like a curtain. Overexpose three stops. Use a Lastalite reflector to bounce light back into the face.

Silhouette. Flash is directly behind the model, aimed at the wall. Overexpose the wall by one stop to keep it white.

Lighting

Lighting is a considerable skill. Of all the photographic skills, the ability to use light and create different lighting set-ups is the greatest. Being able to capture the effect of light can make a picture. Three main types of artificial light are available to the photographer: tungsten, electronic flash, and HMI.

Most domestic lighting is **tungsten,** using bulbs of different strengths. With tungsten, what you see is what you get, unlike flash. Some photographers like tungsten lighting, but it is not generally used in photographic studios as much as in television and film.

Electronic flash runs off domestic power or generators, and provides a light balanced to within the range of daylight (5400–5600 Kelvin). In its naked state, without reflectors, it is a hard, clean, intense light. Professional photographers use such bright light to achieve the best possible picture quality.

The larger the area of a light source, the better the quality of the light – bounce it back off an umbrella or flat reflector, or use a diffuser. Soft boxes are attachments which fit over the flash and diffuse the light. Tape tissue or tracing paper over them for an even softer effect.

HMI is a flicker-free, daylight-corrected light source which was really developed for the film industry. It is good as a supplementary light source and when you need more daylight than is actually available.

Use a single, direct light source to pick out the features of the face, *above left*. Keep the light higher than the head and don't let the eye sockets fill in. This light emphasizes the eyes and molding of the face. The same set-up, *above right*, but the light is reflected off a white surface, softening the features but retaining the roundness of the face.

The lighting of old Hollywood black and white films inspired this lighting set-up, used for both pictures, *above*. In those days, film was so slow they had to light everywhere. Having created a set-up, walk around to see the effect of the light from other angles. Here, the model is lit from back and front; the spot at the back holds him off the background.

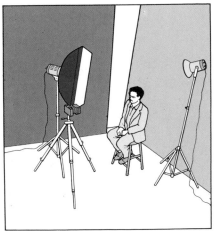

A spotlight creates a theatrical mood, emphasizing the cheek bones and narrowing the face; flattering for a rounded or fat face. But use with care – it is too harsh for bad skin.

Two soft boxes on top of one another allow an even light for a full-length portrait. A reflector lights the shadow area.

Beauty lighting, *below.* Black reflectors, close to the model's face, hollow the cheeks. The model should look up a little so that the face is evenly lit. Good with a soft focus filter.

Lighting 2

Creatively used, lighting brings meaning and atmosphere to a photograph. In this picture, taken in a Los Angeles bar for a drinks company, lighting creates a late-night feeling despite the fact that it was actually the middle of the day. It creates a convivial atmosphere that translates well to film.

The lights used were at different powers to create a sense of roundness and volume in the picture. It is important that the people look good whichever way they turn – the lighting set-up must not be allowed to restrict their freedom of movement. Four lights were used with soft boxes and grilled reflectors. The picture was exposed for the main light.

1 A soft box with a grille lit the hair and bare shoulders and backlit the smoke. It also separated the subjects from the background.

2 A soft box did much the same as the first light but in a softer way, lighting the shadows.

3 The main light was a large soft box placed as close to the models as possible, but just out of the camera's view.

4 A smaller soft box lit the bar, lifting the shadows.

Lights used were (1) soft box 18 x 18 in (46 x 46 cm) with a directional grille; (2) large soft box 36 x 18 in (91 x 46 cm); (3) large soft box 39 x 39 in (100 x 100 cm); (4) soft box 18 x 18 in (46 x 46 cm).

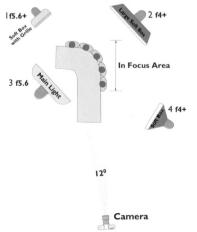

The picture was taken on a 200mm f2 lens at f4/5 so there was a narrow depth of focus, keeping just the people sharp. The dark out-of-focus foreground adds atmosphere and leads the eye to the people, who are having fun together in the bar and enjoying their drinks – the point of the picture.

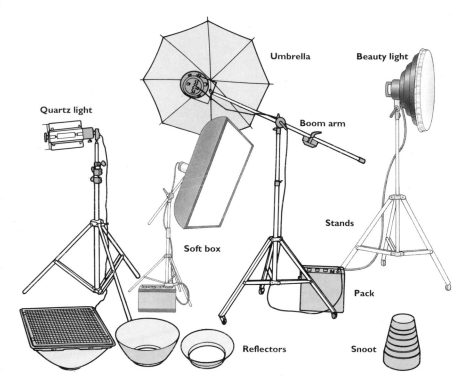

Quartz light

Umbrella

Beauty light

Boom arm

Soft box

Stands

Pack

Reflectors

Snoot

A selection of lighting equipment is illustrated to show the range available.

Pack. A pack plugs into the mains and powers up to four flash heads. All controls are on the pack.

Heads. Flash heads with their own controls are not as powerful as lights powered by a pack, but are fine for 35mm photography. When more than one is used at a time, they trigger one another through built in slave units.

Umbrella. Flash fires into the umbrella and is spread as it is reflected back. Umbrellas can be silver, which gives a hard light, gold for a warm light, and white or translucent for a soft light.

Soft boxes are used by most photographers. They clip on to the flash head and come in many sizes – the bigger the box, the softer the light.

Beauty light. This is a combination of an umbrella and soft box, in that the light is bounced back off an internal reflector before coming through the head. It gives a shadowless, flattering light and round highlights in the eyes.

Grille. As its name suggests, this is a boxlight with a honeycomb grille on the front. It can be softened by adding tracing paper.

Reflectors and snoots control the light. Add grilles to spot the light.

Quartz lights are mainly used in the film industry. Portable kits are useful as secondary lights, with flash, for industrial and location photography.

Tungsten lights are still favored by some photographers who find their softness ideal for portraiture.

HMI is used as a fill light and is ideal for digital photography.

Stands and booms. Make sure all stands are really steady and strong. A boom arm allows you to put the light directly over the subject or camera.

MI

Backgrounds

Good photography requires the rigorous searching out not only of the beautiful, but also of the ugly. What separates the good photographer from the casual snapshooter is the ability to eliminate ugliness from backgrounds.

Be on the lookout for things such as lamp posts that appear to grow out of the heads of subjects, and change position to avoid them. Get into the habit of using the preview button on your camera: what is easily missed when the lens is wide open may be distracting when the lens is stopped down.

On location

When shooting portraits outdoors, a wide open aperture keeps the background out of focus. This is especially effective when using long lenses where the depth of field is naturally limited. Mirror lenses produce their own distinctive doughnut shapes on highlights in out-of-focus backgrounds.

Choose plain, simple textures which enhance the subject for backgrounds. Sand, water, pebbles, and brick walls all make good neutral backgrounds.

Sky is a good background for some shots, but be careful with the exposure readings at close range, otherwise the pictures will be underexposed. A white sheet hung on a clothes line makes a fine background when backlit. A white reflector should then be used to reflect light back onto the subject. When shooting color portraits, a gold reflector gives more pleasing skin tones.

Interiors

To make a large, continuous background area with no floor edge, professionals use Colorama paper. This comes in large rolls 4ft 8in (1.3m) to 12ft (3.6m)

To obtain the half lit, half in shadow effect, *above,* a single well-diffused light source is used. It lights the right side of the face but is masked from the right side background by a screen.

On the left side, a white reflector bounces the light onto the background but not onto the left side of the face. By experimenting with the angles of the screen and reflector, and framing the subject tightly, the degree of contrast can be altered.

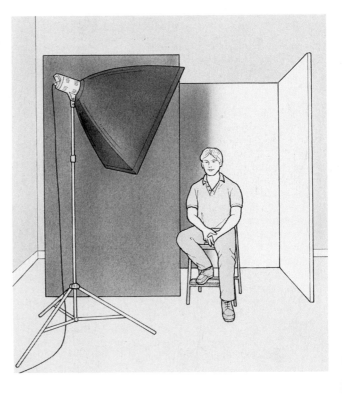

wide by 40, 80 or 165ft (12, 25 or 50m) in length, and is available in a wide range of colors.

Black velvet absorbs light and makes an excellent solid background when you are photographing front-lit still-life subjects or people, especially for stroboscopic multiple-image pictures. The velvet should be thick and of good quality. A transparency light box makes a good "white-out" backlit background for small, still-life subjects. Place reflectors all around the object for a rounded light.

A good continuous background for still life is plastic laminate. It can be bent into a curve and wiped dry – very useful when shooting liquids or food, that could spill and demand a new set-up each time the paper becomes wet. Large rolls of white plastic are available for this. Opaque acrylic makes a fine background material for obtaining a flat bottom light.

Pressure pack (aerosol) paint spray can be used to take the flatness out of plain colored backgrounds. Combinations of color applied in short bursts blend together well.

Projecting slides onto a screen or a paper background and then lighting the foreground subject can be effective.

Computer technology makes it relatively easy to drop in another background behind subjects, making them appear to be somewhere they have never been. When shooting a person to drop into a background, take care to imitate the lighting conditions of the background for a convincing result.

Collect interesting objects, such as pieces of wood, marble, or glass, to use when the right subject appears. These can add an extra dimension to still-life shots. Slate, and even high-tech steel mesh, can add texture to backgrounds.

The studio background, *right*, is spray-painted paper. The diagram, *below*, shows how it is possible to have one set-up with either an overall white background or a dark background. A heavily diffused single light above the subject gives an overall light on both bear and background. By taking the background further back, the subject sits in a pool of light against black. Plenty of light is bounced into the shadows.

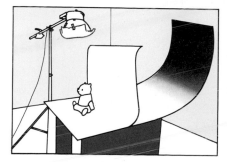

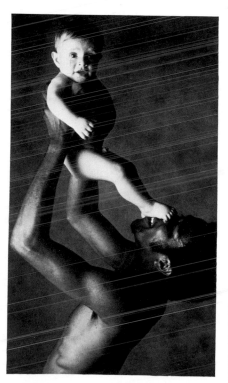

Tripods I

A tripod is an indispensable part of a photographer's kit. It must be portable – although the ideal tripod would be so heavy as to be immovable – but the lightest tripods are too flimsy to be of any use. Extended legs should not flex under pressure, and leg locks should not be able to slip. If the head wobbles when a camera is mounted, the tripod is useless. Test a tripod thoroughly with the longest and heaviest lens available.

Tripods are essential when shooting with lenses with a long focal length, that are impossible to hold securely by hand.

They are also needed to prevent camera shake when using slow shutter speeds. As a rough guide, use a tripod when shooting with a 500mm lens at less than 1/500 second; or with a 200mm lens at less than 1/200 second.

Even when it is possible to hold the camera by hand, a tripod allows for extra precision and control in composition. The photographer can leave the camera in position and move around to make final adjustments to the shot.

The best tripods have a central column, which is adjustable in height or

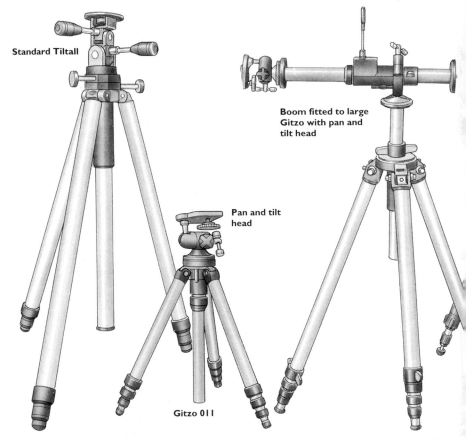

Standard Tiltall

Boom fitted to large Gitzo with pan and tilt head

Pan and tilt head

Gitzo 011

Standard size tripods, such as the Tiltall, Gitzo, or Bogen, are for studio or location use, although they are too heavy to be carried around all day by one person with a bag full of equipment. They extend to a height of 7ft (2.1m) and can be fitted with a boom. The cross-

struts of the Bogen keep it very rigid. A special safari tripod has legs that extend from the top so it can stand in water without damage.

The Gitzo 011 is an outstanding portable tripod that can be extended to eye level. With the ball and

reversible for low-level shooting. They also have heads that pan and tilt so that the precise position and angle of the camera can be adjusted. The bottoms of the legs are fitted with rubber caps for general use, but these can be removed to expose spikes for sticking into soft ground. When working on surfaces such as sand, fit "snowshoe" adaptors to the feet.

The best tripod for the 35mm photographer is one that can be packed into a suitcase. It should be strong as well as compact, with both low-angle and eye-level capability.

A spirit level is essential when the picture has to be perfectly square – for example, when shooting architecture, paintings, or documents. It is also useful in close-up work, when it is hard to square up the picture, and to get horizons flat when framing with a wide-angle lens. Some tripods have a built-in spirit level, but there are also separate units available that fit into the camera hot shoe, *below right.*

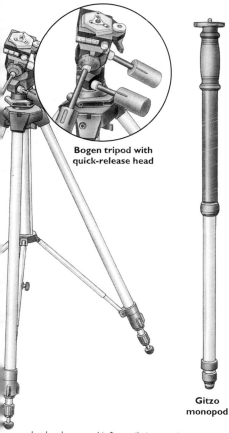

Bogen tripod with quick-release head

Gitzo monopod

The Leitz tabletop unit is a miniature tripod with a ball and socket head. Although small enough to be used almost anywhere, it is extremely solid, more so than some larger stands. When folded, it is less than 12in (30cm) in length.

Leitz tabletop tripod

When shooting without a tripod, use a tabletop stand to steady the camera against any available surface. If there is no wall or table close to hand, the tabletop stand can be braced against the photographer's chest.

socket head removed it fits easily into a suitcase or can be carried between the handles of a camera case.

Monopods are lighter to carry, and useful in crowds and confined spaces, where tripod legs would get in the way of other people.

Tripods 2

There are times when a photographer needs to be mobile and can only carry a small tripod. If clamps or rests of some kind are also carried, the camera can be kept rigid in any situation. Even when a camera is mounted on a tripod or a clamp and slow shutter speeds are being used, it is still best to lock the mirror up – the mirror return action can cause the camera to shake and ruin the picture.

When more than one camera is being used to take pictures of the same subject, it is useful to have a quick-release plate to allow you to change the camera on the tripod very quickly.

With a small ball and socket camera mount, most types of lighting or woodwork clamps can be adapted to hold

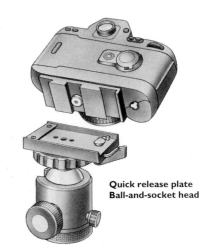

**Quick release plate
Ball-and-socket head**

Bean bags provide a solid base for a camera, *below*. They can be useful for low-level shooting, or when a ledge such as a car window is being used as a rest. A soft camera bag can also be employed in the same way.

With a ball-and-socket head, *above*, the weight of the camera is carried by the tripod but it can still be moved fluidly and smoothly. The secondary locking screw stops the camera falling over when you let go.

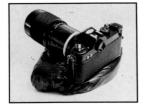

A monopod is ideal for situations when a tripod would prove too cumbersome or slow to use. By bracing it against his body, *below*, the photographer becomes a part of the stand, his two legs and the

monopod making an effective tripod. When kneeling or sitting, the knee provides additional support. Slipping the right arm through the neck strap of the camera provides extra rigidity.

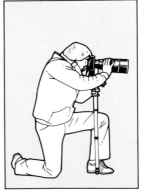

a camera. The tripod screw thread on most cameras is a ¼in (6mm) Whitworth.

Clamps can be attached to most objects, and, by using glazier's vacuum suckers, they can even be mounted onto plate glass windows. They must be strong, however. Be wary of anything with plastic tightening screws that may break under stress. Clamps can also be used to mount lights.

The use of clamps lets you get shots that would otherwise be impossible. A camera attached to an expanding pole, for example, can be placed high up in the corner of a room. If the presence of the photographer is likely to be disruptive, cameras can be positioned prior to shooting and operated by cable release or electronic remote control.

With remote releases, autowinds, and automatic exposure control, clamps open up opportunities for picture taking in situations where the camera can be there but the photographer can't. The camera can be clamped in place and attached to an infrared remote or a long cable release. You just have to press the button at the right moment. Such methods do, however, require careful setting up and an exact knowledge of the desired shot.

Spring grip clamp fixed to a plank of wood.

Flash mounted on a vacuum sucker

A C-clamp attached to the top of a ladder.

A C-clamp screwed to a tripod leg.

A lighting boom with camera mounting attachment and a long cable release, *below*, can be used to set up shots from positions that the photographer cannot reach. It makes a useful arrangement when attempting to shoot out of windows or from the corners of high-ceilinged rooms.

A pistol grip holds a long lens steady at slower shutter speeds. Bracing yourself against a wall further increases stability.

Two camera straps joined together make a foot-hold on which to exert downward pressure when using a tripod in high wind, *below*.

A bag of heavy stones hung from the tripod head, *below*, also adds stability, and leaves the photographer free to move about.

Cases

The job of a camera bag is to protect your expensive equipment, so get the best you can afford. A soft bag with plenty of compartments is probably the best for general use, but metal cases provide better protection.

Pack the bag carefully that so you know where each piece of equipment is – it might be needed in a hurry. Never pack the bag too full – carrying a heavy load all day can damage your back and takes lots of energy. Put some equipment about your person or in pockets.

A roller case is the ideal bag for air travel. Most are the approved size for overhead lockers and the wheels are a godsend when moving around airports with heavy loads.

Lens pouches are essential to keep metal from rubbing against metal. Buy the best that you can find – the felt lining on cheap pouches sometimes comes off and can clog the camera.

Soft bags, such as the Lowe Pro, hold lots of equipment and allow easy access. When packed carefully, they protect equipment well. The top and bottom of any bag should be waterproof. When carried over the shoulder, soft bags leave the hands free.

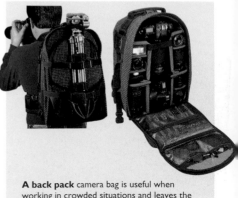

A back pack camera bag is useful when working in crowded situations and leaves the hands free. It is ideal for trekking because the weight is evenly distributed. A ski-belt bag, worn round the waist, can also be used to carry smaller items of equipment.

Hard leather tubes are the best lens cases to use with a soft camera bag. They can also be used to carry a selection of filters screwed together.

Lead-lined travellers' bags offer some protection from X-rays, but they are not completely reliable. Security staff have been known to turn up the power of their machines until they can see what is inside.

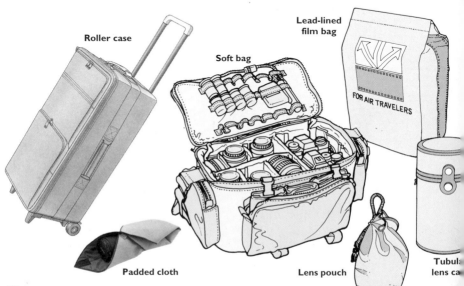

Roller case

Soft bag

Lead-lined film bag

FOR AIR TRAVELERS

Padded cloth

Lens pouch

Tubula lens ca

Cases can be fitted either with partitions held in place by Velcro or with solid foam cut into a shape matching each item, *above*.

A correctly packed case can hold a complete outfit. This case, *left*, includes four bodies (with motor drive), five lenses, two meters, a selection of filters, cleaning equipment, and lens hoods. Batteries and tools such as the Swiss army knife can be fitted into gaps. Keep your case with you all the time and don't check it in – the padding is insufficient.

Optimum dimensions for hand baggage under aircraft seats is 7½in × 21in × 12½in (190mm × 530mm × 320mm) but check weight restrictions too.

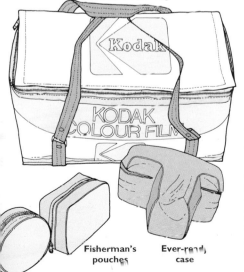

Insulated Kodak bag

Fisherman's pouches

Ever-ready case

Metal cases provide good protection in all weathers. Rox and Halliburton are the best makes. Silver cases reflect the sun, while black ones absorb heat. Pelican cases, made for sailors, are also useful for photographers. They float, and are strong and hermetically sealed.

The Kodak insulated bag is primarily for carrying film, but is also useful for storing cameras in hot cars or on the beach. Use freezer sachets to keep the temperature low.

Fisherman's pouches can be used to carry small items such as filters and are cheaper than photographic pouches. Ever-ready cases are available in soft or hard versions and do provide protection, especially if no other type of case or bag is used. Their size precludes use with telephoto lenses.

Viewers and screens

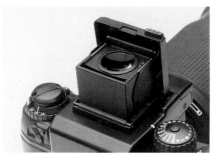

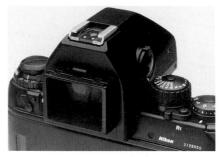

The waist-level finder gives a direct view of the reversed image on the ground glass screen. It is possible to draw on the screen for composition reference. A four-sided hood aids focusing by shielding the screen from unwanted light. This viewer is useful when the camera cannot be brought to the eye or when shooting from low down or overhead.

The action finder is a magnifying reflex viewer, that lets you to see the entire image with your eye some way from the lens. It is useful for shooting fast-moving subjects like sport or wildlife, when the action must be followed with both eyes. The large eyepiece makes it suitable for use when spectacles or goggles are worn.

The pentaprism head, through which the image is viewed, is a feature of all SLR cameras. Its optically precise prism corrects the image, that has been reversed by the lens.

For certain applications, when focusing is critical or difficult, photographers may prefer to use alternative viewers or ground glass focusing screens. The facility for changing these parts is only available on some sophisticated cameras.

On automatic cameras, the electronic meter circuitry prevents the removal of the viewing heads. There are, however, adaptors to aid close focusing, that can be attached to fixed head cameras.

Focusing screens

The screen supplied with the camera is perfectly suitable for most general photography. But for some specialist work, such as architectural or high magnification photography, or when using long/telephoto lenses, different screens may be needed.

Like viewing heads, focusing screens can be interchanged only on the most sophisticated cameras. A choice of screens is available for the Nikon F5 and Canon EOS systems. Other makes of camera have a similar range of screens and a comprehensive range is available for manual cameras.

The standard Nikon screen shows a split image in the centre of a plain screen, that is aligned when brought into focus.

Eyepiece correction lens **Rubber eye cap**

Eyepiece correction lenses are available for wearers of glasses to correct the magnification of prescription lenses. Rubber eye caps prevent stray light entering the viewfinder.

The 6× focusing finder magnifies the image on the screen and is useful in scientific or close-up photography. Its enlargement permits critical focusing of the whole image, while its complex optical construction allows adjustment to individual eyesight. As with all non-reflex viewers, the uncorrected image on the screen is seen reversed, as in a mirror.

The right-angle finder is an accessory to the pentaprism, not a replacement. By swiveling the eyepiece, the image can be viewed from above or from the sides. It is mainly used with a copying stand, but is also useful when the camera is in a tight corner. With the camera turned upright, pictures can be framed by looking straight down into the viewer.

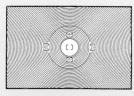

Type EC-B: Matte/Fresnel field with two reference circles, 5mm and 12mm in diameter, and autofocus brackets. The screen for general photography.

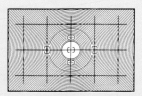

Type E: Matte/Fresnel field with 5mm and 12mm circles, autofocus brackets, and etched horizontal and vertical lines. Ideal for architectural photography.

Type J: Matte/Fresnel field with central microprism focusing spot 5mm in diameter and a 12mm circle. Useful for general photography.

Type M: Matte/Fresnel field with reference circles 5mm and 12mm in diameter for high-magnification close-ups.

Type L: Matte/Fresnel field with split-image range finder and microprism collar.

Type G1-4: Matte/Fresnel field, perfect for shooting in dim light or for fast-moving subjects. Four modes available to match various focal lengths

Accessories I

Cable releases are used when making long exposures with the camera on a tripod, and eliminate the camera shake caused by human contact. Double releases work two cameras.

Soft release buttons are left permanently on manual cameras by some photographers. They are more accessible than the normal shutter button and the action is easier on slow shutter speeds. The **air release** cable is 98ft (30m) long. It is used for single shots and can be fitted to any make of camera.

The **long release** is used with a motor drive. It plugs into the camera body and can be as long as the piece of cable. The plug can be removed and wired to a transmitter or underwater housing.

Double release

Soft release button

Manual cable release

Air release

An automatic winder transports the film and resets the shutter automatically. When using this, several frames a second can be exposed.

A motor drive is a more sophisticated piece of equipment. It can shoot more frames per second, has a fast automatic rewind, unlike the smaller units, and allows multiple exposures to be made. Remote, radio-controlled, and data back equipment can also be fitted to the body.

Motor drives are popular for use in sport, news, surveillance, and sequential photography. The single most important feature of motor drives is that the eye does not have to leave the viewfinder when the camera is wound on. It can concentrate solely on the image in the finder. But remember, with fast action, an image seen in the finder is a missed picture. The ability to anticipate the action has to be just as keen, whether or not a motor drive is being used.

Shooting indiscriminately at four frames a second is not a guarantee of getting the picture. Follow the action by eye, rather than relying on shutter speeds of 1/2000 second to capture motion.

Motorized winders make it possible to bracket exposures incredibly quickly, but the new range of data backs will even bracket automatically.

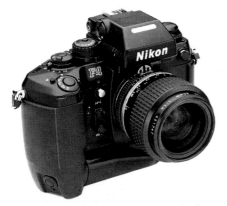

The F5 operates in four modes on motor drive. It is capable of a single frame to eight frames a second or one frame a second on silent mode. It can be set for continuous high or low shutter speed and has a rewind time of four seconds.

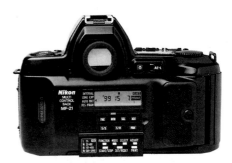

A Multi-Control back is a useful extra that can imprint data such as time, date, frame number. It can also control various camera functions such as automatic bracketing, long exposures, and tripped focus, and it stops film winding back into the cassette.

A pistol grip with connection to motor drive is useful when using heavy lenses. There is also a connection to the camera for single shots.

Be careful when using pistol grips, specially when shooting action with a fast shutter. There is a lot of play from the trigger to the release button.

Connection cable

Long release

Pistol grip

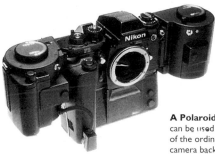

Nikon MD4 motor drive with 250 exposure magazine. the film is bulk loaded. Cassettes can be unloaded in sections as they are shot.

A Polaroid back can be used in place of the ordinary camera back to take a polaroid picture as a check. A useful accessory to keep on a backup body when traveling.

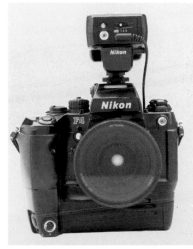

The modulite remote control unit, *right,* is a receiver mounted on the camera and triggered by a hand unit emitting an infrared light beam. In a confined space, the beam can be bounced off walls or around corners. Two cameras can be triggered using one control unit. This allows the photographer to shoot from three places at once and get a variety of angles on the subject. A more sophisticated remote control is the radio transmitter/receiver set, which has a range of 0.4miles (0.7km). It can operate three cameras and is designed to be interference-free at all times. It has many uses, including wildlife, sport, or news coverage. The camera can be pre-positioned hours before an event in a location that would be inaccessible while the event was going on.

Accessories 2

Compass. Well worth carrying to find out where the sun will be.

Filters. Filters can be made of glass, gelatine, or resin. Although optical glass filters are expensive, a filter that is to remain on the lens should be glass, as should polarizing and softar filters. Cheap polarizers can give a greenish hue to transparency film.

Wratten filters are used mainly for color correction. They are made of flimsy gelatine and have to be handled with care. They fit all holders and are cut to fit flash heads and internal lens filters.

Lee filters are tough resin filters. Their graduated and color magic range is

Lee filter system

specially useful. They fit ingeniously into a holder and lens hood combination, and three or four filters can be used together on almost any lens. Lee will also make any shape, color, or combination of filters to order.

Lens hoods should be used with filters. They protect the lens and improve its performance, increasing the contrast and cutting out unwanted flare.

French flag. Is a black, felt-covered piece of aluminum on a multi-jointed arm. It is useful with wide aperture (or wide- angle lenses) as it shades the light source from the lens.

Infrared flash trigger. This triggering system is attached to the camera, and has a receiver linked to a light that allows you to dispense with a flash sync lead. Useful when you want to put lights close to the subject and shoot on a long lens. The trigger has an effective range of about 165ft (50m).

Panorama tripod head. Allows the camera to be moved in fixed stages for making up composite prints from several different negatives.

Reflectors. Such as the Lastolight, these are made of reflective material stretched tautly over a rigid frame and can be simply held up to reflect light back into the subject. As useful as a flash, a reflector's clever design allows it to be folded up neatly so that it is easy to carry.

Retort stands are useful for holding small reflectors or mirrors for use in still-life set-ups.

Rubber eye caps help cut out light from behind the photographer's head that interferes with the image seen in the finder. Eyelashes often create shadows in the viewfinder.

Rubber lens hoods are much more convenient than metal ones when shooting in crowded areas where cameras can get jostled. A rigid (metal) hood increases the length of the lens, thereby putting more strain on the lens mount Rubber types are washable, they don't get hot, and don't scratch – scratches can cause flare. But don't use rubber hoods in a helicopter – they bow out of shape.

Silica gel absorbs moisture. Always keep a sachet in your equipment bag with camera or film.

Spirit levels that fit directly onto the hot shoe are vital for any picture that requires a level camera.

Step ladder. With two or three steps, this is invaluable for shooting over the heads of crowds or down onto a subject. Also surprisingly useful for landscape photography to separate the horizon from the middle distance.

Straps. Use wide straps: they disperse the weight of the camera and lessen the strain on the shoulder from heavy motor drives or long lenses. Good straps have long lugs with dog-collar fittings and buckles on each side that do not settle on the shoulder and dig into the neck. Rolled up, they can be used to fill out the corners of the camera bag. Nylon straps with nonslip, padded shoulder pieces fix directly onto the camera, and have no buckles to catch in the hair. They are good to use with lightweight equipment. Always buy good quality straps.

Three-way flash sync. Used to link three flash heads to the camera.

Tripod bush adaptor. Used when camera thread and tripod screw do not match. Check the length of tripod screws, especially if using an adaptor. Screws that are too long can damage the internal workings of the camera.

Vacuum sucker. Sticks even to shiny surfaces and can hold a second flash unit when required. A magic eye on the vacuum sucker triggers this second flash when the first goes off.

Household objects

Photographers who are interested in making pictures as well as just taking them should have most of these household tools and objects close at hand. They can have many uses and sometimes a pair of pliers, a spare plug or a piece of tape is essential to the success of a photograph. A painting might need to be hung on a wall for atmosphere in a shot, a light taped up on a wall, or a sheet stapled over a window to diffuse light. If there is only one power socket in a room, a simple item such as an adaptor can rescue the shot.

Always be as well prepared as possible. With a comprehensive tool kit, the photographer is ready to make any repairs or adjustments that are needed.

The basic tools should include ratchet and electrical screwdrivers; multi-purpose screwdriver kit; wire strippers; long nose pliers (which can be filed down for use in tight areas); insulated heavy pliers; big scissors; retractable-blade knife for heavy cutting and retractable-blade scalpel for fine cutting jobs; coiled nylon/terylene mountaineering strap for securing cases and adding weights to tripod.

A jeweler's tool kit includes a variety of small screwdrivers. Essential for the minute screws on cameras and lenses, which tend to vibrate and become loose.

Battery flashlight, candle, and pencil light. Always carry spare plugs, including an adaptable travel plug.

Mirror reflects light into close-up shots. Stockings are effective filters. Use a string bag filled with bricks or rocks to steady tripod.

The Swiss army knife is as important as any photographic accessory and the latest models hold an amazing array of blades, screwdrivers, saws, scissors, pliers, and so on. As well as doing the job they were designed for, blades have photographic applications: the bottle opener can be used on stubborn cassettes, and the tweezers or toothpick for taking hair or fluff out of the camera.

A huge variety of clips, pegs, pins, and clamps should be carried. There are always things to be held in place, from paper backgrounds to ill-fitting clothes. A powerful staple gun is a vital tool; string, superglue, rubber bands, drawing pins (thumbtacks), and paper clips are always handy. A selection of clamps hold heavier equipment and props. Hard and soft brushes are for cleaning equipment.

Aluminum foil can be used as a reflector and shaped to fit behind objects. Elasticated luggage straps are useful for securing bags. Blu-tack and a variety of tapes are needed for different applications. Strong and cloth-backed, gaffer tape holds most things. Masking tape is used to stick paper. Plastic, clear adhesive and double-sided adhesive all have their uses.

Equipment chart I

It is possible to take most types of picture with one camera and one lens, but as a photographer's enthusiasm grows, so does the need for a versatile system. This chart is a guide to the equipment discussed so far, and its application to the most popular types of photography. The most useful equipment for handling specific interests are listed against the subject heading.

	CAMERA TYPES						
	Manual	Automatic	All-weather	Widelux	Compact	Autowind/motor drives	Fisheye
Portraits (studio)	✓	✓				✓	
Portraits (location)	✓	✓					
Children		✓			✓	✓	
Weddings		✓			✓	✓	
Photojournalism	✓	✓	✓	✓	✓	✓	✓
Out for the day	✓	✓			✓		
Still life (studio)	✓						
Still life (location)	✓	✓					
Close-up	✓	✓				✓	
Close-up wildlife		✓				✓	
Sport		✓				✓	
Landscape	✓	✓		✓	✓		
Aerial		✓				✓	
Marine		✓	✓		✓		✓
Beauty	✓	✓					
Nude (studio)	✓	✓					
Nude (location)	✓						
Gardens and flowers		✓			✓	✓	
Animals		✓				✓	
On safari		✓	✓	✓	✓	✓	
Architecture	✓	✓		✓	✓		✓
Travel	✓	✓		✓	✓	✓	✓
Travel (hot & humid)	✓	✓	✓		✓	✓	
Travel (cold)	✓		✓				

LENSES						FILM							
Normal 50mm	55mm, 105mm, 200mm	Zooms	Telelenses 135–180, 200mm	Long lenses 300, 400, 500–1200mm	Special purpose, Macro	50–100 ISO E6	200–400 ISO E6	800 plus E6	Type B	Color negative	Black and white 25–160 ISO	Black and white 200–1600 ISO	Special film
	●	●	●			●				●	●		
	●	●	●	●		●	●			●	●		●
		●	●			●				●	●		
			●									●	●
●	●	●	●	●	●	●	●	●	●	●			
		●	●				●			●		●	
					●	●					●		
					●	●				●			
					●					●			
		●		●			●	●					
	●	●		●			●			●			
	●	●	●			●	●			●			
●	●	●				●	●			●			
●		●			●	●				●			●
	●								●	●			
●		●				●				●	●	●	
	●	●	●			●				●			●
		●			●	●				●			
		●	●	●		●				●	●		
		●		●		●				●	●		
●		●			●	●				●			
●	●	●	●	●		●	●	●		●	●		●
●	●	●		●		●	●			●			
●	●			●	●	●	●	●		●	●		

Equipment chart 2

	TRIPODS					CASES			
	Normal	Heavy	Monopod	Tabletop unit	Clamps, beanbag	Aluminum case	Soft bag	Roller bag	Back pack and bumbag
Portraits (studio)	✓								
Portraits (location)	✓								
Children			✓						
Weddings	✓		✓				✓		
Photojournalism	✓	✓	✓	✓		✓	✓		✓
Out for the day				✓			✓		
Still life (studio)		✓		✓					
Still life (location)	✓								
Close-up	✓			✓					
Close-up wildlife	✓								✓
Sport			✓				✓		✓
Landscape	✓								✓
Aerial							✓		✓
Marine								✓	✓
Beauty	✓								
Nude (studio)	✓								
Nude (location)	✓						✓		✓
Gardens and flowers	✓						✓		✓
Animals			✓						
On safari	✓		✓		✓	✓		✓	✓
Architecture		✓							✓
Travel	✓		✓	✓				✓	✓
Travel (hot & humid)	✓			✓		✓			
Travel (cold)	✓						✓		✓

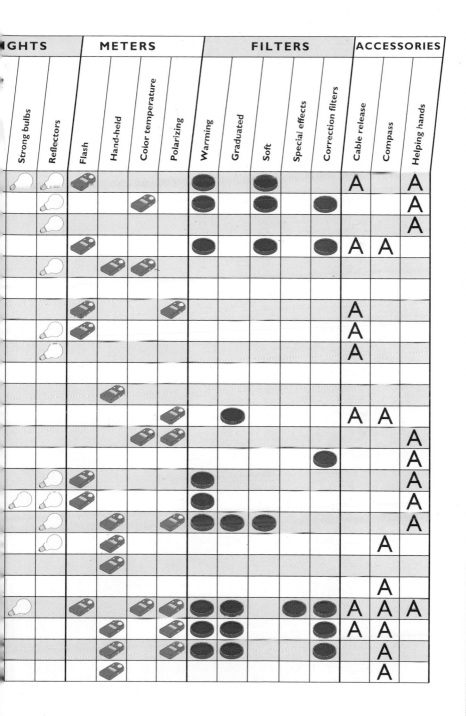

GHTS — Strong bulbs, Reflectors

METERS — Flash, Hand-held, Color temperature, Polarizing

FILTERS — Warming, Graduated, Soft, Special effects, Correction filters

ACCESSORIES — Cable release, Compass, Helping hands

The system

Anyone just beginning to take 35mm photography seriously needs to know how to build up a good camera system – a system that gives maximum versatility. The following suggestions for a 35mm system are based on picture-taking performance. Virtually all the pictures in the portfolio sections of this book can be taken with this set of equipment.

Many manufacturers offer a fully comprehensive range of equipment. A Nikon system is illustrated, but Canon, Leica, Olympus, Contax, Pentax, Rollei, Minolta, and several others also supply complete 35mm camera systems with a similar range of lenses and other items.

The flexibility given by zoom lenses makes it possible to have a system with a good range with several different lens combinations. Consider the number of lenses you will want to carry – for most people, three is enough and, if zooms, should provide for all your needs.

First, buy an automatic camera body with manual override. Check that the body is strongly built and ergonomically designed. The dealer may try and sell the body with a normal (50mm) lens, but the best buy for your first lens is a 28–200 zoom if you can afford it; a 35-70mm zoom would be the next best choice.

Modern quality lenses are sharp at any aperture, whether wide open or stopped down. At one time it was thought that a lens would be sharper if stopped down two stops from wide open, but this no longer applies.

The best second purchase is probably a 20mm fixed lens or a 20–35mm zoom. Wide-angle photography is exciting and you will be amazed when you first look through the lens and see the possibilities.

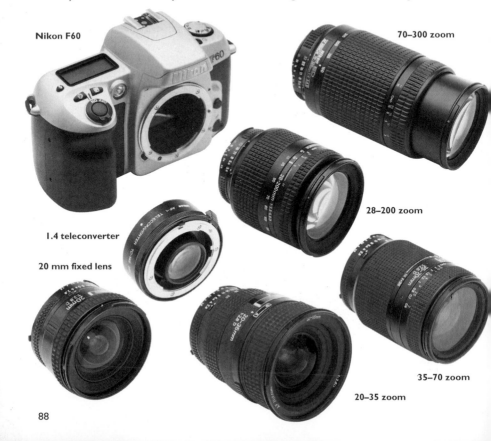

Nikon F60

70–300 zoom

28–200 zoom

1.4 teleconverter

20 mm fixed lens

35–70 zoom

20–35 zoom

Third should be either a long fixed lens such as a 300mm or, if you started with a 35–70mm, a 70–300mm zoom. This is an ideal lens for carrying on, say, a day trip when the photographer does not want to be burdened with too much equipment. It is versatile and copes with a wide range of subjects, from landscapes to intimate portraits. One of its qualities is that it lets you get candid shots of subjects from a distance so that they are hardly aware of your presence.

A few years ago the recommended fourth purchase would have been a second camera body. Now, with the flexibility allowed by zooms, a more sensible purchase might be a compact or specialist camera, or a fixed lens, compatible with your area of interest.

The fifth item should be a telelens, such as 300mm or even longer. It sees more than the naked eye and is good for photographing subjects that you might have to view at a distance, such as sport and animals. The telelens also foreshortens perspective, thus providing some interesting effects. A sixth purchase should be a 1.4 teleconverter for your telelens. These are now made for zooms.

Of the other equipment necessary for the serious photographer, a good tripod is the most important item. It allows you to take pin-sharp pictures even when using small apertures and slow shutter speeds.

Putting such a system together is undoubtedly expensive, but buying some items second hand can reduce costs. There are many reputable dealers, and classified ads in the photographic press are a good source of equipment. Always test second-hand equipment thoroughly

Tripod

Soft bag

In addition to the basic cameras and lenses, the serious photographer should have a range of accessories, beginning with those illustrated below.

The following filters should be added to the beginner's system: 81A/B/C, 85A, 80B, polarizer, graduated, 20 magenta, and soft.

Glass filters

Gelatine filters

Wide strap

SB28

Sekonic

Preparation

A systematic approach to photography depends as much on preparation and care of equipment as on the readiness and ability to take a picture. Everything from expensive cameras to the cheapest accessories must be kept in an orderly condition if good, clean, accurate pictures are to be made. Protect cameras and lenses from dust, moisture, and extremes of temperature, and keep them separate from darkroom equipment.

Cleaning equipment

Compressed cleaning air (1). Always hold the can upright or the air comes out as vapor, that smears the lens and takes time to clear. The small cans tend to vaporize the air even if held upright. Compressed air should be used sparingly on the lens elements and around the film path. Often a chip of film lodges behind the take-up spool. Remember that a camera is not a sealed unit and compressed air is as likely to blow dust in as blow it off.

WD40 (2). Use on tripods, camera case locks and hinges, and on any metal parts of the camera to protect against damp and rust. Put a small amount on a piece of soft lens cloth and wipe the camera metalwork (never the inside or the glass). Use WD40 if taking the camera near the sea or out in the rain. It slows down the corroding effect of salt and water.

Aero-stat (3). An antistatic pistol used on the film, take-up spools and back pressure plate. It is important to use this with motor drives, which create static on fast rewind.

Lens tissue (4). Do not use the cleaning cloths recommended for glasses; these are often impregnated with a greasy cleaning agent. If rubbed on the lens, grease can give a star filter effect.

The best cleaner is a well-washed **chammy leather (5).** Use the **cleaning liquid (6)** on a cloth or tissue, and wipe gently over the lens, but only if compressed air has failed to remove the dust, or if there are oily smears. In some parts of the world, dust is so fine that only the fluid will remove it. Under these conditions, fit a filter to the lens and keep it clean. Never wash a filter. Most smears will come off with a "huff" of breath. Always keep the back of the lens clean.

Top surface should be large enough to hold camera case, trimmer, or light box. Fit a rim all round to stop objects rolling off.

A camera trolley is an invaluable piece of furniture when shooting in the studio or around the house. If an area of the home doubles as a make-shift studio, a trolley makes a mobile version of the camera and accessory cupboard. Build a workbench with cupboards, drawers, and a fitted trolley that can be wheeled out next to the camera set-up, providing ready access to equipment. After shooting, the trolley rolls back into the bench.

Top drawer holds items such as household tools, staple gun, and adhesive tape. Second drawer contains cameras and lens. Others hold film and miscellaneous equipment.

Drawer slides are strong so they can be left open. Should be made of wood or metal with firm joints.

Trolley should be high enough to use surface without stooping, and big enough to hold lots of equipment without getting in the way.

Plastic wheels swivel independently.

into the camera bag; they can discharge on contact with any metal object, including other batteries. Buy batteries in plastic packs if possible, and keep them wrapped until needed. If the only batteries available are not in sealed packs, ask the retailer to check the voltage.

When buying a camera, check what batteries are required; some now use lithium batteries made specifically for that camera, which can be difficult to find.

Maintenance

A leading camera service center reports that more than 50 percent of camera malfunctions are due to worn-out batteries. Always carry some spares and replace them regularly.

Other common camera faults are: damage to circuitry; plastic cogs wearing out quickly; compact camera mechanisms, such as shutter, wind-on, and mirror lock, getting jammed by the smallest grain of sand; and small screws falling out of complex cameras.

Brushes (7). Blow brushes are manual versions of compressed air. They are good for general use and when traveling, but the bristles do get soiled easily. A **sable paint brush (8)** is useful for lenses and can be kept clean by simply washing gently in warm water. Use a **stiffer brush (9)** for the camera body and metalwork, including the outside lens housing. Be sure to brush any grit away from the wind-on lever and small controls.

Cotton buds (10). Use these to clean around the lens mount, controls, and hinged back. Never touch the mirror with anything. Leave any cleaning to a specialist camera shop.

Batteries

In the new automatic cameras, everything is battery powered. If the batteries fail, nothing works. One of the first signs that batteries are running low is that the mirror fails to go back down properly after an exposure; this function takes more power than anything else.

Batteries have a built-in clock – they always fail when the stores are shut. Check batteries are working before going out with the camera, and always carry spares. Keep batteries warm and clean. As a rule, do not touch terminals, but if they are corroded, scrape with a knife or sandpaper. Never throw loose batteries

CHECKPOINTS
● Never oil the barrel of a lens. Oil will seep through and clog the iris blades.
● If the camera is not used for long periods, do not forget about it. Periodically run through a series of exposures – even without film.
● If the camera is in daily use, have it checked over and serviced once a year. Most camera stores have electronic equipment to check the shutter speeds.
● If you have more than one camera and a selection of lenses in use, a camera mechanic can match the shutter speeds and aperture to within ¼ stop.
● Most faults with modern sophisticated cameras are operator malfunctions. PEOPLE DO NOT BOTHER TO READ THEIR CAMERA MANUALS PROPERLY.

Checklist

Consistently good results depend largely on good habits. Make this checklist automatic to avoid disappointment when pictures come back from the laboratory.

If the film is changed in mid-roll, always make a note of the frame number when the film is unloaded and mark it on the cassette or can. It is better to have

1. Check camera is not loaded, indicated by lack of tension on film advance lever on manuals. On automatics, E for empty appears on LCD screen.

2. Check that the film path is free of dust, especially around the shutter. Check that there are no hairs caught in the shutter track.

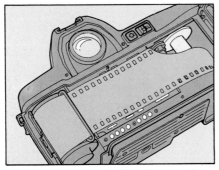

3. Check on automatics that film will automatically engage on take-up spool. On manuals, check it is threaded into take-up spool.

4. Check the back of the camera is properly closed. The slightest knock could open it and ruin the film.

5. Check battery power. On many automatics there is a battery check button. If both LCDs light up when button is pushed, power is sufficient.

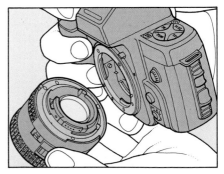

6. Check that the lens fitted to the camera is absolutely clean, particularly around the rear element.

a blank frame than a double exposure.

Many a great shot has been lost through carelessness. Never assume that everything is right. Check it, check it, CHECK IT, with the help of the following diagrams. Where there are two images in a square, the top one refers to automatic cameras, the bottom to manuals.

7. Check on automatics whether the lens is on manual, macro, or autofocus. On both manual and automatics, check lens is mounted properly.

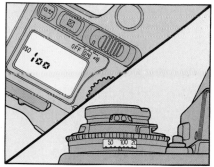

8. Check that ISO scale on the camera is set correctly for the film that is in use, and that you know if it is over, or under-rated.

9. Check which film is in the camera, especially if it has not been used for a while.

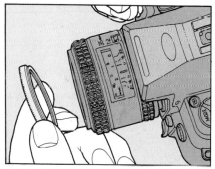

10. Check that there is no unwanted filter fitted to the front of the lens.

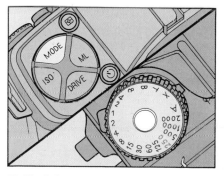

11. Check that an automatic camera is set on the right mode. Check that a manual is on the correct shutter speed.

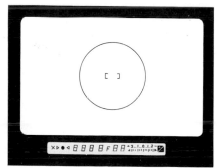

12. Check that the information in the screen of an automatic camera is realistic. Always be aware of the decisions the camera is making.

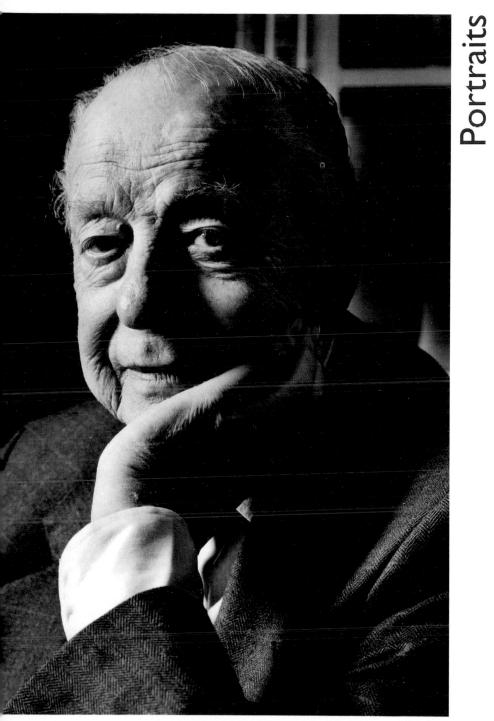

Portraits

The 35mm camera brings its own qualities to portrait photography – just as do the larger format cameras like the Hasselblad and the Mamiya.

Its speed of operation and small size make the 35mm the obvious choice for location portraits, or for spontaneous pictures when the photographer wants to be free of lots of cumbersome equipment. The high-quality fast lenses do not need a lot of light to hold sharpness through a shot. All lenses have a creative potential for portraiture, but those most appropriate are the 90/105mm range, including the macro.

A 35mm camera is much less intimidating than larger format equipment. Most people, even models, are apprehensive when sitting for photographs and it is vital to help them feel relaxed before you start work.

Do not separate photography from the rest of your life. Most people have to relate to others in the course of their work, and have to make them feel at ease. Portraiture is little different, except that over the duration of the sitting the photographer must produce a good picture of the other person.

Do not waste time. You have to project an air of confidence and it helps if you know what you are doing.

The search for the true personality of the sitter makes portraiture one of the most fascinating aspects of photography. Have faith in first impressions but also be observant. Look at the stature, face, hands, and carriage of the sitter – body language can be very revealing. Try to observe with discretion, especially if the subject is very nervous.

The facial lines of middle-aged and older people are not there by chance – they are the result of the lives they have lived. Do not change such characteristics but be kind when it matters.

Portrait photography takes several forms. In the studio, you can achieve a good likeness or a glamorous or critical view. When taking formal portraits, most photographers attempt to make a

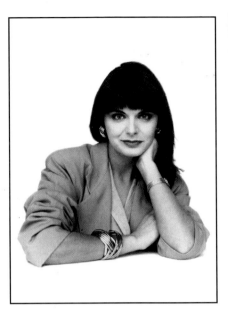

The simplicity of this daylight portrait allows the confident, self-assured personality of the model to shine through. A north-facing window provided a soft, even light; the model was leaning on a white surface against a white background.

The snapshot portrait, right, is the type of picture carried in millions of wallets to remind people of the ones they love. These pictures would never be considered art but bring more pleasure to more people than any other type of photograph. The snapshot portrait should never be dismissed as trivial.

sympathetic likeness of the subject. Use a tripod to give the sitter a constant point of reference. You can then move about and look at the sitter without inhibiting him or her.

Make sure the sitter knows there will be more than one exposure; several rolls might even be shot. If a subject feels particularly intimidated by the camera, shoot a roll or two in a throwaway manner but always have film in the camera. The best shot may come early in the session, but if the camera is not loaded, it will be lost.

Sculptor Andy Goldsworthy was photographed in his natural setting – outdoors with his work. The informal portrait shows not only the man, but his relationship to what he has created.

We decided to take the photograph at midday when the circle on the side of the black slate sculpture appears white due to the angle of the sunlight – a feature of the work. This picture was a joint effort.

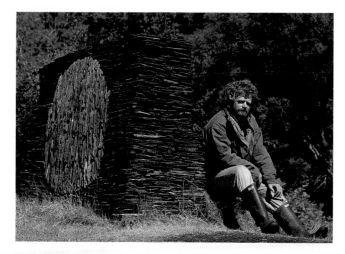

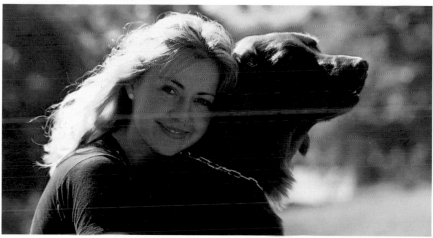

Keep talking to the sitter to establish eye contact. Always ensure that the eyes are sharp even if the other features are out of focus.

Environmental and reportage portraits out of the studio show people in less controlled situations and give an idea of their lives. Such pictures present the subjects in their world rather than just a facial likeness.

People do not always have to look at the camera. A successful portrait can be taken even if the subject is unaware of being photographed. Such shots are very difficult to take with anything other than a 35mm camera – the best camera for taking pictures of people going about their business, or unguarded moments.

The most universal type of the photographic portrait is the snapshot. Snapshots are pictures of the ones we love. They are fond memories to be carried in the wallet, and at their best represent a valid photographic form. The essence of a snapshot is that it does not require much technique, so modern compacts are the perfect snapshot cameras, even for the professional.

Portraits 2

Knowing how to help subjects make the best of themselves is as important as understanding the lighting techniques and philosophy of portraiture. Take some trouble to make your subject feel special.

When taking a portrait which is intended to flatter, start by putting the subject at ease. Often just getting people to help you put the set-up together has the effect of distracting them from their natural nervousness. If your subject is relaxed and happy, the portrait will be all the more successful.

To help subjects project the image they desire, the photographer must have a sympathetic attitude. With practice, the eye will become more critical and speedily recognize faults that are better hidden or camouflaged.

Be aware of the graphic relationship between subject and surroundings. Patterned clothing and bold backgrounds can be used to good effect, but often they can distract the eye from the main point of interest – the subject.

Have plain black polo neck sweaters or T-shirts to hand. Most people look good in them, and the face and hands stand out with no visual distractions. When shooting color film, choose clothing in plain colors that compliment the subject's appearance and character.

People who are nervous may grip the chair or clench their fists while being photographed. To overcome this problem, ask subjects to fold their arms, clasp their hands together or put them flat on a table in front of them or on their knees. If this does not work, keep the hands out of the picture.

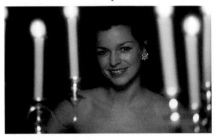

Candlelight is soft and warm in color and is one of the most flattering and romantic of all portrait lights. The flickering, directionless light smooths out facial wrinkles. Don't try to work just with candlelight – the shot will look better with the room lights on. Take reflected readings off the face since the image flame will give an incorrect reading.

Watch out for neck wrinkles when shooting over the shoulder. If the head is tilted back and then turned to camera, the neck will wrinkle. If the subject drops the head forward a little and then lifts it while turning to camera, wrinkles will be reduced.

If the subject has a bald or shaven head, light him from the side and shoot on a long lens just below the eye line. Shooting from any higher gives the top of the head too much prominence. If you shoot too low, below the chin level, this may highlight a double chin. To avoid this, ask the subject to raise his head slightly.

Being photographed can make people nervous and they may pose as if in front of a police camera. Chat to relax the subject and ask him or her to turn sideways. This narrows the shoulder line, giving the head more prominence. Keep the camera angle slightly above eye level and crack a few jokes before pressing the shutter button for a natural, friendly looking portrait.

The veins on a hand can be noticeable in a photograph, particularly if lit from the side. Just before the picture is taken, ask subjects to hold their hands up for a moment or two to let the blood drain away. If shooting in color, it may help to apply make up to the hands to reduce redness or other discoloration.

Wide-angle lenses exaggerate and distort the features. This can be interesting when you first start working with a wide-angle lens, but soon becomes boring. It is better to use a longer lens which gives the face a more attractive shape.

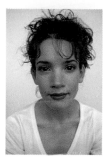

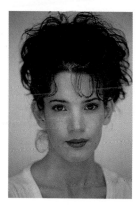

Portraits 3

While it is easy to record a likeness of a person, it is much harder to make a visual statement about their personality. Photographers often need to think around their subject to make an interesting portrait that shows some aspect of that person's character or life. For instance, rather than just showing an architect in front of a building he or she has designed, try adding a model or drawings of the building to the picture.

One of the advantages of using a 35mm camera is that most people being photographed have no idea how much the lens sees of them. A wide-angle lens can place people in among the symbols of their life and maintains a strong relationship between the camera and subject. A long lens can either isolate the subject from the background or bring the background up behind them, establishing another relationship.

The many special effects techniques can add visual interest to a portrait, but should only be employed when relevant, not just as gimmicks. Study the lighting of great portrait paintings and learn from them. The best photographic portraits can make as important a visual statement as most paintings.

The shepherd belongs to the nomadic Guja tribe of northern India, descendants of the ancient biblical Syrians. The intention of the portrait was to show him looking like a biblical character. It is a set-up shot – although the tribe do carry lambs like this, it was placed there for the picture. A 300mm lens was used to keep a good distance from the shy subject.

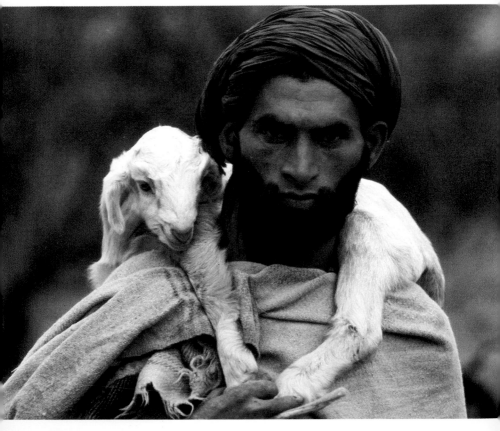

Singer Keith Flint of the band Prodigy was shot in action, using a 35–70mm zoom, from the pit by the stage. Filled with guards and fans, the pit is not a good place to work — a good picture was a just reward.

A group portrait normally requires careful composition and control. These men in Suffolk, England, however, were so perfectly grouped when spotted that they were photographed just as they sat.

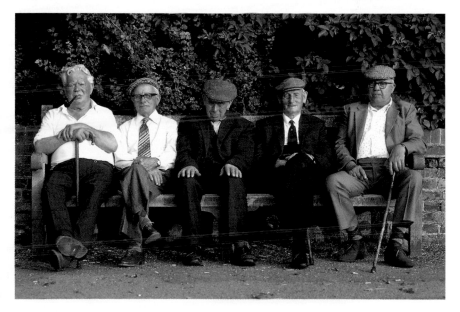

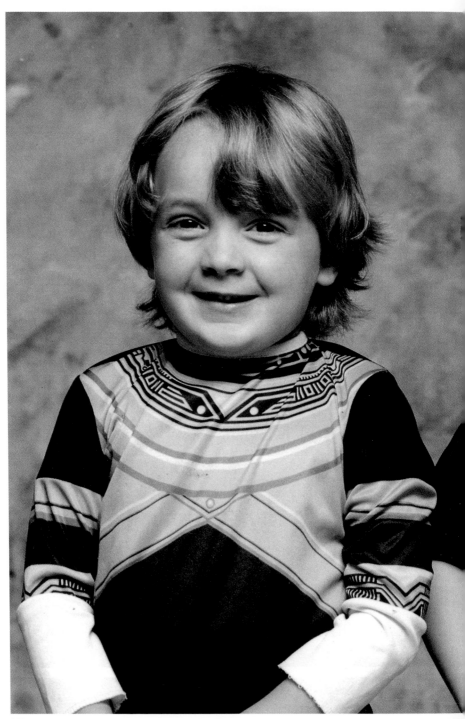

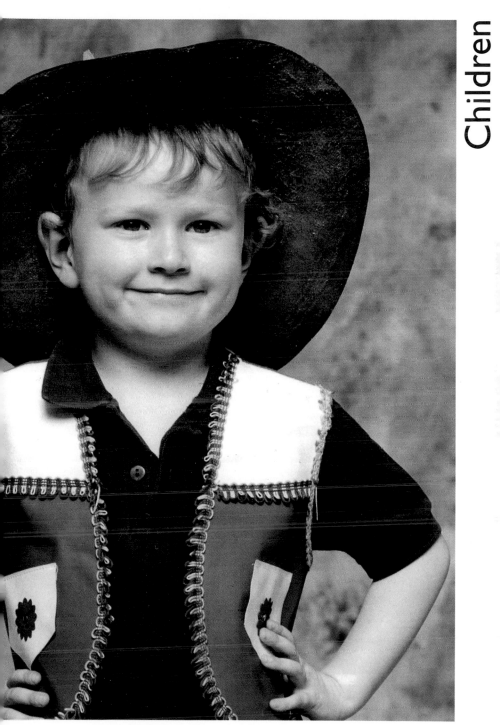

Children I

Photographing children is a part of the overall enjoyment of family life. Parents should be relaxed and confident, taking pictures whenever the spirit moves them. If you fail today, there is always tomorrow. Adopt this philosophy and you will get many good shots.

Photographing one's own child can be extremely rewarding and involves the parent in one of the great photographic themes. The great children pictures are those in which the photographer has recorded the world of the child, not just taken a likeness. Taking pictures of children can also be a most exasperating and frustrating experience. Looking back, the parent with a camera will remember as many near misses as a fisherman.

Children go through different stages, sometimes extrovert, sometimes shy. Never try to force children into being photographed when they don't want to be. They resent it and may never feel comfortable in front of a camera gain. Understanding and sympathy works much better than force.

In the real world, children (especially babies and toddlers) have colds, rashes, spots, and bad tempers. Even under these conditions good pictures can be made that are interesting to look back on in later years.

There is no such thing as a special light for child photography, but many of the best pictures are shot in natural light. The absence of complicated lighting arrangements allows the photographer to concentrate on the actions and expressions of the child.

It is not just parents who like taking pictures of children. When traveling, for example, local children are often willing subjects and make memorable pictures.

In the studio

When taking pictures of other people's children, find out the child's best time of day and work round that. If a child always has a sleep after lunch, it is no use planning to photograph her then. With very young children, ask the mother or

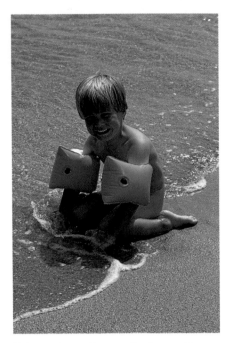

Take a waterproof camera for photographing children on the beach, *above*. If sand gets into a camera body, it can do a great deal of damage.

father to stand behind the camera with you, so the child is looking at the parent.

Children are small people, not beings from outer space, so don't insult their intelligence. Be firm, polite, and precise when giving directions. Children don't have to be handled with "kid gloves." It is often a good ideal to let the child help with setting up a studio session. This helps them to feel relaxed and involved.

Never start the session until you are absolutely ready. When setting up the lights use an adult; a child's concentration does not last long. When the child is there do not waste time – especially if he or she is under six years old. Have the camera ready and loaded, with the next roll out of the packet. Take meter readings in advance.

If the child is not interested, forget it. You will waste film and lose confidence. Don't ever panic – after all, it is only a photographic session.

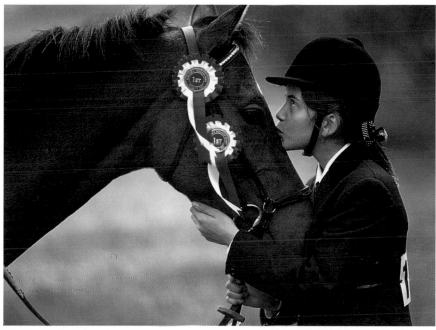

The girl and her pony, *above,* were photographed at a gymkhana. A 135mm lens at f2 with a shutter speed of 1/500 has thrown the background out of focus but kept the profiles strong, creating a strong composition.

Three Kashmiri boys, *below,* display frank awe and curiosity when faced with camera equipment. In such situations let the children look at the camera, involve them, and record their reactions.

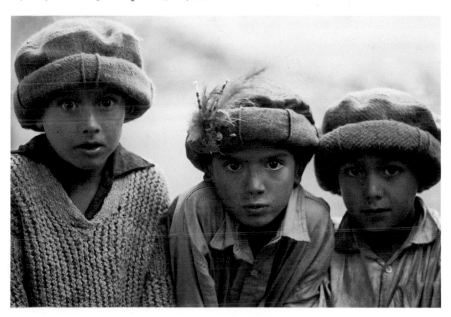

Children 2

The biggest mistake people make when photographing children is to put the camera down too soon. Children have a talent for performing the moment the camera is put away. Be patient and stay around. Keep the camera close at hand and be ready to seize the moment. If the camera is always there, the child will soon get used to it.

Don't just take simple portraits of your children. Try and document their life and activities. When photographing "world of the child' shots, set up a situation in which the child is sure to respond. Then back off. Allow them to become involved, then shoot. The fact that the environment has been set up allows shots to be anticipated to some degree – easier

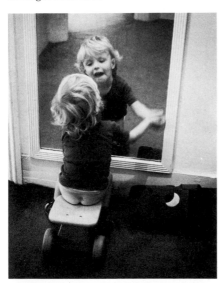

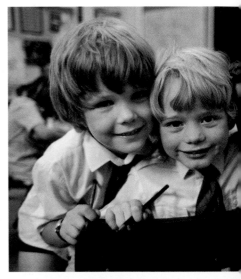

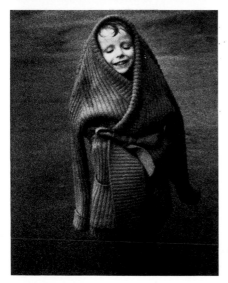

than trying to follow a child's totally spontaneous activity.

When shooting in the studio, it can be a struggle to keep the child entertained. Try recording his or her own voice and playing it back as you work; children are usually fascinated by the sound of their own voices. Try shooting from a kneeling position to get the child's eye view. One seldom sees pictures of children shot from their own level.

One of the most important factors in photographing children is the ability to follow focus to cope with their fast, unpredictable movements. An autofocus camera is ideal in this situation and will probably produce a better result than manual follow focus.

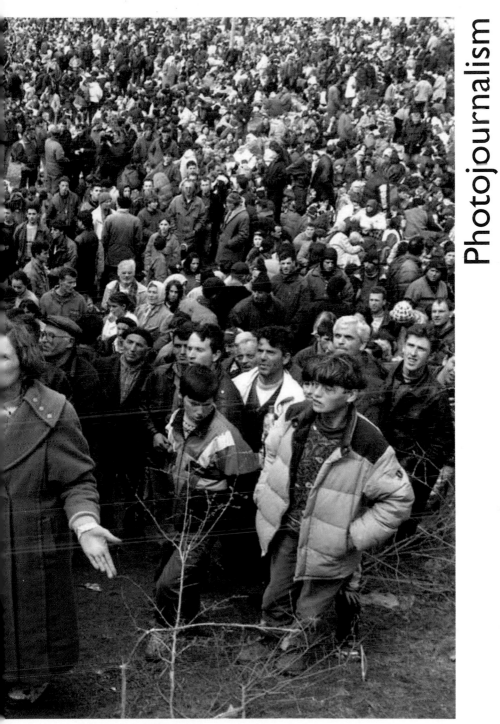

Photojournalism 1

The photojournalist remembers good pictures with pride but is inevitably haunted by the great ones missed.

The skill of photojournalism is to capture the essence of the human condition in pictures that will inform and clarify the minds of those who see them. The great news pictures and photo stories are a comment on the times in which they were taken, and they can have long lives.

The attitude of the photographer to his or her subject is of prime importance. Success may often depend on using common sense, but there are some basic techniques which the aspiring photojournalist should remember.

1 Concentrate on the subject and always look for the poignant picture.

2 Stay keenly aware of what is going on around you and develop the knack of being where the picture will happen.

3 Have a personal response to the subject while maintaining sufficient detachment to spot the right picture.

4 Be ready to go to almost any lengths to get the picture.

5 Inspire faith in others so that they help you get what you want.

6 Keep faith in yourself when the pictures are not happening. Often the best pictures happen just when you were thinking of giving up.

7 Have a thorough knowledge of photographic technique so that operating your camera becomes second nature and does not distract you.

8 Fully understand the properties of the film being used.

9 Never be put off by what may seem problems – mixed light sources, low light levels, or inaccessibility, for example. With patience and a full command of all the techniques, a problem can be turned into a creative advantage.

10 Obtaining the picture is your prime object. If you see a shot without the camera at your eye, you have probably missed it. The ability to anticipate action can only come with experience.

A photojournalist is always on the alert for pictures that inform about the world and that may even make a difference to the human condition. The misery on the faces of these Kosovan refugees, . . *preceding pages*, says more about the terror of the situation than any words. The plight of the urban homeless, *above*, is made more poignant by a juxtaposition of subjects, and the fast-disappearing way of life of Yorkshire hill farmers is documented (*left*)

"Some of the most compelling reportage shots have been taken by photographers working with a journalist. A good journalist has a mind like a camera – that is, he thinks not only in abstract ideas and facts but also in images – and he can suggest situations to a photographer which he has "photographed" in his mind. A good photographer can see images through his lens which can best be described in words, and these he passes to the journalist. Some of the finest reportage pictures and words stem from this rare overlapping of talents".
John Pilger
Foreign correspondent

"A photograph is as vital to a newspaper page as a news despatch. Like a written article, it should be informative and entertaining. It can grab a reader's attention faster than an article and almost as quickly as a headline. A good news photograph tells the news at a glance. It also can seduce the reader into examining the written word.

A reporter wants a photograph to report. A photograph should tell the reader of a place, and of action, and of people, and their emotion. A photograph can set a scene and show the action of world events; tears, laughter, boredom, triumph, and tragedy can be reported in words that take only minutes to read. A photograph can do the job in seconds – and make the impact last a lifetime. A good photograph is worth one word – impact."

The late Richard H. Growald
formerly National Reporter, U.P.I.

Photojournalism 2

CHECKPOINTS

● Ideally carry two bodies, both with motor drive, three zooms, such as a 20–35mm, 35–70mm, and 80–200mm, a 300mm lens, a manual back-up body – this might be a FM2 or a Leica for black and white – and a good compact. In the camera bag, have a fast lens such as a 85mm f1.4, a compact flash with turbopack, and a monopod. (Many photojournalists also use their car like an extra camera bag for carrying items such as a tripod, extra lighting, and even a ladder.)

● Carry smaller items such as film, meter, and caption book in your photographer's vest or bumbag – this is usually easier than carrying a big camera bag.

● Multi-speed film can be rated at different speeds from 100 to 1,000. When out on a story, it helps to carry only one sort of film.

The crowd at an English race track, *above,* was shot on a 400mm lens, which foreshortens perspective and packs up the figures. The picture of the African woman, *top left,* becomes something special when you notice the child's eyes. Look out for telling details.

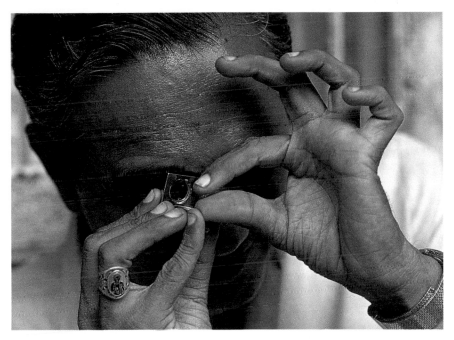

Photojournalism is about photographing people's lives, telling their stories. The ballerina, *below left*, was shot during rehearsal to catch something of the sweat and strain involved in her work, rather than the glamour. A working portrait of an Indian diamond dealer, *above*, shows him as he spends most of his day – in close examination of a valuable gem. When taking a picture of the Seoul police, *below*, the photographer tried to see beyond their image as law enforcers and show them as fellow humans in uniform.

Photojournalism 3

Rarely commissioned today, the photo story allows the opportunity for vivid insights into the human condition. Some of the most thought-provoking of all pictures come from photo stories, as they require great commitment on the part of the photographer. The 35mm camera is the most appropriate equipment for capturing the definitive moments.

These pictures of a day in a teaching hospital took a month to do. They range from general shots to details, and include moments of drama and tension as well as joy and even humor.

Photojournalism 4

The services of the photojournalist are often called upon by design groups to record a company's activities. The picture that successfully defines the relationship between worker and machine, or conveys the atmosphere and activity in a workplace, may take a day or more to stage manage, or may be taken spontaneously. The work environment is usually interesting and guarantees a good picture.

A good test of such a picture is to show it to the people in the photograph. If they say, "yes, that's how it is," then the photographer has gone a long way to creating a convincing picture.

The barrel testing routine in a Californian winery, *right*, was shot for a corporate brochure. As well as recording the daily activity it was important to convey the brand identity in a natural way.

The scene in a Hong Kong tailor's shop, *below*, shows people engrossed in their work – no glamour, no fuss but a picture that takes you right into the middle of those workers' lives.

A welder in action, *above*, was shot on a 300mm lens with an exposure of 1/15 second to record the sparks and smoke. The camera was mounted on a tripod. The result is a dramatic picture that conveys the intensity and precision of this work.

The Yorkshire blacksmith's shop, *right*, was photographed in daylight on fast (800 ISO) film; lighting the scene would have destroyed the atmosphere of the interior. A number of shots were taken in order to catch the exact moment of a blow to the horseshoe.

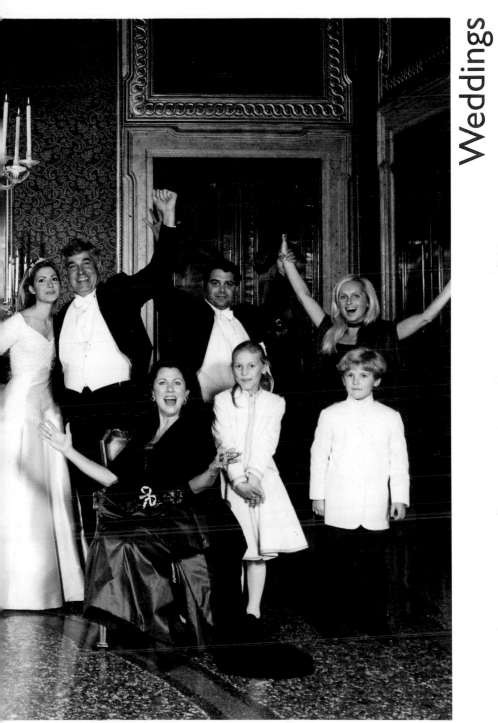

Weddings

119

Weddings I

For many couples, their wedding day is one of the most important of their lives. Don't offer to take the official pictures of such a momentous occasion unless you are completely confident of what you are doing – sure of your equipment, the light conditions, and of your ability to handle people and work fast.

If the formal wedding pictures are left to the local specialist who uses a larger format camera, the 35mm photographer is free to record all the unguarded, informal moments of the day. The best pictures may well be taken long after the official photographer has gone home. It is a friendly family time, when everybody is excited and far more interested in talking to long-lost relations than paying any attention to a photographer.

Your presence may be barely noticed for some shots but, if necessary, be pleasantly dictatorial to get the pictures you want; in years to come people will thank you for your persistence.

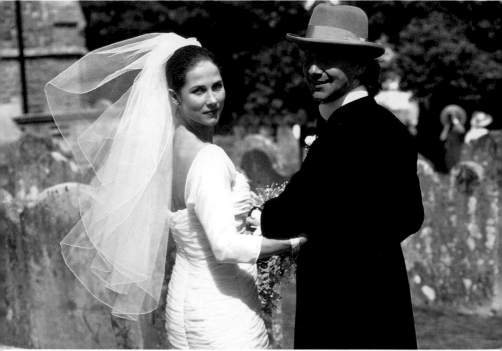

Everyone in this family group, *preceeding pages,* knew the photographer, so was relaxed. The room was lit earlier and the chairs set up so that no one was kept waiting on this all-important day. The picture took no more than ten minutes.

The couple emerging from the church, *bottom left,* is a must to photograph, but watch for problems caused by the contrast between the groom's dark suit and bride's white dress, and expose for the faces. An automatic camera would expose for the white dress and faces would be too dark.

Set up a studio at a wedding and invite guests to take their own pictures. This always results in lively, informal images (*top left*). The same studio can be used to take some slightly different portraits of the main participants, such as this picture of the bride and bridesmaid perched on a bale of hay (*above*).

Weddings 2

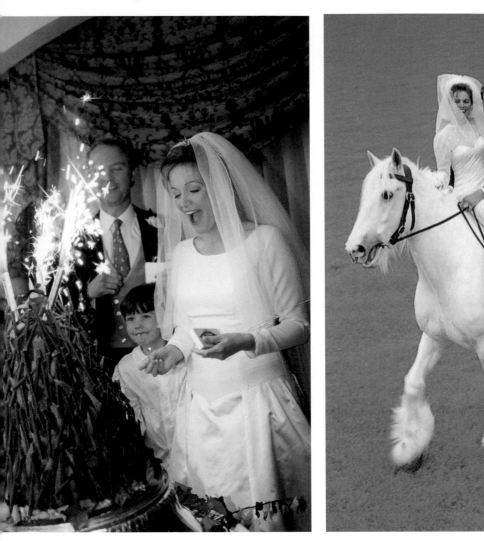

Remember • Take plenty of batteries and shoot lots of film. ISO 400 color negative is usually best.
• Get quick machine prints with an index print and then choose the best pictures for hand prints or enlargements. • Know what the plan for the day is so that you don't miss anything. • Make sure all the main people are photographed and no one is left out.
• If working in a room with a low ceiling, bounce flash or use an Invacone. • Remember to photograph details – flowers, cake, features of the dress. • Use a good SLR with a 28-200m zoom, and a 24mm or 20mm lens for getting in among the crowd. • Outdoor weddings are often in the middle of the day when the light is hard. Use fill flash or reflectors.

This image of the cake-cutting ceremony was taken with matrix-metred fill flash and the camera on auto everything. From experience, the photographer knew the best place to be at just the right moment.

Being forewarned that the bride and groom were to leave on horseback was crucial for this image. The photographer was able to get a good vantage point, with the right lens, even though the departure was a complete surprise to nearly everyone else.

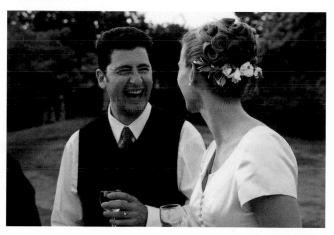

A small APS camera
with a zoom, which you
can carry in a small
handbag or suit pocket,
is perfect for weddings.
At weddings with sit-
down meals, many
couples now also leave
disposable cameras on
the tables for guests to
take pictures during the
meal – everyone takes
different pictures.

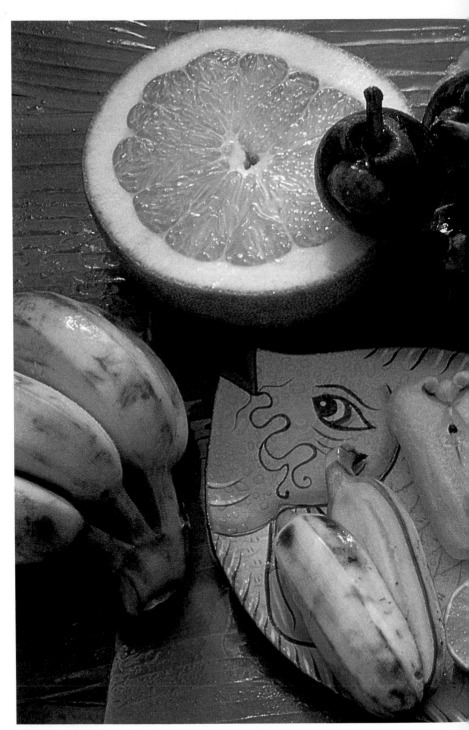

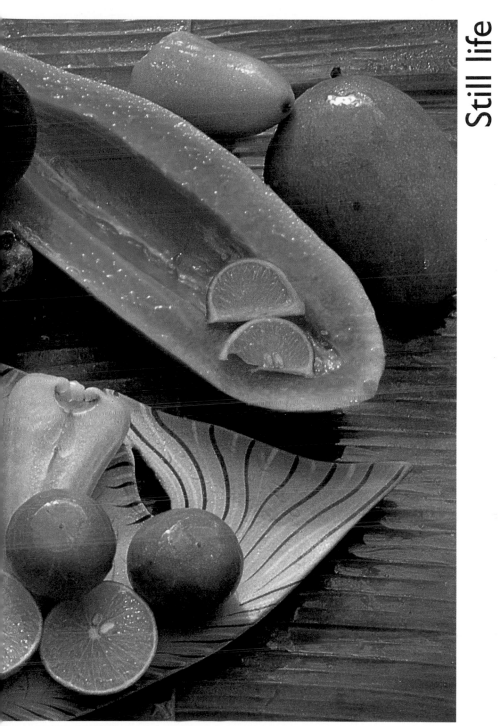

Still life I

Form, texture, and the relationship of one object to another are the primary concerns in still-life photography. The lighting of those objects and the overall composition of the picture are important considerations in achieving a good photograph. Mount the camera on a tripod so you are free to compose your picture, and rearrange the objects until you have the desired effect. Still-life photographers have been known to take hours arranging items, striving for a simple, yet harmonious picture.

Professional still-life photographers generally use large-format cameras, but 35mm equipment gives its own quality to still-life work. It is quick and allows you to bracket extensively, while the depth of focus of a standard 35mm lens means that you can keep the picture sharp from foreground to background without needing a lot of light.

The objects in a still life, although appearing in one dimension, must look as if they have body and substance. This impression can be created by the careful use of lighting. Although the photographer controls the lighting, nothing is original. All artificial lighting effects are imitations of natural light, so study the effects of daylight on various surfaces and textures. When re-creating an effect with studio flash, use the modeling lights to see what the flash is going to do.

Top backlighting makes objects stand out from the background, separating one from the other and giving good 3D light around the edges. Diffused light is better than hard, raw light for most subjects, so use a diffuser.

The larger the light source, the better the light. One light source with several reflectors to put the light back into the set can be used to hold natural detail in the shadows. This is generally better than lighting the dark areas of the picture with separate lights.

Still life at its simplest – a hastily arranged collection of fruits for a tropical breakfast *(preceding pages)* was shot using only daylight.

This collection of objects (*above*) was set up in the studio with the lighting shown *below*. A soft box was positioned above the objects and light was also bounced off the white card. This gives ideal lighting for a still life with different textures, shapes, and colors. Flash, tungsten, or HMI lighting could be used with this set-up.

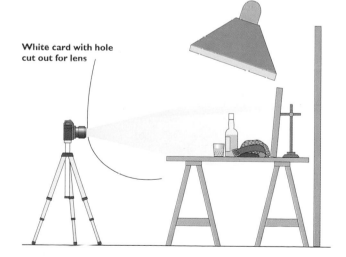

White card with hole cut out for lens

A sketch book belonging to the artist Andy Goldsworthy makes a pleasing subject. It was arranged by a window and the light picks out detail and gives molding to the objects. Quick to set up, this is a perfect still life for the 35mm camera.

Still life 2

Great still-life shots were being taken long before the invention of electronic flash with the best of all lights – daylight. The mobility of the 35mm camera lets the photographer take still lifes anywhere.

Pictures may come from arrangements of favorite objects or from sheer chance. Take these pictures quickly and simply, or if there is time, use a tripod, which gives more opportunity for deliberation and minor adjustments in the relationship between objects.

Still lifes can be used to add detail to any series of pictures, and can sometimes say more about a subject than conventional shots. They need not always be arrangements – a close-up of a tiny detail can make an attractive picture and gives that detail its own importance.

A detail, such as this car mascot, can make an interesting still life. Even though such a shot does not have to be arranged, it requires just as much care. Make sure the subject is sharp and that peripheral items are out of focus or eliminated.

CHECKPOINTS
● Use retort stands to hold mirrors for reflecting light into dark areas.
● Black velvet and sheets of white, opaque plastic make useful backgrounds for still lifes.
● Have sheets of colored card, especially black, white, silver, and gold, available for use as reflectors. Sheet glass placed on top of black velvet creates a very good reflected image.
● When photographing a bottle of red wine or port, dilute the liquid or light will not penetrate. If ice cubes are required in a shot use plastic ones – real ice melts much too quickly.
● Take extra care with lighting and make-up if a model's hands are to be in a picture; they can easily look like claws or chicken legs.
● Keep pictures simple.

Black and white still life photography deals with texture, shape, and the relationship of objects to each other and to their background. Color tends to distract from these elements.

Before taking a still life, consider every part of the picture in the viewfinder, and create a balanced, pleasing composition.

The simplicity of the apples on a pewter plate, *right*, is deceptive; the composition took some time to perfect and each apple was positioned with care. The shot was lit by simulated daylight, created by a grilled box light softened by several sheets of tracing paper. This lighting gave the apples roundness and volume.

Close-up

Coming in close on small objects or details can produce interesting and revealing pictures. To shoot moderate close-ups, use a macro lens or close-up supplementary lenses. For greater magnification, use extension rings or a bellows attachment, both of which mount between camera and lens.

Since bellows and extension rings take the lens further from the film plane, there is some loss of light; this can cause exposure problems. Extension rings have exposure factors engraved on them; bellows exposure is calculated by the length of extension. Electronic cameras, however, will gauge the exposure for you if set on aperture priority.

Providing enough light is a problem in close-up work; the closer the lens comes to the subject, the narrower the depth of field. There are two ways of dealing with this: long exposure or flash.

When shooting close-ups with a long exposure, make sure that the subject is completely stationary, and that the camera is securely mounted and will keep steady. Tungsten light provides good constant illumination for studio work. Use mirrors, foil, or white card to bounce light in between subject and lens at an oblique angle.

Outside, when shooting something like a flower, use a ring flash or a small compact flash. These will freeze any movement from the wind and allow the lens to be stopped right down for maximum depth of field. Take a silver reflector and a piece of white paper to use in combination with the flash; it will throw a shadow that may need to be softened. Ring flash provides shadowless light so no reflector is necessary.

Electronic cameras have made flash-lit close-ups easier to take – the amount of flash necessary when using an autofocus macro lens is automatically calculated.

The camera was mounted on an inverted tripod in the set-up for the coin picture. Tungsten lights were used with diffusers and barn doors. A reflector placed on one side of the coin, and black card on the other side, gave some modeling to the light.

When shooting a close-up of a flat object, such as this coin, make sure that both camera and subject are squared up. Use a spirit level to check.

The shot of a JFK coin was taken on a 60mm macro lens after experimenting with reflectors to pick up a glint in the eye.

The same lens was used with an M extension ring. Numbers on rings are exposure factors – 2 require a one stop increase.

The M ring was replaced with K rings for this shot. The factor was 4, which needed an increase of two stops exposure.

Greatest magnification was achieved with a bellows fitted to the same lens. Exposure factors still apply, but bracket shots.

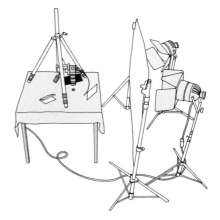

The baby's hand was photographed on an 80–200mm zoom. Flash was reflected from above by an umbrella. The tiny size of the hand is accentuated by the inclusion of adult fingers, which gives the picture scale and more impact.

The hyacinth was shot on a 60mm macro lens at f16, with a backlight from each side and fill-in light from the front.

The eye, *below right*, was shot with a 105mm macro and lit by ring flash mounted onto the front of the lens.

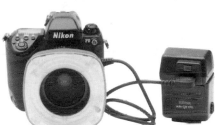

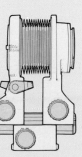

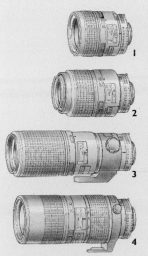

A macro lens is the simplest way to shoot moderate close-ups. Illustrated are a 60mm macro **(1)**, a 105mm **(2)**, and a 200mm **(3)**. Alternatively, use close-up supplementary filters, that fit to the front of the lens. Exposure adjustments are not necessary, but there is some loss of definition, specially if the subject is backlit.

For greater magnification, use extension rings **(4)** and **(5)**, which fit between the lens and the camera body. The rings come in fixed lengths and can be added together to provide increasing magnification. A bellows attachment **(6)** that mounts between the camera and lens, provides even greater, high quality magnification. The bellows can be adjusted to various extensions.

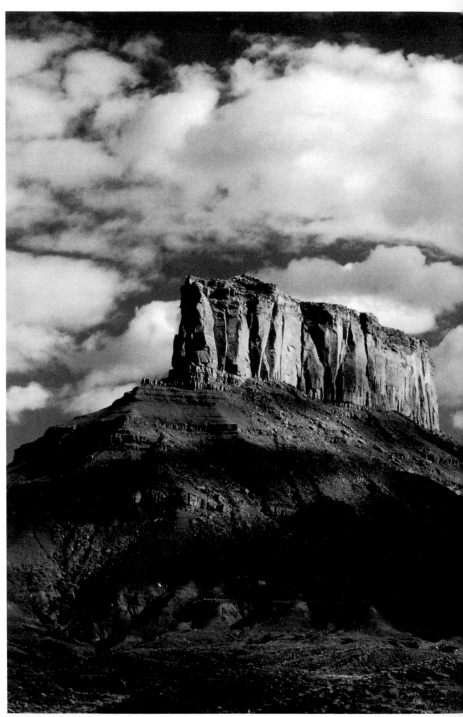

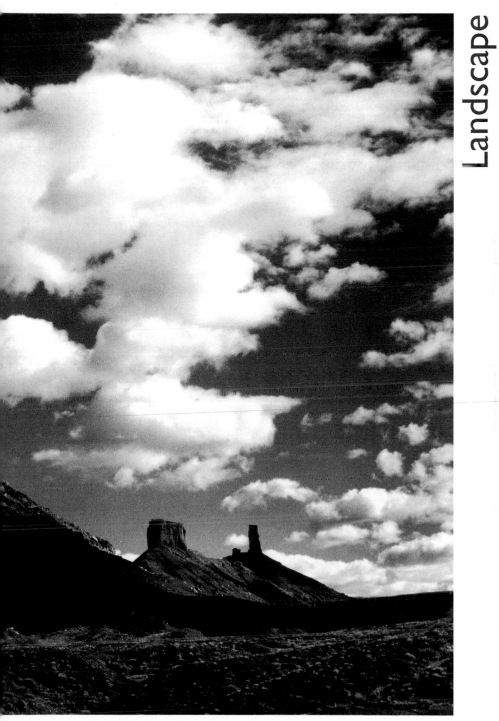

Landscape I

Taking a successful photograph of a dramatic and beautiful landscape is one of the most challenging experiences for the 35mm photographer.

The major difficulty when using a 35mm camera to photograph a landscape is how to do justice to a huge vista on a small piece of film. There is a big difference between looking at a small picture on a viewer and that same image projected on a big screen.

Scale is important in landscapes. Vistas look most impressive if there is something to relate to, such as a person, a house, or a car. Panoramic shots should include foreground detail to catch the attention and then sweep the eye into the background of the picture.

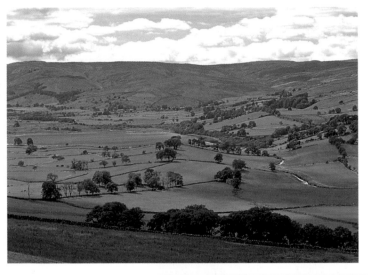

Semer Water in North Yorkshire, England, *left*, was photographed on an 85mm lens with a Polaroid filter to make the fields greener and the clouds whiter.

This impressive landscape in the Himalayan foothills, right, was also taken on a 35mm lens. The figure and campsite in the foreground underline the immense scale and grandeur of the scene.

The Tuareg, leading his three camels, completes this picture of a flat, stoney area at the heart of the Sahara Desert.

Utah, USA, *preceding pages,* photographed late in the afternoon, an hour before sunset, using a 28–70mm zoom at 40mm, slow film, and a red filter to accentuate the drama of the sky. When working with red filters, expose for the shadows – the increased contrast can reduce shadow detail, so increase by 2/3 stop on auto.

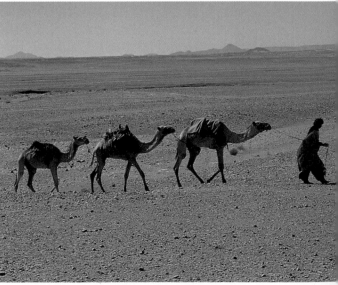

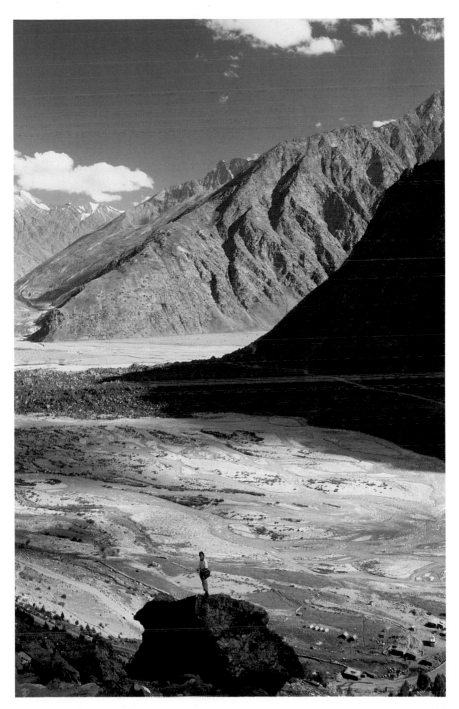

Landscape 2

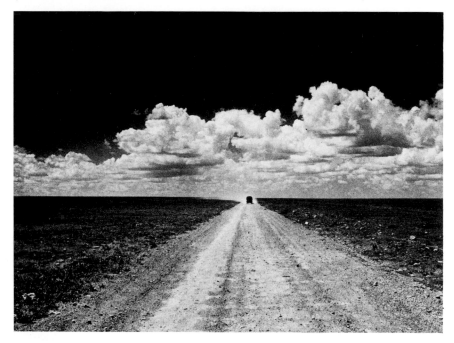

Many beginners think that the wide angle is *the* landscape lens, but telephoto lenses, especially the 300mm, are also effective. When this lens is focused on infinity, the landscape is compacted into the picture and is rich in shapes. From a high vantage point on a clear morning, a view of more than 90 miles (150km) can easily be seen. To get such a scene into a picture to take home with you is well worth all the effort.

Choose your position and lens with care. Many of the great landscape painters cheated. They moved rock outcrops, even mountains, a few inches on the canvas to make the composition work. Photography may lie a little but it doesn't cheat.

Graduated filters are useful to hold detail in the sky while retaining foreground interest. Polarizing or red filters on extreme wide angle lenses also add drama to the sky.

It is frustrating to be driving along in fantastic photographic weather, such as pre- or post-thunderstorm light, and not

Tanzania. Shot at midday with a 20mm lens and a red filter fitted to emphasize clouds. The truck arriving at the point of converging perspective becomes the focal point of the picture. Expansive landscapes such as this need something in the picture to catch the eye.

have a subject to photograph. Keep a good contour map in the car so you have some idea of the geography of the land and where there might be interesting features worth investigating. Sunsets always help a landscape picture, but they disappear fast. Use a compass so that you can work out where the ball of the setting sun is going to drop that evening.

A keen landscape photographer will learn to interpret weather patterns. In some parts of the world, the weather is very predictable and not a problem but, if it is changeable, use it. Don't be defeated by bad weather. Find a way round it, such as using grainy film or working in black and white. For an interesting series of pictures, try photographing a favorite landscape at intervals throughout the day or in different weather conditions.

An aerial shot of a château surrounded by vineyards in the Cognac area of France makes a graphic landscape with plenty of central interest. Being airborne gives the photographer a privileged view of the subject but little time to compose the picture.

Ladak, Northern India, *below*, shot on a Widelux camera to convey the scale and immensity of the landscape.

CHECKPOINTS

- Many photographers prefer to use black and white film for landscapes, because the print is tangible. The grain and tones in a black and white print are also in harmony with the natural textures of rock, grass, lakes, mountains, sky, and clouds.
- Color landscapes in *National Geographic* magazines often include a back view of the photographer in his "special issue" red jacket. The eye goes straight for the red and, then wanders around the picture, taking it all in.

- Take a selection of lenses, filters, and a steady tripod when photographing landscapes. A spirit level helps you to keep horizons level.
- A Widelux camera or panoramic tripod head enables the largest vistas to be photographed.
- Carry a compass and binoculars. Don't be lazy and just shoot out of the car window – you are unlikely to get interesting shots. Leave the vehicle and walk around looking for the best possible camera angles.

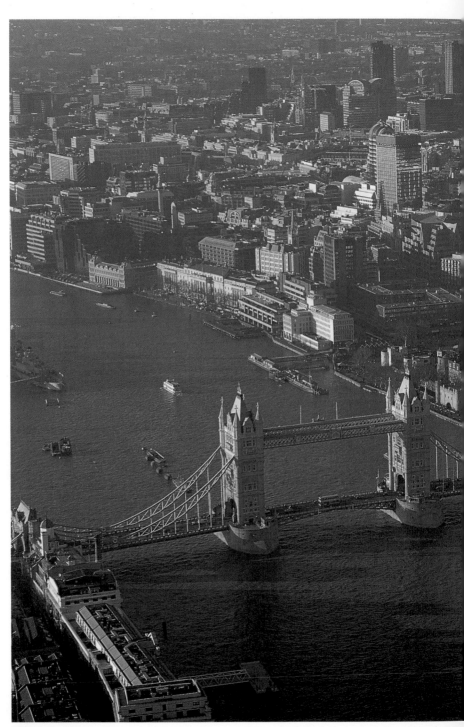

Aerial

From the air, the world becomes one huge and incredible graphic design. Familiar cities and landscapes become a series of shapes made of light and shade.

If flying in a helicopter or a light aircraft, brief the pilot on your needs before take-off. Explain what you want to photograph and the angles from which to approach the subjects. Ask the pilot to let you know where the aircraft's shadow will be, and ask him or her to make rudder turns if possible, rather than flap turns, which cause the plane to bank steeply. Rudder turns keep the aircraft on a more even keel.

The best time to shoot pictures from an aircraft is early morning (up to two hours after sunrise), when the light is fresh and clean, and late afternoon (two hours before sunset), when the shadows are once again getting longer and the light is full of color.

Unless the sun is catching a bright, reflective surface, such as water or glass, and throwing very strong highlights, exposures should be easy. Take an incident light reading of the light falling on the ground, and expose accordingly. If it is a hazy day, underexpose slightly. On clear days the atmosphere tends to make colors appear cold; use a 2A or an 81 series filter. Orange filters are effective with black and white film. Use polarizers to cut reflected light, especially in the heat of the day.

Since the subject is a long way from the camera, use the sharpest possible film, such as Fuji Velvia. Remember that helicopters vibrate, so use the fastest shutter speeds. Ideally, shoot at between 1/500 second and 1/250 second when hovering. With a stabilizer lens you can use slower shutter speeds.

Aerial photography from light aircraft is a pursuit limited to specialists and those lucky enough to know pilots, but there is also potential for picture-taking from scheduled aircraft.

The most common problem when shooting through the window of an aeroplane is the intrusion of reflections on the inside window. These can usually be eliminated by cupping the hand around the front of the lens and pressing that against the window. A rubber lens hood can also cut out the light effectively. If you can do so without disturbing other passengers, throw an airline blanket over your head and shoulders to cut out all chance of reflections.

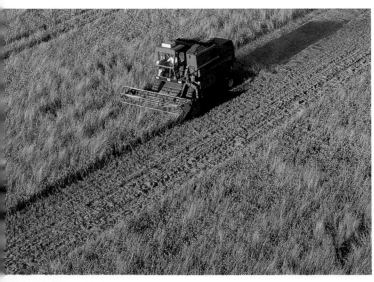

The bold pattern made by the combine harvester working a field, *left*, was shot on a zoom lens with fast shutter speed. The zoom allows some "fine tuning" of the picture.

Hong Kong harbor, *right*, photographed from a helicopter about 300 ft (90m) over water. The aerial position enabled the photographer to shoot the ship in its location – the point of the picture.

The river Thames, *preceding pages*, was shot on a 35-70mm zoom from a helicopter hovering 650 ft (200m) above the scene.

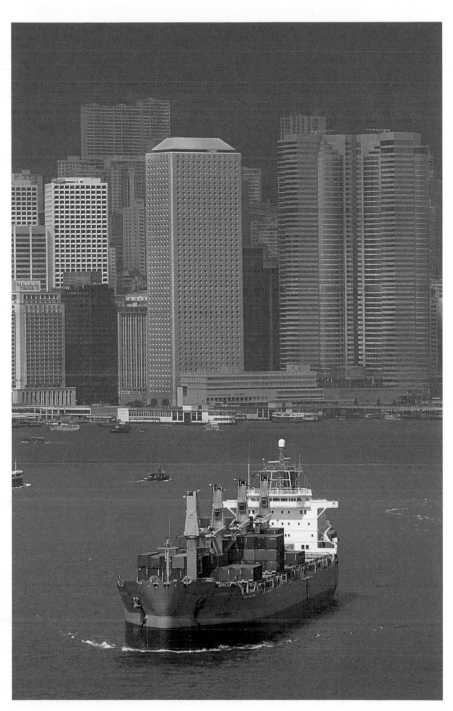

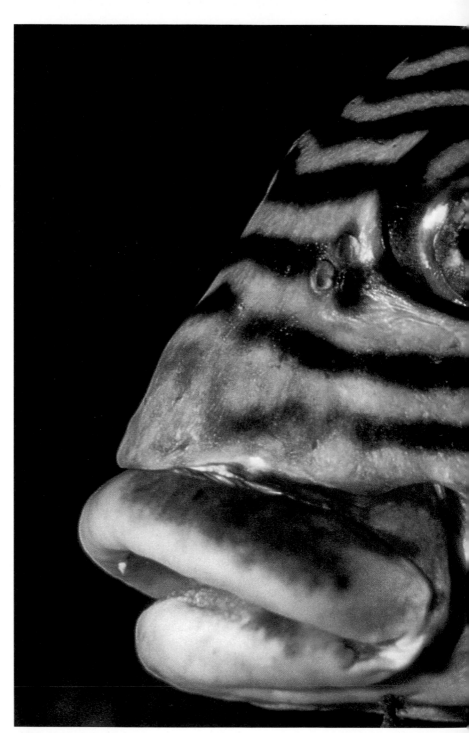

Marine

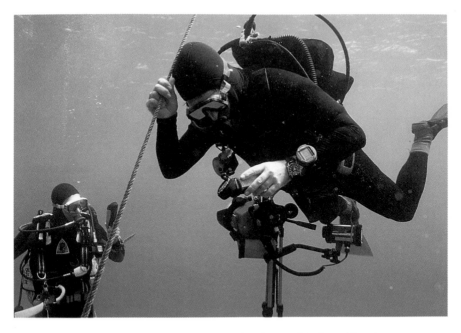

Underwater photography is becoming more and more popular, but unless you know exactly what you are doing, underwater can be a dangerous place to be. Most people start by learning to dive and then take up photography to record the amazing sights they see – basic tuition in photography is even included in some diving courses. For the real enthusiast, revenue from photographs can even help supplement diving costs.

You must be confident about your diving skills before starting to take pictures. Although divers usually work in teams, you may want to go off on your own to follow a shot and you need to be experienced enough to cope with any emergencies that might occur. You should have excellent breathing control to help you float and descend as necessary to get your shot.

Most diving takes place in water of about 65–100 ft (20 to 30m) deep, where there is still some daylight, but you need to use flash from about 16 ft (5m). Macro underwater photography always needs to be lit with underwater flash.

Preceding pages The Oriental Sweetlips was photographed in the Maldives on a Nikon 801 with a 105 macro lens in a Subal housing.

Above The wreck of the S.S. *Dunraven* in the Red Sea was photographed on a Nikon F4 in Subal housing, using a 20mm lens and Agfa Scala film.

With so many physical and technical limitations, it is difficult to be creative underwater. Start by faithfully recording what you see, then look for color and strong graphic shapes. Something to give an idea of scale can help to make underwater pictures more interesting. Include another diver in the picture, for example, and try to ensure that they make an elegant shape.

Specialized underwater cameras, such as the Nikonos, have largely been superseded by watertight housings that contain and protect your normal camera, letting you use all the best land-based technology underwater with no risk of damage. Subal housing is designed by a diver and takes all kinds of cameras. Other makes of housing include Inon, Nexus, Aquatica, and Ikelite, a budget

model. All housings must operate mechanically, not electrically, because they are exposed to the saltwater.

Nikons are particularly suitable for use in housings because the position of the dials makes them easier to access from the outside, and their high viewpoint helps when looking through a mask. A Nikonos underwater camera makes a good second camera as it is small and easy to carry on your person – it also gives you another roll of film.

Underwater photographers should be conscious of the environment they are privileged to work in and never, for example, move something in order to photograph it in another setting. Be patient and work within the environment. Try not to invade the animals' space. Hover above an area such as a coral reef and wait: fish are territorial so even if they are scared off at first, they will come back. At night, don't shine your torch onto a fish. It has been known for a predator to spot your subject and eat it.

Interesting underwater photographs can be obtained without using scuba equipment. Use a snorkel in shallow water. A wet or dry suit can be vital in some locations such as icy mountain lakes, and even in tropical water you can get cold hovering around for a shot. A suit also offers protection from sharp rocks, coral reefs, and jellyfish stings.

Subal housing protects a normal land camera under water

White housing

Nikonos underwater Speedlight SB-102

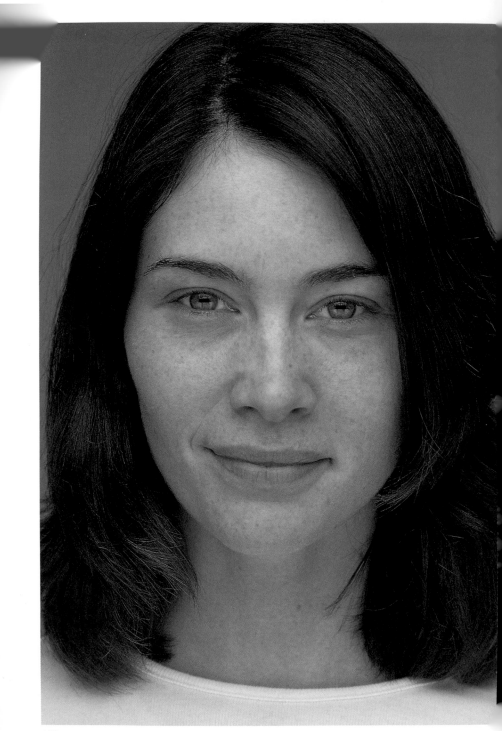

Beauty

Beauty photography differs from other portraiture in that the photographer wishes to picture women at their most glamorous. Beauty images are specifically aimed at women, rather than men, and must appeal to female fantasies. The photography, which must be tasteful, requires the painstakingly clinical attitude of the still-life photographer. Top beauty photographers are highly skilled technicians, who can work with the model to get the right looks and pose at the decisive moment.

The photographs on the preceding pages show a model as she arrived for the shoot and after being made up – details are given opposite. The beauty shot was taken on a 135mm lens at f5.6. No filtration was needed. A soft box light was positioned directly over the camera, and central to the model, while a silver reflector under her face bounced light back onto her, keeping her skin smooth and softening any shadows.

The model chose to stand, even though only her head was to appear in the picture. Standing makes the head and shoulders look more alert.

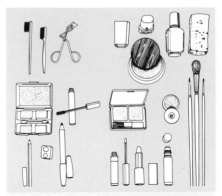

Some knowledge of the application of make-up is essential to the beauty photographer, who must represent subtle cosmetic hues. Professionals use make-up artists, but amateurs should learn as much as possible themselves.

The basic equipment illustrated above includes:

Eyebrow brush	Sponge for base
Eyelash comb	Translucent powder
Eyelash curlers	Dip stick lipstick
Eye shadow	Lip gloss
Mascara	Lip brush
Kohl pencil	Powder blusher
Pencil sharpener	Cream blusher
Concealer	Blusher brush
Fluid base	Eye shadow brush

CHECKPOINTS

- Keep foundation light and natural. Match the color to the skin on the model's chest.
- Concealers are invaluable for covering dark shadows and blemishes. Anything made lighter stands out – anything made darker will recede.
- Blend all make-up well. For the best effects, use professional make-up brushes. These are usually larger and fluffier than the brushes that come with most make-up products, and much more efficient. Eye make-up brushes are tapered or chiseled depending on their purpose.
- Cover the skin with powder before applying quick-tanning cream so that the uncovered areas are visible.
- For eyes, apply basic cover first. If using pencils, apply on top of the base. If using powder, lighten the eyelid with translucent powder first, so that the shadow will set better. Emphasis can be applied with eyeliner; use only a thin line and carefully blend it into the lash roots.
- Use bounced light off reflectors or umbrellas to make the face appear shadowless.
- A soft-focus filter with the lens stopped down smooths the skin.
- Experiment with other filters. A 2A or 81A, B, or C, plus a 5 Red will give a warm glow to skin tones.
- Make sure the model is happy. If she feels good, she will look good and that makes a better picture.

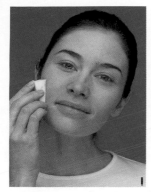

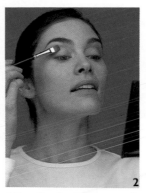

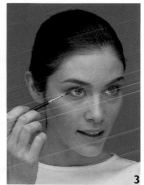

1 Base make-up. Use a light foundation, not a heavy mask, for a more natural look. Match the color with the pale skin on the chest and blend carefully. A lighter color used around the eyes will make them look brighter. Finish with a light dusting of translucent powder over the whole face, including the eyelids.

2 Eyes. Start by applying a neutral beige shadow in the eye socket, and blend it along the browbone and down the outer edge of the eyelid. Apply a very light cream shadow onto the eyelid.

3 Define the eyes, using a dark brown or grey matte shadow and a small pointed brush. Choose the color that best suits the model's hair and eyes. Load the brush with

shadow, shake off any excess powder, and outline each eye. With the brush used to apply the neutral shadow, blend the edges of the outline softly. Hard lines are aging and ugly.

Curl the upper lashes using a lash curler, and then apply mascara. Comb through the lashes after applying mascara to get rid of any blobs. On the lower lashes, use little, if any, mascara.

4 **Apply blusher on the** cheek bones and softly blend it out to the hair line. Use natural colors, not strong pinks or reds. Always shake the blusher brush after loading and before application to avoid a garish concentration of color on the cheeks.

5 Outline lips with a brownish-red pencil and fill in with color. Lipsticks that have an element of brown, whether the main color is

pink or red, are kinder to most skin tones and much less aging. Blot the lips well and add a little gloss to the central area for a really "sensuous" look.

6 Style the hair. It's generally best to style hair when damp, particularly for the natural look shown here. Apply one of the many brands of mousse or body-giving sprays to increase the lift and volume of the hair. Blow dry,

styling with a round brush, and then use velcro rollers to give more body. These are now available in many sizes – the larger the roller, the more body and less curl you get. With the biggest sizes, you can even end up with straight hair. Leave the rollers in for at least 30 minutes, using a hair dryer to increase the effect if desired. The resulting style will appear much more natural than if set on hot rollers.

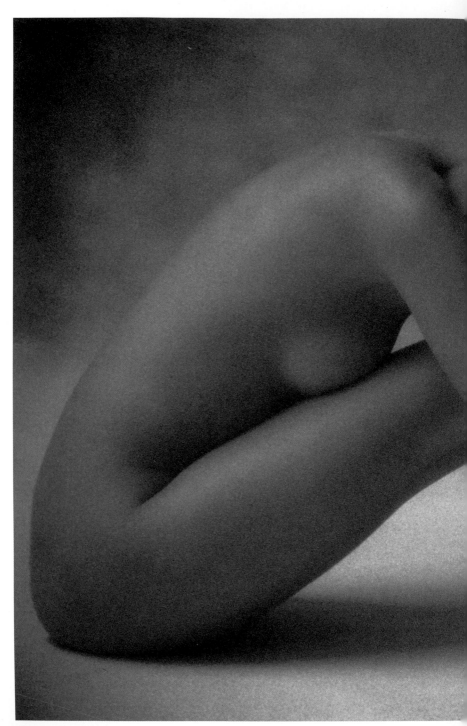

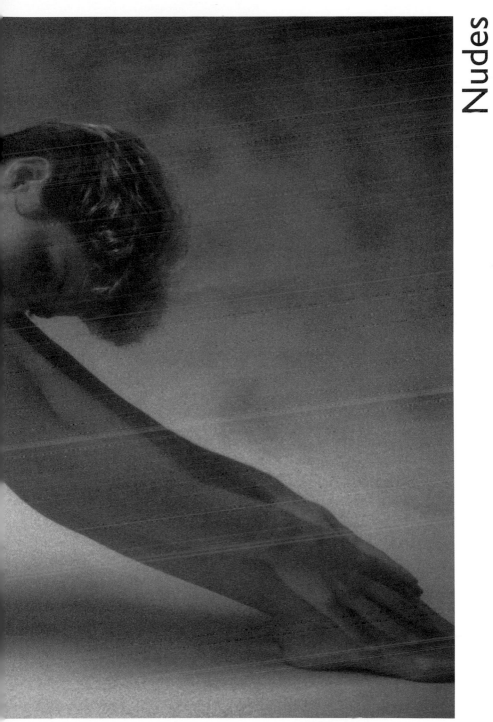

Nudes

A difficult subject to photograph well, nudes are all too easy to shoot badly.

The popular image of an amazingly beautiful Venus or Adonis waiting in front of the camera, of whom a failed picture would be impossible, is just a fantasy. The plain truth is that there are few perfect bodies – most people have blotchy skin and lumps in the wrong places. Once this has been accepted, nude photography becomes an exercise in creative lighting technique.

Always bear in mind that a human body is a collection of round shapes. Never light the body front-on as this will flatten those round shapes. Instead, light from above, or on one side, and use reflectors where necessary. The body must be lit to throw any imperfections into shadow or away from the camera. Arrange the pose as carefully as possible so that the model's best features are facing toward the camera.

When photographing a nude subject (even if the model is a friend), keep the atmosphere casual and relaxed. Make sure that the room or studio is warm. Cold skin does not photograph well and blue blotches and goose bumps are not considered attractive. Assuming that the photographer does have clothes on, the temperature should be slightly too warm for him or her. To make the model's nipples stand erect, apply an ice pack for a few minutes.

Models should not wear underclothes or other tight clothing for several hours before a session since the elastic on socks and underwear leaves unpleasant marks. These take a long time to fade away so insist, tactfully, that models wear loose clothing only before the session.

Never bother to attend group sessions with a shared model. These vulgarize the true spirit of nude photography and are useless for getting a beautiful picture.

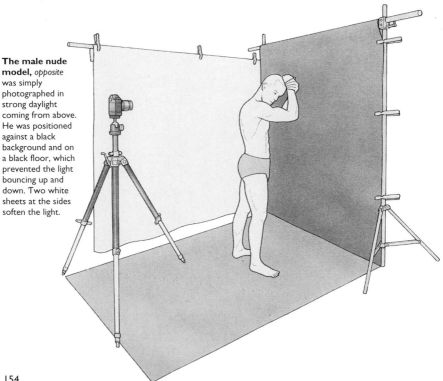

The male nude model, *opposite* was simply photographed in strong daylight coming from above. He was positioned against a black background and on a black floor, which prevented the light bouncing up and down. Two white sheets at the sides soften the light.

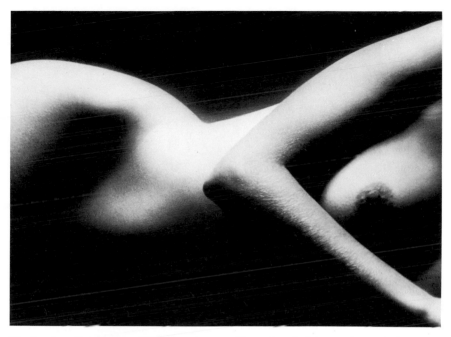

The female nude reclining on a mattress, *above,* was lit by a single light source bounced off a gold-colored umbrella covered with tissue. By using an 80–200mm zoom lens, fitted with Softar and 81B filters, an almost abstract effect was achieved.

The male nude, *below,* was photographed in daylight in the studio using a 35–70 zoom lens. Strong north light – the traditional painter's and sculptor's light – coming from above helped to convey the muscular contours of his body.

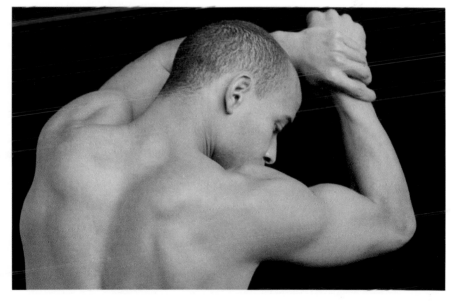

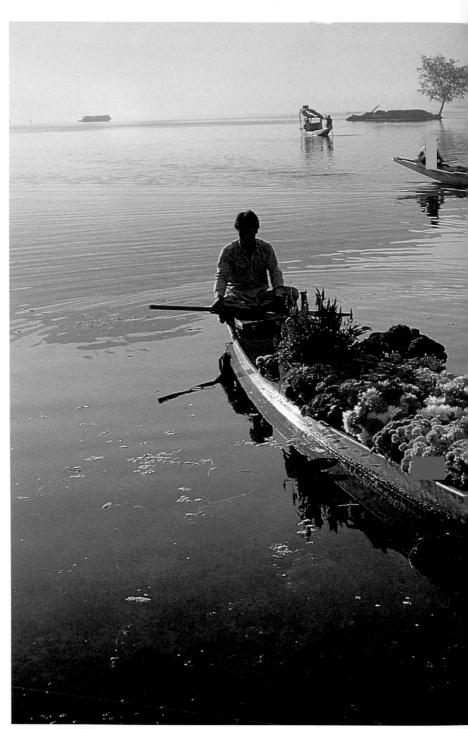

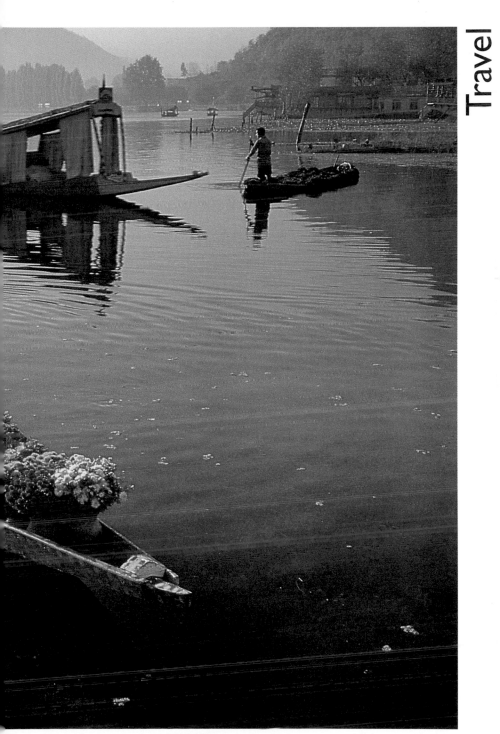

Travel

Successful travel photographs come from good trips, and good trips come from meticulous planning. Think carefully about the equipment to take, and try to pack what you are likely to need without overloading yourself. Don't buy a new camera or lens just before going away; test and be familiar with all equipment before leaving.

When on a trip away, don't only look for the obvious pictures – the panoramas, the strange clothes, all the things that are different from back home. Have an eye for the more subtle, but equally interesting, details. Remember that you will show these pictures to friends on your return, so try to convey the atmosphere and feel of the place in your pictures. This is sometimes done more successfully with a few detail shots than with one general picture.

Shooting both color and black and white film when traveling can be problematic; each needs a separate photographic approach. Sometimes the "human family" type of picture works better in black and white; color can detract from the essence of the subject.

It is helpful to have a positive interest in something, rather than a "today's Monday, must be Mexico" attitude. Something that fascinates you personally may make a better picture than the city's most famous monument.

Carry a camera at all times. Compacts are eminently portable. If you miss a good shot, you will kick yourself – you won't forget the image left in your head.

A priest and nun in a Greek island monastery were photographed in the late afternoon sun. Always ask and smile before taking such pictures and you will usually get the permission you want.

A flower seller on his barge in Srinigar, Kashmir, *preceding pages.*

CHECKPOINTS

● Never put off a shot until tomorrow. The chance may not be there – and neither might the photographer. Take the shot anyway and return if you can.

● Do not photograph military installations. Even civil airports have restricted areas, so be careful. Military-type clothing should not be worn in countries where there is, or could be, dangerous. Nobody wants to become a prisoner while on holiday

● Respect other people's cultures. Never intrude into places of prayer or private areas. Ask permission to take pictures, but be prepared to sneak a shot if the answer is no. Be discreet and always polite, or you will make life more difficult for the next photographer.

● The ability to "lens" a picture is one of the traveler's greatest assets. Learn to visualize the effects of different lenses on a picture and use their characteristics. Each can help you

Do not rush travel pictures. Although the photograph of the girl on a camel is just a snapshot, it took time to get her and the camel into position with the best light for the picture.

treat a subject in an interesting and different way.

● Overhead electricity cables, which appear in streets all over the world, can be a nuisance. Shoot in low light and push the film. This minimizes the unwanted lines.

● Professional photographers clean their cameras every day when they return to base. Captions can be written at the same time when the memory is fresh.

● Take along a Polaroid camera if only to give pictures away. Local children begging for gifts can be a nuisance and a picture is more useful than chewing-gum.

● Most photographers shoot film in 36-exposure rolls, but film that is only used for specific types of picture (400 ISO negative, type B color, slow black and white, for example) is more convenient in 20-exposure rolls. These can be finished in one go without having to be rewound, and the cassettes marked off.

● A waist-level finder is useful for shooting people when you do not want them to react to camera. Right-angle lenses, designed for shooting around corners, can take so long to aim and focus that they become a liability, often drawing attention to the photographer.

● For many people, travel is an experience shared with family and friends, and it may be difficult to carry lots of camera equipment with all the other luggage to worry about. Fit the camera with an 80–200mm zoom lens for maximum flexibility, and carry other photographic items in the adapted jacket described on pp. 206–7. In one of the pockets carry a 24mm lens wrapped in chamois leather, and fill the other pockets with a range of accessories.

● If visiting a city for more than a few days, take a "city tour" bus trip. It is a quick way of getting your bearings and discovering something about the atmosphere and layout as well as the major landmarks.

Travel 2

1 Spetze, Greece **2 Tuareg, Tamanrasset** **3 Malindi, Kenya**

Read all about a place before going there. A knowledge of local customs, main features, and interesting events is helpful and doesn't detract from the excitement of first impressions. When you arrive, buy postcards. They will help you to choose what to photograph.

4 Kashmir, India

The excitement of arriving in a new place can lead one to overshoot on the first day, or to try to cover too many places in a hurry. Relax, look around, and take your time to get the best shots. By overshooting early on you may run out of film, just as you have absorbed the feeling of the place and could put the film to its best use.

Try choosing a location and waiting for the action to come to you. Stand back and observe what is happening around you before shooting a number of frames.

5 Istanbul, Turkey

With a 35mm lens, the composition has a strong curve (**1**) in sympathy with the shape of the boats. A 35mm lens was used (**2**) to "pull" in a black background. Shot (**3**) was taken on a Nikonos with a 35mm lens. The hard light has turned the figure into an abstract shape. A figure in a landscape is always a good subject.

People at their daily tasks (**4**) usually make interesting shots. Here a 180mm lens was used. A 500mm mirror lens was used to make the sun big (**5**), balanced to the silhouette of the mosque. At a daily tourist event such as (**6**), watch the show more than once and choose the best position. Use a 35–70mm zoom to get close-ups and wide-angle shots. Isolate pleasing pictures (**7**) by use of lenses. The 80–200mm zoom allows tight pictures to be composed.

6 Inca Sun Dance, Mexico

7 The Algarve, Portugal　　**8 Central Park, New York**　　**9 Kremlin, Moscow**

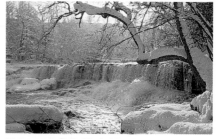

10 Shepherd, High Atlas, Morocco　　**11 Aysgarth Falls, Yorkshire, England**

The contrast between figures and buildings (**8**) is emphasized by using a 20mm lens. Muted color is as effective as a vibrant full-color picture. Strong sunlight picks out the golden domes (**9**) and is not affected by the polarizing filter that has only darkened the sky. (**10**) was shot from a car on a 400mm lens, using a bean bag for support. A 35mm lens was used for (**11**), taken on a bright, sunny morning before the snow began to melt. Always bracket in these conditions. A 105mm lens, wide open, held the subject off the background (**12**). The photograph of the priest (**13**) was taken with an 80–200mm zoom in the shade. White around the hat gives emphasis.

12 Kafir Kalash, Pakistan　　**13 Priest, Corfu**

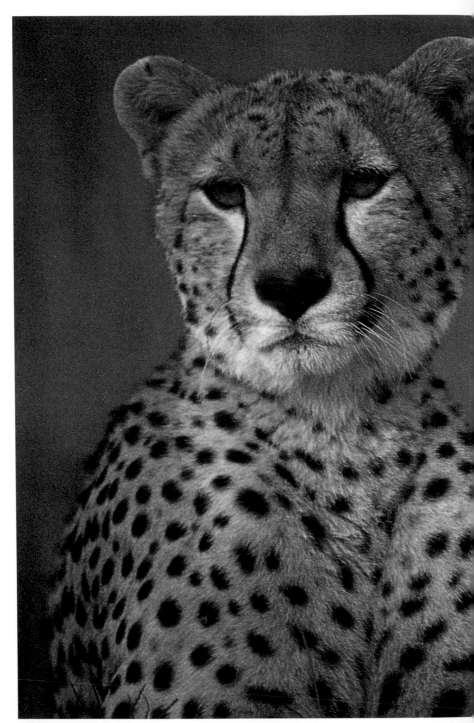

Animals

Animals ❙

Great wild animal shots require patience and dedication as well as some knowledge of wildlife. The best shots are seldom the result of luck, but are mostly taken by specialists who spend their lives photographing animals. Each picture may take days of waiting for just the right moment.

The amateur should not be put off, however. Wonderful pictures can be had with a combination of concentration, patience, luck, and the right equipment.

A 70–300mm zoom is the perfect lens for wildlife. A 300mm is really the minimum length for safari pictures, but a wide-aperture 400mm lens lets you take pictures at the end of the day when there

tends to be a lot of animal activity. The best pictures are usually shot early in the day or late in the evening.

To take really good pictures of wildlife, a photographer needs to know a certain amount about animal behavior to help him or her anticipate action. A naturalist's sensitivity can be as important as photographic technique.

Once an animal has been located (with the help of an experienced guide), total concentration is the vital factor. Keep the eye to the camera and constantly check focus until the animal moves into the right position. Autofocus is invaluable for wildlife photography, since it lets the photographer concentrate on the shot.

On safari in Africa. There is very little color in such locations in the middle of the day. Use a warming filter to put some color back into the picture. The lions, caught feasting on a kill, *below*, were taken on a 500mm mirror lens. The photographer worked from the car with the camera supported on a bean bag. The elephants, *below right*, were photographed on an 80-200mm zoom in the golden light at the end of the day.

You may come across animals suddenly so always be prepared. But often it is better to be patient and wait for the animals to come to you – at a waterhole, for example – than try to chase the action.

There are many safari parks around the world that can be rewarding to visit on quiet days. Clean the car windows beforehand; with the lens pressed against the glass, picture quality should not be affected.

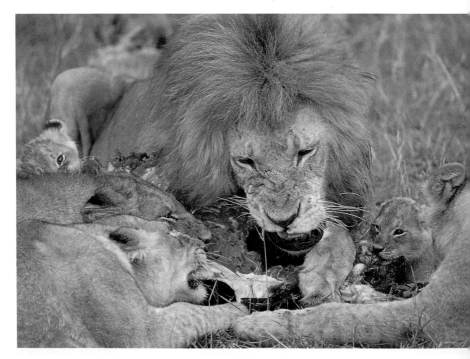

Be careful – even in a vehicle animal photography can be dangerous. Wild animals move fast. Do not go in where you cannot get out again quickly. Unless there is a great deal of light, use fast film so that the fastest shutter speeds can be used with long lenses, which, in many instances, have to be hand held.

On an organized safari, pictures can often be taken from a car window or through a wagon roof, and a bean bag makes an ideal camera stand. If you do not have one, fill a carrier bag with small stones and balance it on the car window or roof. Rest the camera on the bag of stones and wait in the vehicle until a shot presents itself.

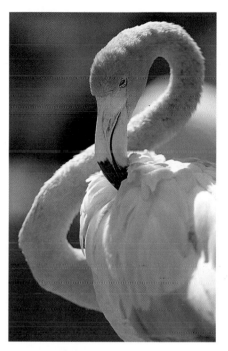

The flamingoes, *right,* were photographed in San Diego zoo on a 80-200mm zoom lens held wide open. Caged animals do not make good pictures, but in modern zoos where the animals roam relatively free, there are plenty of opportunities for wildlife photography. The animals look healthy, their fur or feathers in good condition, and you can usually get much closer to them than you can in the wild.

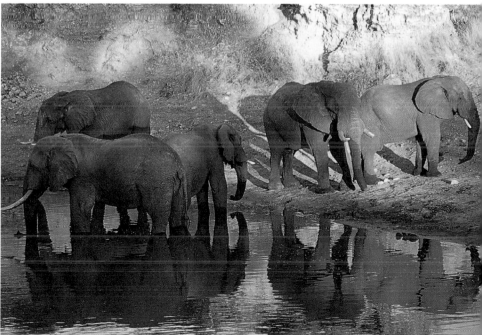

Animals 2

In the average city or suburban garden, there is a surprising variety of wildlife. Photographing it can be as great a challenge to the animal photographer as African big game. Take any opportunity to take pictures of local wildlife and domestic creatures. Even common garden birds or a pet cat or dog can make interesting shots.

When photographing animals that are nervous, as most are, think of the first shot as *the* shot. Make sure of it; the noise of the shutter will frighten the animal and it may never return. Use electronic flash when taking close-up pictures of birds to freeze them in motion.

Portable unit flashes are of such short duration that many birds do not even notice them. Those that do see the flash often get accustomed to it quickly.

To get the best results, be single minded about which type of animal you wish to photograph, then determine the best location, season, and time of day. Let the animal settle and never frighten it. Even small animals need room to

escape. If cornered, they may panic and you could even be in danger. Never get between an animal and its food.

Choose clothes to blend in with the scenery. Do not wear silvery items such as belt buckles. Cover shiny equipment with black tape, and even cover yourself with camouflage netting if necessary. Carry a selection of bait, such as bread for birds and honey for insects. Binoculars are also essential for scanning the horizon when working in the country.

When shooting at a zoo or marina, find out the times for feeding or displays that often provide good opportunities for pictures. At the marina, watch the show through once to look for the best viewpoint on the action.

The blue tit, *below left,* was photographed from a kitchen window. Birds are so used to activity in the house that they are not bothered by the camera shutter. The dog, *below,* was shot from a low position so that the photographer could keep its attention. Autofocus made a difficult picture easier.

A small flash unit was mounted on the camera to photograph the cat, *below right.* The shot was overexposed to hold detail in the fur.

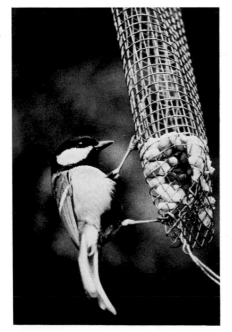

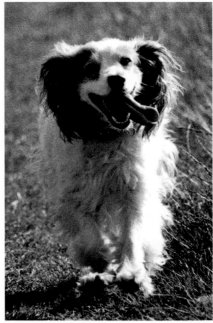

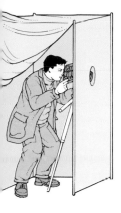

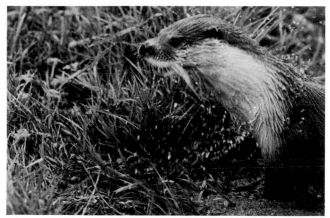

Use a hide when photographing shy birds or animals, such as the otter, *above*. Birds are particularly nervous of any sudden movements.

The simplest type of hide is made with four stakes knocked into the ground and covered with canvas. Leave spaces through which you can shoot. Over the years, nature photographers have come to realize that a hide need only be the most basic of structures. Its purpose is simply to hide the photographer from the animal; it does not need to look like a tree or be otherwise camouflaged.

For photographing birds in their nests, the hide may have to be built up in a tree or at least high enough off the ground to enable the nest to be seen. Study the species thoroughly before investing the effort needed to set up a hide.

Once the hide has been set up, it may be hours before the animal shows itself. Be prepared for a long wait — if you are lucky it will be worth it.

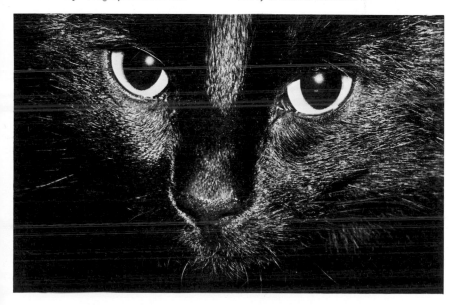

Gardens and flowers

Gardens may be beautiful subjects but they are difficult to photograph well. Even if there seems to be a riot of flowers as you look at the garden, pictures often appear surprisingly green and dull, with little to hold the attention.

Help your pictures by making more of the color in the garden. Use a long lens and selective focus so that any out-of-focus color is enlarged. Look for pattern and design, and get rid of any rubbish or unnecessary distractions as you look through the viewfinder. Don't try to get everything in at once – concentrate on a small area of the garden or a detail. Try to identify the main elements, such as color or graphic shapes, and accentuate those. Famous gardens are usually designed to be looked at from certain positions and have a number of focal points, such as topiary, statues, or arbors. Find out about these and use them to give purpose to your picture.

Individual blooms are easier subjects to photograph than whole gardens – with a macro facility there is no reason why any keen gardener shouldn't take good flower pictures.

When photographing flowers or groups of flowers, keep the background simple. Isolate the subject against a single color or place some colored card behind the flower. Don't ignore flowers that are past their prime – the petals of tulips, for example, make wonderful shapes before they fall – and take pictures at different times of day and in all kinds of weather, not just sunshine. Use a macro lens for close-ups on flowers or parts of flowers. A ring flash gives a shadowless light or use a SB28 with a diffuser. Autofocus is useful when photographing flowers – it can hold them sharp despite any little movements in the breeze.

In summer, get up early while the light is fresh and there is still some moisture in the air. In winter, look for the underlying structure of the garden and take advantage of cold mornings when plants get a dusting of silvery frost that can make magical pictures.

Bring flowers into the studio, too, and use them as still-life subjects. A single bloom can make a wonderful graphic shape for a photograph.

A sturdy wheelbarrow gives a hint of all the activity that takes place in a well-kept garden and gives scale and context to the picture.

Single blooms make simple, pleasing pictures. The flower takes center stage – there is nothing to distract the eye from the beauty of its shape and form.

CHECKPOINTS
● Use Fuji Velvia film for saturated color and bracket exposures.
● Hazy sunshine is best for photographing gardens in color – it gives a soft, shadowless light.
● In hard sunlight, use a Lastolite reflector to put blooms in shadow, creating a softer light.
● Try taking shots from high up to accentuate the pattern of a formal garden, specially in winter.
● Use a tripod and fast shutter speed when taking close-ups of flowers or foliage – even the slightest hint of a breeze can ruin the picture.
● To exaggerate color, use a narrow depth of focus to separate the flower from its background (see p. 36).
● Spray flower petals with water to give a fresh, dewy look.
● When planning garden pictures, call round famous gardens first to find out when blooms will be at their best or the time when autumn colors are at their height.

Architecture 1

The effect of light on buildings is the main consideration when photographing architecture. A photographer may spend several days checking the appearance and atmosphere of a building at different times of day and in the evening, when interior lights are switched on.

A change in light conditions can transform some structures. On a dull, cloudy day a building may look flat, gray and boring, but if the clouds clear later in the afternoon, it may become bathed in warm, golden light and appear beautiful and alive.

Buildings, like people, should be photographed in a way that brings out their individuality and character. A brash, new building may be best taken on a sunny day, with the hard, bright light picking out the steel and glass. With the help of a polarizing filter, the building's uncompromising hard edges will stand out against a dramatically dark blue sky.

A Georgian terrace, on the other hand, may look at its most charming at dusk, with soft, warm, natural light and a few lamps shining in the windows. An 81A filter could be used to bring this warmth to the fore. Good shots can be taken of buildings at dusk when interior lights or external floodlights are first turned on, but there is still some blue light in the sky.

CHECKPOINTS

- A compass is a great asset when photographing buildings. Calculate where the sun will be all through the day and plan for it.
- Essential accessories are a polarizing filter for color, and orange and red filters for use with black and white film. Use perspective correction lenses for correcting verticals, or shoot from halfway up a building opposite and avoid distortion.
- Light interiors with care – only introduce the light necessary for taking the photograph.

A perfectly
symmetrical picture
of St. Peter's Square in
Rome, preceding pages,
was taken on a
35–70mm zoom lens
for exact framing.

The Roman baths and
Bath Abbey, *left*, were
photographed on a
20mm wide angle lens.
The composition was
made from a crane.

The Chrysler Building
in New York, *right*, is
so familiar that it is
interesting to look at it in
a slightly different way.
Here it is photographed
in relation to the other
buildings nearby and yet
remains the focal point.

The streets of Siena in
Italy were photographed
on a 80-200mm zoom to
compress the
perspective and make an
abstract pattern of the
windows and the
terracotta walls.

Architecture 2

A stone mill, nestling among trees at the water's edge, was first seen in the morning when in shadow. By afternoon the scene was bathed in sunlight, creating perfect reflections and making a simple shot something really special.

An art deco hotel in Miami, *below,* makes a strong graphic image. Instead of looking at the pastel-colored building from a distance, the photographer stood close, looking up at it so that its straight lines appear to soar away into the bright blue sky.

Light pours into this modern factory headquarters, making it impossible to photograph on a sunny day. Contrasts would be too strong and shadows hard. This picture was taken on a very dull day with flat, natural light, but the building still looks bright and inviting. No extra lighting was necessary. The camera position shows off the building's construction to advantage.

Hotel bedrooms can look bland, and the aim of this picture was to make the room appear as attractive as possible. Fill flash and a long exposure on daylight film gave a warm glow to the scene, making the room look inviting.

Sport |

The 35mm camera system revolutionized sports photography in the 1970s. The portable telelenses and motor drives enabled the photographer to get right in with the action, showing the viewer what it was like to be a player rather than just a spectator on the sideline.

The special demands of sports photography have been responsible for many innovations, both in technique and camera equipment. New items such as faster lenses are often brought out in time for major sporting events. Recent technical developments, such as wide aperture lenses, autofocus, and flash sync at 1/250 second, coupled with the high image quality of fast ISO film, have made sports photography more exciting than ever before.

The colorful sailing boats (*below*) were shot from another boat, using a 300mm lens mounted on a monopod for support. The long lens allowed the photographer to stay well back, but foreshortened perspective for a dramatic, well-packed picture.

Good pictures are easier to achieve if the photographer knows the sport and style of play of the main participants. Photograph steadily through the game; this way you are more likely to hit the button at that critical moment.

It is always interesting for the sports photographer to search out and take pictures of that ingredient which makes a champion player different from the others. But sports photography is not only concerned with freezing the moment of victory or defeat; it must also capture the spirit of endeavor and the drama on the sidelines.

Major sports meetings are often difficult to photograph. Public seating and press enclosures are usually a long way from the action. But remember, it doesn't have to be a world-class event to produce a good picture. Dramatic photographs can result from local fixtures or even from watching a bunch of enthusiastic amateurs in the park.

This sumo wrestler (*above*) was caught at a crucial moment, using a 300mm lens, fast shutter speed, and tungsten film. The picture was taken from a seat in the stalls, which allowed a better view of the action than the position allocated to photographers. Its success depended on being able to choose the viewpoint.

The thrill and terror of white-water rafting (*left*) is evident on the faces of the participants in this picture, shot from the riverbank with a 600mm lens and fast shutter speed to freeze the foaming water and expressions on the faces. Like many sporting events, the action is repetitive – boats come one after another, giving you the opportunity to take a number of pictures. If you miss one, get the next, and learn from your mistakes.

Sport 2

An Olympic gymnast (*left*) is captured at a key moment of his routine with the help of the autofocus. Notice the athlete's eye — it expresses his immense commitment and concentration.

This star rugby player was shot from a low angle to highlight his bulk and power. The picture was taken on an Nikon F4 with a 500mm f4 lens. Its success depended on getting a good position out on the wing, where the player was sure to be in action.

An Olympic diver is caught at the moment of impact by panning vertically downward with the dive at 1/25 of a second. The photographer was there to take a shot of another competitor, but experimented while waiting for her turn. The result is a great picture.

CHECKPOINTS

- Know the game and the players.
- In stadiums, sit in the west stand so that the late afternoon sun is on the east stand, not in the lens.
- Sit ten rows back in the stand to use the height, rather than in the front row at a low level.
- Take pictures of people playing sport in the park: you can get much closer and it is good practice.
- Reload during the intervals; be prepared to waste frames rather than lose the picture because the film ran out in mid-action.
- Use a variety of shutter speeds, from panning at 1/4 second to shooting at 1/1000 second. It is often better to have movement, such as a blurred foot or arm, in the picture rather than freezing it.
- Use as wide an aperture as possible so the subject "stands off" the soft background.
- Never chase after the peak action; anticipate where it is going to occur and set up for the shot. It may only occur once in the day. When shooting an area such as a finish line or goalmouth with a fixed camera, tape down the lens so it does not get knocked out of focus.
- When panning with the action and using a motor drive, keep shooting while focusing for the shot.
- Autofocus is ideal for sport photography. Set the camera on continuous autofocus and shutter priority - 1/250 second or above. This should give sharp, perfectly exposed pictures. Autofocus also works well when panning with the action in subdued light and when the subject is coming toward you – as in a horse race, for example.
- Always endeavor to fill the frame with the action.
- Don't let the excitement get to you – keep taking pictures.

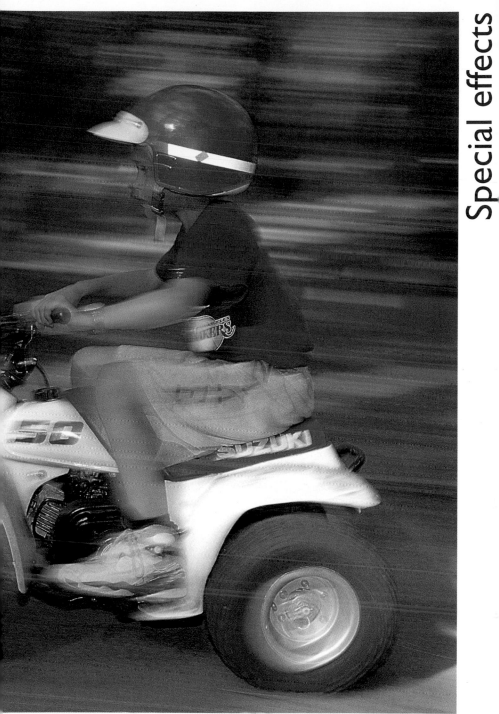

Special effects 1

Once you are in command of the basics of photography, there is a range of special effects you can call upon to increase your ability as an image maker. Special effects need not always involve additional equipment such as filters. Interesting results can be created just by particular movements of the camera or by different ways of processing. Take advantage of the creative possibilities with flash, such as multiflash.

There are hundreds of filters on the market, produced by many different manufacturers. All of them have a special effect on a picture, but sometimes the filter effect *is* the picture.

Panning
Get the subject, such as the child in the preceding pages, in frame and hold it in the center of the viewfinder as it moves. With the camera hand-held, move at the same speed as the subject – it will remain sharp while the background will be blurred. Use an exposure of about 1/15 second and a SB28 flash set on TTL, balanced with the ambient light.

Pulling zoom
Use of the full range of the zoom lens has "pulled" the lights of New York's Times Square into streaks *(top left)*. To achieve this effect, use a 20–35mm zoom lens and mount the camera on a tripod. If no tripod is available, hold the camera as steady as possible. Using an exposure of about two seconds, start shooting with the 20mm focal length, then pull the zoom through to 35mm during the second half of the exposure.

Graduated filter
Filters can be used to achieve a range of special effects that can make a picture. On a graduated filter, color covers only the top third of the glass, fading to clear over the rest. A magenta graduated filter was used *(top right)* to add more color to the sunset and make the picture more exotic.

Double exposure
An unusual portrait can be taken using this technique. For the first exposure, the subject was positioned on the left-hand side of the frame against a black background. The camera was not wound on; a second exposure was taken on the same frame and using the same background, but with the subject moved to the right-hand side *(bottom left)*.

Open shutter with multiflash
This effect, a homage to artist Marcel Duchamp, has to be in darkness with the shutter locked open. As the model walked slowly down the stairs, the flash was fired ten times and the shutter was then closed. The flash was about half a stop under the normal setting to compensate for the overlap in the images *(bottom right)*.

Special effects 2

Sabattier print
The sabattier technique is just one of a number of special effects that can be achieved in the darkroom. It was used in this portrait of three Masai women, (*above*) to give depth and atmosphere. The print is partially developed and then exposed briefly to white light. This has the effect of partially turning the positive into a negative.

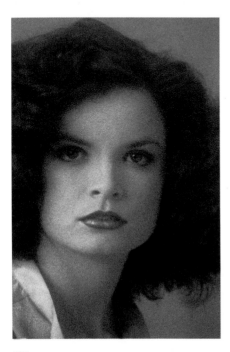

Infrared black and white

In this picture of Sizergh Castle in England's Lake District, infrared film helps to give an eerie, mysterious look to an ordinary view of the building. Black and white infrared film gives a unique semi-negative effect. It registers heat as well as light and is sensitive to wavelengths beyond the red end of the spectrum. With a red filter, leaves and grass appear white and blue skies become black. Infrared is not ISO rated and can be difficult to handle. On a bright day, try an exposure of 1/500 second at f8, with various strengths of red filter to deepen or lighten contrast.

Heavy grain

Grain is a useful special effect for creating a painted, impressionistic look in pictures, used most often for portraits and landscapes. The faster, the film the grainier the picture will be, but grain can also be achieved by duping or by processing at a higher than recommended temperature.

The girl (*far left*) was photographed on Scotch 1000 with an 81C filter to give warm, glowing colors. She was flatly lit to minimize detail. The film was processed normally, but a section was then copied to accentuate the grain. The result is a romantic, flattering portrait.

Using wrong film

Type B film is designed for use indoors with tungsten light, but here has been used at sunset outdoors (*left*). The strong blue cast that the film creates effectively disguises the ugly concrete of the building. The film is processed as usual.

Cross processing

For this effect, negative film is processed as transparency. When taking the picture, you need to underrate the film and push by one stop. It does require practice but can be extremely effective. In this photograph, *right*, of a model wearing a steel dress to advertise an exhibition on materials, cross processing gave a cool, steely look to her swirling skirts.

Manipulated image I

DIGITAL DARKROOM

More and more photographers are now setting up digital darkrooms – an array of computer equipment for scanning in images and manipulating them on screen. Such equipment is now seen as an extension of photography. Even if all you want to do is clean up your pictures and correct exposure, it is enormously exciting to have such control over your work, and to be able to adjust tiny details in order to create the perfect picture. Traditionalists may take a while to accept computer technology – it is the clients commissioning the photography who will understand its potential and force the pace.

The equipment shown here costs a great deal more than a conventional black and white darkroom, but you can do much more with it. Images can be scanned in from prints, film, or transparency, depending on the type of scanner, and manipulated or retouched on screen. They can be stored on disk or CD, made into web sites, and printed out on a range of papers for different effects.

There is a lot to learn in order to master these techniques. Don't be too ambitious to start with – buy an introductory program or go on a course to learn the basics. Even if you don't want to try image manipulation yourself, it is helpful to have an understanding of what can be done. Knowing that there are other ways of getting the perfect picture can save you time and money.

The Trooping of the Color in London is a difficult event to photograph. You never get one shot that sums up the whole day. In this image (preceding pages), ten pictures have been put together on the computer program Photoshop to create a photographic representation of the event and its main participants. The pictures, selected from a total of 144, were taken over a four-year period, from different positions and in different weathers. Photoshop evened out the colors and lighting to make it look as though all these pictures were taken on one day. It took eight hours work on the computer to get the picture just right – sometimes the definitive moment just won't do.

CD writer to copy information on to a CD permanently

CPU (Central Processing Unit) with an internal x 24 CD read only drive and Zip drive. It has 128Mb Ram, 6Gb hard drive and an additional 8Mb video Ram

A4 Graphics tablet for drawing and manipulating images

Iomega JAZ drive

The equipment shown here is standard for people setting up their own digital darkroom

Large format film scanner for film formats 35mm to 5 x 4

A4 Flat bed scanner with 36 to 42 bit color depth

Nikon film scanner
A dedicated 35mm film scanner produces better results than a flat bed scanner of similar price

Colour calibrated
17" (43cm) monitor

Inkjet printer with a resolution of 1400 dpi. When used with the correct media this produces photograph quality prints

Storage Media
(from left to right)
CD 650Mb
Jaz 1Gb or 2Gb
Zip 100Mb or 250Mb
Floppy 1 or 2Mb

Manipulated image 2

Although the images on this and the following pages have been manipulated on computer, an attempt has been made to stay true to photography. A designer would have probably treated the images in a different way, but a photographer has a better of understanding of light, for example, and tends to be more bound to the photographic image. The most successful commercial retouchers are those with sound photographic knowledge.

The Royal Bannerman of Scotland

Sometimes it can be hard to get a subject and location together at the right time. The statue of Robert the Bruce at Bannockburn made an ideal setting for a portrait of the Hereditary Bannerman of Scotland – the title came from the Battle of Bannockburn – but Lord Dundee, the title holder, was unable to get to the location. Instead, two separate photographs were taken – one of the statue on an autumn evening and another of Lord Dundee in a different location on a winter's afternoon. The same film and lens were used and the light on the two occasions was as similar as it could be. The two images were then put together on computer, using Photoshop. When you know you are going to put images together on computer, minimize any problems at the shooting stage. Here, the angle of light was the same for both pictures. A silver reflector was placed close to the figure, giving a hard edge and making it easier to cut out.

Gas cooker advertisement

The brief was to photograph the latest model of gas cooker in an idyllic landscape, but it proved much easier, and more successful, to take all the elements separately than to carry the cooker up onto the clifftops. The landscape was shot with a rough mock-up of the cooker in position. The real cooker was also photographed outside, but in the garden next to the studio, with the sunlight at the same angle as in the landscape. The seagulls were photographed individually, some at 1/500 second so that they were frozen in flight, and some at 1/15 so they appear blurred and give a sense of movement. All the images were then "comped" together using the Quantel Paintbox system.

Your perfect cooker can now be found at 240 beautiful locations, nationwide.

Leisure Professional 55 Auto Freestanding Cooker (shown in stainless steel) is just one of the huge range of electric and gas, cooking and heating products found at your local Energy Centre.

Call 0800 850 900 for details of your nearest high street shop.

Energy
CENTRE

Manipulated image 3

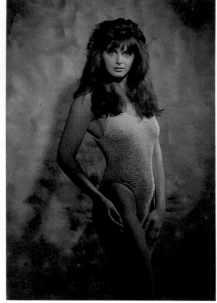

Color changes
This simple image of a model in a bathing suit demonstrates the possibilities for color change on computer. In the second image, the background and suit color have been changed and the blue eyes have been intensified, but the skin tones remain the same. This is a good way of creating effects but is also useful for varying background colors or matching a particular color that may not be available as background paper.

Abu Simbel, Egypt
The top picture shows the colors of this awe-inspiring temple as they really are. The second picture shows the image after the color channel curves have been adjusted in Photoshop for effect. The change in the color balance subtly alters the image – you never know quite what you are going to get.

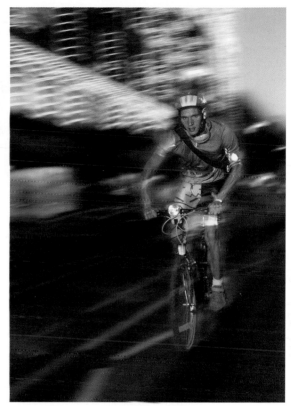

Nighttime cyclist

This image was shot conventionally and then manipulated for effect. The cyclist was photographed from an open back of a car using a Nikon camera and SB28 flash, with rear curtain sync at 1/10 second. Initially the background was too sharp, but the lights have been smoothed out in Photoshop and defocused. This gives more movement to the picture and holds the subject off the background.

Angry man

A still portrait can be made into a caricature or the features exaggerated to get a particular message across. Using Wacom PenTools plug-in software for Photoshop, noses can be made bigger, ears pointed, and lines added. Here, the angle and shape of this man's mouth have been changed to make him appear really angry, and the eyebrows and lines on his forehead have been greatly accentuated.

Manipulated image 4

Beauty

Nowadays all close-up pictures of models in the quality magazines have been cleaned up on computer. When the camera is so close, even the best skin, expertly made-up, needs a little help. The skin tones are smoothed out and any imperfections and stray hairs are removed. Eyes are made a little stronger in color and any red in the white of the eye is taken out. These may be minor adjustments, but they all help to make a perfect picture.

Lincoln Cathedral, England

This was a conventional double exposure – the film was exposed for a series of "moons" and then rewound and re-exposed for Lincoln Cathedral. The resulting image was perfected using Photoshop. For example, the right-hand spire appeared to be missing, so the left-hand spire was flipped and put in place. The floodlighting made the cathedral appear green so the color was corrected to make it look more stone-like. This ability to correct color, especially for pictures taken in fluorescent lighting, is extremely effective.

Old Master
The university chancellor's gown and canvas background gave this simple portrait of Margaret Thatcher the air of an old master. This look was accentuated by giving the portrait the Rembrandt treatment on computer. The hard eyes were softened, and subtle brush strokes and canvas texture added. The balance of the light was altered, making the shadow areas much darker to resemble those in a Rembrandt painting.

Contact sheets
It is extremely time-consuming to get more than two images on one sheet of paper by conventional methods, but images scanned into a computer are easy to reduce and output as a contact sheet using the Photoshop 5 standard plug-in.

Watercolor paper
This image, taken in Kashmir, has been given a painted look. Using the standard brushstrokes and watercolor filters in Photoshop 4, it has been retouched and output onto iris watercolor paper.

199

Digital photography

Digital equipment has revolutionized photography. The new digital cameras use a totally different method of taking pictures, and do not need film – the pictures are turned into digital information and can be viewed instantly. If the image is not what you want, you can take the shot again and discard the unwanted picture. Successful images can be stored on computer disks. Film will always be with us – just as color has never usurped the popularity of black and white – but for many subjects, digital photography will eventually take over.

Equipment

Digital equipment falls into three distinct groupings, just like conventional cameras. There are compacts and low-budget models, mid-range equivalents to SLR cameras, and the professional bodies at the high end of the market. These can be used with existing lenses. Most digital cameras have built-in flash.

Many digital cameras don't conform to traditional camera design – some look like video cameras, others more like a book with a lens, and not all have a viewfinder. If you are going to be working outside, it is best to choose a model with a viewfinder as well as an LCD (liquid crystal display) screen, which can be difficult to see out of doors, particularly in bright light. The screen uses a lot of battery power, so choose a camera that uses rechargeable batteries.

The compact digital camera is being developed for the home PC user who sees it as an add-on, only needed to view images on screen or to output small prints with or without text. How digital photography will affect the APS market, only time will tell. The major camera manufacturers have spent millions developing this user-friendly form of domestic photography and the digital compact is aimed at the same market. Processing labs will soon be printing digital files as well as conventional film.

Camera resolution, or the amount of detail a CCD chip can capture, is measured in pixels per inch. Pixels are the digital equivalent of the grain in conventional film. A digital camera at the low end of the range captures an image size of 320 x 240 pixels, while a top-of-the-range professional 35mm camera is capable of about 3,000 x 2,000. Large-format scanning-back cameras can capture about 6,000 x 7,500 pixels, but the subject has to be completely still and lit by a constant source. As always, the quality of the final image depends on the lens you are using, whatever equipment you have.

If the images are only going to be viewed on screen and there is no demand for detail and color accuracy, then the least expensive digital cameras will do, but this is not real photography. If your images are destined for print, you will need higher resolution, but remember that the higher the resolution, the fewer the number of images that can be stored in the camera. All the better quality digital cameras have more than one setting for taking pictures – high, fine, normal, or basic.

A good example of a mid-range digital camera is the Fujix DS 330. This looks like a conventional camera, has autofocus and a quality 35-105mm zoom lens, and can be used manually or programmed. With the extension unit, images can be downloaded directly to a PC or a color printer.

The top-of-the-range professional digital camera is the standard setting Canon/Kodak DCS 520, popular with photojournalists and newspaper photographers. This camera is based on the Canon EOS body and takes all the Canon lenses. The image quality is high and the camera can shoot a burst of 12 frames with full two megapixel resolution. The digital file operates at the equivalent of ISO 200 to 1,600 but when using fill-in flash sometimes overexposes. The viewfinder is full field and a color LCD on the camera back allows instant review of the shots. Unsurprisingly these cameras cost a lot of money!

The digital photographer

Digital cameras now make it possible to shoot, view, and transmit pictures across the world in seconds and see the picture in print in hours. But in order to do this, today's photojournalist has a new array of gadgets to carry and must be skilled at handling computer technology. Essential equipment includes an Apple Mac G3 notebook, a satellite mobile phone for speed of transmission, and various leads to power everything, whether by domestic supply, or from car, or battery packs. A pair of sunglasses with contrast-enhancing yellow lenses helps make the images on the LCD screen clearer. Many journalists also carry a digital compact such as the Canon ZR camcorder that shoots stills and a burst of video.

The successful use of digital camera equipment depends on all the elements being in place and working at the right moment. There are still improvements to be made, but this technology that lets you see your pictures immediately is incredibly exciting. It will transform the lives of many photographers, particularly those working in the fields of sport and photojournalism.

The news picture on pages 108–109, for example, was taken on a digital camera, a Canon DCS 520, for Reuters. The medium-size file image was then sent direct to the picture desk in London by satellite phone from the war zone on the border of Kosovo and Macedonia. All the subscribers to Reuters News Service look at the day's images from around the world on screen. From there, the image might be selected for use in a newspaper the next morning or simply stored for future use. A black and white reference print is filed with caption information.

But in the end, whatever equipment you use, taking pictures is a singular, private process. All too often carrying a camera and all its accessories is a nuisance and you wish you could do without all the extras. In digital, as with conventional photography, it is the image that matters.

Digital dictionary

Bitmap – the image produced by a digital camera, made up of dots or pixels.

CCD – a CCD, or charged coupled device, converts light into an electrical current.

Compression – the process of compressing data to speed up transmission time or to make files smaller for storage.

File – a document, such as a photograph, which can be stored on disk.

File format – way of storing information on files. Methods of storage for graphic files include TIFF and GIF.

LCD monitor – the color screen on a digital camera that allows images to be viewed as they are shot.

Megapixel – one million pixels (1,000 × 1,000). See *pixel*, below.

Modem – a device that plugs into the computer and telephone, allowing images or information to be sent via phone lines.

Noise – the electrical interference that can affect digital cameras and disrupt the image, causing colored pixels to appear in the wrong areas. This may happen in low-light conditions.

PC card – a PC card contains a hard disk or modem, and can be used in some digital cameras and laptops.

Peripheral – equipment such as scanner, printer, or camera that connects to a computer.

Pixel – a pixel or picture element is the smallest part of a digitized image.

Resolution – the amount of information in an image, measured in pixels per inch.

Serial link – the connection between a digital camera and computer through which images are transferred.

Square pixel – the pixels used by most digital cameras and computer monitors. These produce a better image quality than the rectangular pixels used by the first digital cameras.

Video output – this facility allows images to be displayed on a television set and to be recorded on videotape.

White balance – adjustments made by a digital camera to ensure color balance.

Travel with the camera

Before starting on a trip, make sure that camera equipment and film are insured for their full replacement value. Many household policies do not cover camera equipment abroad, nor if it is left in a car.

In a hotel where security is suspect, use a sturdy cycle lock to fix the handle of the (locked) camera case to the plumbing. Remember, too, that an obvious camera case might attract the attention of thieves. Some photographers prefer to conceal their camera bags inside less conspicuous luggage.

Customs

Carry several copies of lists with the serial numbers of cameras and lenses – but the value only on one. Most countries will permit the temporary import of camera equipment up to a certain value for personal use, so declare the equipment to that value. The main concern of customs officials is that goods are not resold in their country. Have a list ready – it saves time and looks efficient. The list will be stamped and attached to your passport. Keep it safe and surrender it on your departure from the country.

Some countries subscribe to the *carnet* system whereby equipment of value may be imported for a limited period without attracting payment of duty. Another way of safeguarding against payment of duty is to arrange with a home bank to lodge a bond covering the amount of duty on the cameras in the main bank of the country being visited. The bond is then cancelled on your return.

The traveller with one camera and two or three lenses seldom has any difficulties with customs, but some professionals have spent weeks trying to retrieve impounded cameras. Avoid such problems by carrying the right papers.

If cameras are bought abroad, keep all the paperwork. Even if equipment was bought at home, carry receipts for everything to show on your return. The customs know by the serial number of the camera whether the batch was officially imported.

The number of cameras and lenses and amount of film that can be imported varies from country to country. Check with a travel agency or with the embassy of the country concerned before travelling with equipment.

All these problems have been greatly eased within the EU (European Union) since customs and border regulations have been relaxed.

Establish a method of captioning pictures and recording exposure details. There is no perfect way, but having a good memory helps.

Tape onto the back of the camera a piece of paper folded lengthways into four; this gives one side per film for eight films. Write a brief description of the shot and exposure details next to the frame numbers. Later, transcribe the information to a master caption book containing other background information. This is a good method to use if there are a lot of difficult names to spell or if several cameras are being used. For electronic cameras, multi-control backs are available that print data such as date, time, and frame number on the film.

The photographer's record sheet, *above*, was styled for use in personal organizers. It has separate columns for film number, type of film, and filter used, description of the shot, exposure, and processing.

Packing

Good pictures come from efficient preparation, which starts with packing. Empty the camera bag and start again from scratch so you know what is in there and where it is. Check that items such as tripod screws, flash leads, filters, and spare batteries have been included. Take extras – pack with the assumption that you are going to lose some things.

Wrong

Correct

Hold the camera in the palm of the right hand with the index finger on the trigger. The left hand supports and maintains focus. Use the right eye; this leaves room to wind on without moving the camera. Use the camera as if shooting a rifle. Make yourself stable, keep elbows in, feet apart. Squeeze the trigger; do not jerk it.

Wrong

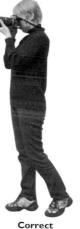

Correct

Set lenses on the widest aperture so there is no strain on the iris, and check that nothing is pressing on levers. These measures do not apply to electronic cameras, which have no mechanical functions. Make sure that spare batteries are not in contact with metal objects.

Cameras are likely to be subjected to bumps and vibration during travel, none of which does a precision instrument any good. Check that the corners of the camera case are well padded to give as much protection as possible. Most manufacturers now offer worldwide guarantees so if you do have problems, your camera can be repaired out of the country of purchase.

Film

Remove film from the camera when crossing politically sensitive borders; an official may open the camera causing damage to loaded film.

If you run out of film abroad, check that the film you buy is in date. Try and buy from a shop that has a large turnover. "Process paid" film can be processed in a country other than the one where it was bought – as long as there is a plant there. But don't take the risk of expecting the processor to mail the film back to the home country. In most developed countries, one-hour processing machines are fine. Get the film processed and have prints made.

The cost of film varies from country to country. In some countries it is so valuable that photographers have used it as currency. If possible, take what you need with you, or buy from a respectable dealer or duty free shop.

X-ray machines at many airports carry signs which claim that they do not cause any damage to film. In most developed countries this is true. But if in doubt or if you are doing a number of flights and film is likely to be scanned several times, ask for a hand check. In North America they are usually willing to do this, but in Europe you may have to put film through the machine.

Adverse conditions

Cameras need constant loving care and daily attention when are they being used in adverse conditions.

Extreme cold

Most cameras are fine in temperatures down to 4°F (–20°C). If a camera is to be used in temperatures below –69°F (–45°C), the oil should be changed for one of a much finer grade. The normal camera oil congeals at sub-zero temperatures, rendering the camera useless. Once a camera has been winterized, do not use it in normal temperatures; this would cause excessive wear.

Carry camera equipment in a hermetically sealed metal case. Leather, canvas, and rubber lose their natural properties when they freeze. Cold canvas, for example, snaps like a piece of thin wood. Gaffer tape can be used to seal equipment against fine snow, but is only effective down to temperatures of 14°F (–10°C). Take great care when touching metal parts, especially with the face. Skin can stick to the frozen metal and be torn off, causing an extremely painful wound that takes a long time to heal.

Try to keep cameras at a constant temperature; bringing them into a warm room from the cold causes condensation to form inside the camera body. The moisture then freezes on contact with the outside air. Put cameras in airtight plastic bags containing packets of silica gel before bringing them indoors. The condensation will then form on the outside of the bag and not in the cameras.

Cameras worn under an anorak are protected from the weather. But if you start perspiring, the moisture soon freezes on the camera. Snow landing on a camera that is warmer than the outside temperature melts and immediately freezes again. Wind-blown snow can be as fine as talcum powder, so make sure all hinges, cracks, and joints are sealed.

Keep film as cool as the camera. Do not subject it to great changes in temperature; this can upset the color balance. In adverse conditions it is generally best to use amateur E6 film rather than professional – amateur film has been manufactured for a longer shelf life and is more stable. Cold "freeze dries" film, making it brittle, so do not wind on too quickly or the sprocket holes may tear. Wind manually in extreme cold: the sudden movement of a winder can rip film that is under stress. Cold film can be razor sharp so handle carefully.

The light in polar regions causes several exposure problems. In summer it is very bright and clean, but for many weeks there is no direct light. Exposures in cold regions can vary from 1/500 second at f8 with 25 ISO film on one day, to 1/125 second at f4 with 400 ISO film the next. Take every speed of film.

In mountainous regions the light can be so bright it almost goes off the meter scale. Use polarizing and graduated filters to put some form and shape back into areas of snow that are reflecting the light. Keep battery-powered meters inside your jacket and only bring them out when needed. The Luna Six works well in extreme cold.

Desert

Ground temperatures in the desert can be more than 122°F (50°C). If cameras are left unprotected in such heat they become untouchable. Direct sun on a camera may melt the cement and glue holding the lens elements in place, causing them to shift if the camera is jolted. When the lens cools down again, the materials contract at different rates, which can cause permanent damage.

Keep cameras in silver-colored cases to reflect the sun or make a foil covering for a soft bag. Don't place any case on the ground or on a car roof – allow air to circulate around it.

Clean and maintain equipment at night when it is cool. Store film in a metal case with a thick polystyrene inner case that is only opened at night. It will remain relatively cool all day. A camera wrapped in chammy leather at night will stay cool well into the day.

Humid tropics

High humidity is the major problem in tropical conditions. Going between air-conditioned buildings and the humid air outside fogs glass and takes a long time to clear. Keep equipment constantly outside rather than in if possible.

In damp heat, fungus grows on film and leather, stitching rots, and rubber splits. Tiny creatures may even take up residence in cameras. If there is not an electric dehumidifier available, keep camera and film in sealed plastic bags with several packets of silica gel; carry the bags in a hermetically sealed camera case. Do not open rolls of film until needed; seal exposed rolls in plastic containers, also with a bag of silica gel. Dry the gel out periodically by putting it into a domestic oven for a few minutes.

A plastic bag protects the camera from rain, snow, or dust. Cut a hole for the lens and secure it with tape. Keep right hand in the bag, left one outside.

Dust

Electronic cameras such as the F-90 and F5 are well-sealed and should resist dust. Older cameras are not sealed units. Give some protection from dust by applying Vaseline or Nikonos "O" ring grease around the joints of the meter head, lens mount, hinges, and grooves at the back. The dust gets trapped in the grease. Tape over all exterior parts which are not in use such as the flash sync, motor drive terminals, battery check button, and levers. Never apply any form of grease to electronic cameras.

The strong, molded plastic Pelican case is ideal for use in the harshest conditions. It is waterproof, dustproof, insulated against cold and heat, and it even floats on water.

Sea water

Salt water and even salty sea air can cause permanent damage by corroding the metal parts of a camera. The best protection against sea water damage is to insure the camera; if it falls in, claim for a new one as nothing much can be done to repair it.

If a camera is exposed to spray, wipe the metalwork periodically with a swab of lint lightly soaked in WD40. Keep it off the lens and apply sparingly. The use of toughened plastics in most modern cameras has reduced the amount of metal and they are less at risk from corrosion.

An inflated inner tube provides much needed stability when shooting from a low angle in the water. The elbows are supported, leaving the hands free to work the camera controls. The head is kept higher out of the water than with just a life jacket.

Clothing I

The ideal jacket is comfortable, keeps you warm and dry, and has plenty of pockets for carrying equipment. The lightweight U.S. Army combat jacket, *right*, is perfect and there are now custom-made photographers' jackets with similar features, although some of these have more pockets than necessary. All are of light, natural fiber, and have deep side pockets and inside pockets that can be securely fastened. A hood folded into the collar is a useful feature and also gives good support for the camera strap around your neck. A standard safari or bush jacket is also suitable, but is more expensive and may be too tailored.

Whatever type of jacket is chosen, make sure it is loose fitting and avoid manmade fibers. All pockets should be secure. Velcro tabs are excellent – they are quick to use and noisy, which may discourage pickpockets.

Extra pockets can be added on the sleeves. This may sound an unlikely place for a pocket, but it is easily accessible and the bulk doesn't get in the way. Inside pockets should be deep. Put a handkerchief and a chammy leather in with small things to stop them bouncing out.

Keep all official passes handy. If called upon to show a pass, it is more impressive to find it first time rather than search around for ages. Some people wear trousers with pockets on the thighs for documentation and maps.

Jeans are fine, unless conditions are wet and cold – then they are uncomfortable. Trousers should be strong, since time may be spent kneeling or even lying on wet or rocky ground. The knees always seem to wear out first.

Wear cotton shirts with high collars, so camera straps don't cut into the neck, and good breast pockets for money, passport, and other important items. Wear a money belt around the waist if you feel really vulnerable.

Avoid military-style clothing in politically sensitive countries. Some people associate cameras with spies, so try to look like a tourist. Officials, armed or unarmed, are the same the world over: they are suspicious of photographers. So if you really want an official to be on your side and to do a favor for you, don't dress outrageously and try to give a good impression. Remember, it is the picture that counts.

A few other tips learned from bitter experience. It is better to have things in separate pockets rather than everything jumbled up in one. Really long hair can get tangled in camera straps or in the way of the lens. Photographers tend to be on their feet most of their time so good footwear is vital. You can't afford to slip and sprain your ankle when out on your own with heavy equipment. Make sure shoes are sound, comfortable, and well broken in. Wear woollen socks in most climates and cotton in the heat. Nylon socks can cause blisters and aching feet.

The Banana Republic waistcoat is loose fitting and comfortable for hot climates, in which a jacket would be too warm. It has eight well-distributed pockets, with ample room for all the items on the opposite page. There is also an additional pocket on the back of the waistcoat in which a lightweight anorak can be carried in case of rain.

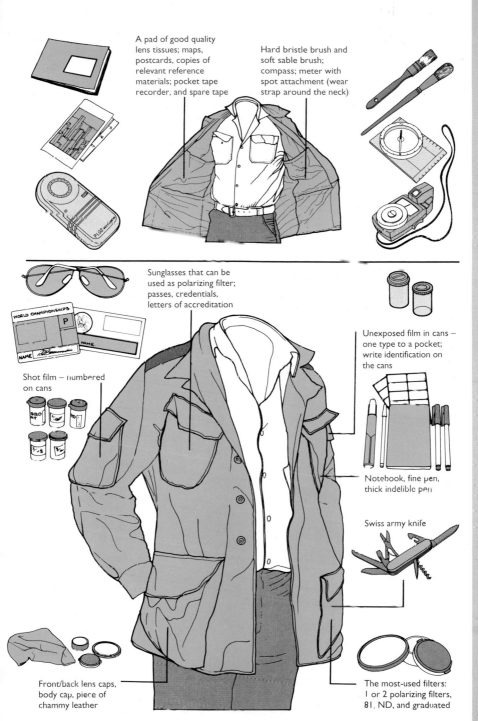

A pad of good quality lens tissues; maps, postcards, copies of relevant reference materials; pocket tape recorder, and spare tape

Hard bristle brush and soft sable brush; compass; meter with spot attachment (wear strap around the neck)

Sunglasses that can be used as polarizing filter; passes, credentials, letters of accreditation

Unexposed film in cans – one type to a pocket; write identification on the cans

Shot film – numbered on cans

Notebook, fine pen, thick indelible pen

Swiss army knife

Front/back lens caps, body cap, piece of chammy leather

The most-used filters: 1 or 2 polarizing filters, 81, ND, and graduated

Clothing 2

When setting out to take pictures in cold or wet weather, always dress for warmth and comfort. You will work all the better for it. Bear in mind when shooting outdoors that long periods may be spent waiting for the right moment, so be prepared. Respect nature, it always has the upper hand.

An anorak is a good all-weather garment, but always carry a three-quarter length windproof jacket (or waterproof), too. A cold wind can be lethal. When the chill factor is taken into account, the temperature may be more than ten degrees lower than indicated by the thermometer.

Zip cameras up inside the jacket to keep them warm and dry. Keep the batteries warm. With some cameras, it is possible to keep the motor drive battery pack in a pocket with a short cable connecting it to the camera.

Never carry too much equipment. Energy is needed to keep warm. In wet, dew, hill fog, or condensation, keep the camera parts protected in plastic bags and off the ground.

Genuine Harris Tweed trousers give excellent protection against wet or cold. They are always warm and the material dries quickly in the wind. Specialist climbing stores now offer many types of light thermal clothing for keeping out the cold. Keep waterproof footwear and a large golf umbrella in the car at all times.

A good coat is the first line of defence against bad weather. The layers beneath

Wear good quality training shoes with non-slip soles if weather permits. You must be sure-footed when carrying equipment.

A fisherman's sou'wester worn back to front gives good protection from the rain when using short lenses.

Bumbag

Carry a lightweight, showerproof anorak; useful for protecting both camera and photographer in a sudden shower.

An extra anorak can be used to cover a camera mounted on the tripod. Carry one small enough to pack into the belt of a ski "bumbag." When folded, the anorak also makes a good ground sheet.

keep you warm as long as the coat is made of strong, tightly woven fabric to keep out the wind and rain. The Berghaus/Gore-tex coat, *below*, is an excellent example. Windproof and waterproof, it keeps the wearer warm but allows the body to breathe. Coat zips should have Velcro seals to stop the zip freezing. The hood should have wire around the face area so that you can bend the opening into a slit and get maximum protection from the wind.

In extreme dry cold, wear a goose down suit, *below right*, with a windproof Berghaus/Gore-tex coat over the top.

Thermal underwear

Fiber-pile suit

A woollen balaclava does not impede vision and can be rolled up into a hat.

Thermal underwear, *top left*, designed for climbing, allows perspiration to pass through to the next layer of clothing.

The Helly Hanson or North Cape fiber-pile suit with hood and jacket, *top right*. The cuffs hook round the thumb, keeping the wrist warm.

Helly Hanson mittens allow the thumb and fingers to "pop out," so re-loading is no problem.

Water/windproof Gore-tex overtrousers can be taken off without removing boots.

Heavy-duty, waterproofed canvas gaiters keep the snow from packing into boots.

Wear boots, not shoes, in cold weather. Boots should have cleated Vibram-type soles that give good footing on most surfaces.

A duvet jacket made of goose down is light and extremely warm as long as it is kept dry, but is useless if wet. Wear under a waterproof Gore-tex coat.

Medical and legal

MEDICAL ADVICE
Allow as much time as possible to undergo immunization before travelling to exotic places – some courses of immunization may take up to two months to complete. Check with your doctor or travel clinic. Immunization is only part of the protection against infectious diseases. Try to follow the tips below:

Food- and water-borne diseases
Avoid by drinking only bottled or filtered water. Beware of foods such as washed salad, unpeeled fruit, ice cubes, and raw meats or seafood.

Traveler's diarrhoea. No immunization. Fluid replacement is the main treatment. Oral rehydration sachets are better than water alone, or use a teaspoon of salt and eight teaspoons of sugar in 1.8 pints (1 liter) of water. Some doctors give antibiotics to hasten recovery.

Typhoid. Symptoms include fever, headache, and stomach pains. Immunization available but is only 80 percent effective.

Cholera. Symptoms include profuse watery diarrhoea. Immunization is not effective and not recommended by the World Health Organization. Although it is not an official requirement for entry to any country, not all officials know this, so be prepared to produce evidence.

Hepatitis A. Symptoms include fever followed by jaundice. Immunization covers you for one year and a booster gives 10 years cover.

Insect-borne diseases
Malaria. Transmitted by mosquito bite. Avoid by using insect repellents, protective clothing, netting, and antimalarial pills. Start the pills one week before departure (in case of side-effects) and continue for four weeks after return. Always obtain the latest advice on the best medication as drug resistance is a major problem.

Yellow fever. Transmitted by mosquito bite. There is no specific treatment and non-immunized travelers risk a 50 percent death rate. A single dose of vaccine confers immunity for at least 10 years.

Japanese encephalitis. Transmitted by mosquito throughout Southeast Asia. Take expert advice.

Tick-borne encephalitis. Transmitted by ticks found in heavily forested parts of Central and Eastern Europe and Scandinavia. Take expert advice if you are going to be traveling through thick undergrowth.

Other serious infections
Hepatitis B. Transmitted sexually or via blood to blood contact. Vague, flulike symptoms are followed by jaundice and there is a risk of chronic, even fatal, liver damage. Immunization is available.

Poliomyelitis. A viral infection transmitted by breathing in or ingestion, especially affecting children. Oral polio vaccine requires a single booster every 10 years for travel to high-risk areas.

HIV/AIDS. Transmitted sexually or via blood to blood contact. For protection, use condoms and carry a travel kit with sterile swabs, needles, and syringes.

Rabies. Transmitted by bites from infected animals. Symptoms include numbness around the bite site, fever, and headache, followed by hydrophobia, spasms, hallucinations, paralysis, and death. Immunization can take place before travel, with a booster after two to three years. If bitten, the bite site should be scrubbed with soap and water as soon as possible, doused in antiseptic (or 40-70 percent alcohol) and medical help found within 24 hours. If you are not immunized, you will need five doses of vaccine (possibly with immunoglobulin as well). If immunized, two booster doses will be given.

Height, heat, and cold

Acclimatization to heat and altitude takes some days. As you acclimatize, fluid requirements increase, but salt tablets should not be necessary except in extreme conditions.

Acute mountain sickness. Symptoms include headache, nausea, dizziness, and vomiting then fluid on lungs and brain swelling. Lessen the risk by making a gradual ascent. Acetazolamide (diamox) obtained prior to travel may help to prevent the mild symptoms, but only descent to low altitude will stop life-threatening symptoms.

Cold. Local effects include frostbite, preceded by frost nip. Onset is usually painless but recovery is painful. Massage and rub the affected area to re-warm. Cold feet may lead to trenchfoot.

Hypothermia. Disorientation and lethargy can be followed by descent into gradual coma. An emergency plastic body bag to prevent evaporation is more effective than a metallized space blanket. Avoid too rapid re-warming.

LEGAL ADVICE

In most Western countries, there are no restrictions on taking pictures in public places. In Britain, the 1988 Copyright, Designs, and Patents Act introduced a limited right of privacy. Where pictures are commissioned for private use, the person commissioning the work has the right not to have the work published or shown publicly, even though, in most cases, copyright will be vested in the photographer. Other countries have more extensive privacy laws, and in some, such as the United States, France, and Germany, a person's image cannot be used for merchandising without their consent. If a photograph is used which suggests that a person endorses a product, he or she may have grounds to file suit against the photographer. In France, a householder's privacy is invaded if a picture of the house is used without permission.

When taking portraits, a model-release form signed by the subject, and specifically including a waiver of the subject's right of privacy, is the photographer's best protection. This should cover all eventualities such as the finished print being retouched, digitally changed, or incorporated into a collage. The more comprehensive the release form, the less chance the model will have to sue. Whenever a paid model is used, a contract should be drawn up that includes a section in which they waive all rights to the picture.

Photographs of people in public places can be used for most artistic or editorial purposes, but in some countries the subject's consent is required if the picture is to be used for merchandising purposes.

Pictures shot in private places such as theaters, sports arenas, and private houses are a different matter. Under local bylaws or conditions of entry, a person taking photographs may be guilty of trespass and in some places equipment can be confiscated. In most British art galleries, photography is not permitted; some European and American galleries do allow pictures for personal use only to be taken.

Work should never be submitted to an agency or publisher without a delivery note with terms clearly stated. Draft contracts are available from the national unions that represent photographers. Fees for use and penalties for damage, loss, or delayed return should be stated. The client's signature is needed for the photographer to make any claims.

Faults on film

Sometimes when a roll of film comes back from processing it includes pictures which do not look at all like the ones you remember taking. The faults discussed here are common to all cameras and all types of color and black and white film. Even the most seasoned professionals make mistakes occasionally, but with a careful and methodical approach, these faults can usually be avoided.

The photographer must be familiar with his or her equipment, but not to the point of contempt. The shots that are ruined are too often those you most want.

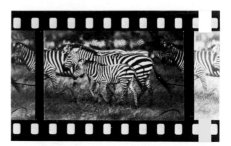

Hair can get into the back of the camera and lodge in the track that the shutter runs in. A similar, less sharp image appears if a hair is caught on the back of the lens. Check both areas when reloading film.

Unsynchronized flash occurs when too fast a shutter speed is used – usually more than 1/250 second. Check that the shutter speed dial is not accidentally moved during use. Most modern SLR cameras sync at 1/250 or slower with all types of flash.

Shutter bounce can happen with old cameras and is caused by a slack spring on the shutter. When the shutter bounces back after an exposure, a fraction more light is allowed onto the film. This is an easy fault for a dealer to repair.

Fogging is what happens to the film if the back of the camera is opened. Wind film back after exposure. If the back is opened, five or six frames are usually lost. Tape the back shut if it is likely to pop open accidentally.

Double exposure. Even if you have several bodies, it is sometimes necessary to change films in mid-roll. To avoid double exposures, write the number of shot frames on the leader of the partly exposed film.

Motor drive fault 1. The motor has fired twice. With modern cameras this only happens at the end of a roll – on frames 37 and 38.

Motor drive fault 2. The film has wound on while the camera shutter was open. The result is that the film is transported during the exposure making the highlights streak.

Raindrops on a lens act like small lenses and distort the picture. They are most noticeable on wide-angle lenses as individual drops, but on longer lenses they appear as blurs. Use a UV or 1A filter and a big lens hood in the rain.

Vignette is a rounding of the frame corners caused by using the wrong lens hood or fitting too many filters. Bellows can also cause vignetting if they are extended too far. Check with the preview button, looking at a light area.

Flare occurs when a hard light shining directly into the lens either projects the shape of the aperture opening, *left*, or creates rings of light and loss of color by overexposure. Wide aperture telephotos are most susceptible and may need a French flag to mask light.

If exposed film is black it may not have been loaded properly and has not gone through the camera. Another cause of this fault can be that the shutter is not in sync with the aperture of the camera, and no light is hitting the film.

If exposed film is white but with black lines between frames, too much light has reached it. The shutter is staying open too long and is faulty or the aperture is not stopping down.

Processing, printing, and paper

The best way to get consistently good results from your film, whether you shoot color negative, transparency, or black and white, is to build up a friendly relationship with a local professional laboratory. They are usually willing to take time to discuss the results and it is amazing to see what a good printer can do with an average negative. If the picture is destined for the wall, it is well worth the extra cost, but good processing benefits any type of photograph.

The one-hour service offered by mini-labs for processing color negative film usually gives good results. If there is a problem with the prints, is is usually because the film used was old or badly stored. And even if the machine prints are disappointing, they do give you the chance to sort through the pictures and chose the best for hand prints.

Transparency film can be "push" processed. In effect, "pushing" alters the ISO speed of the film upward – for example, ISO 100 pushed one stop becomes 200. The more a film is pushed, the more grain and contrast it will have. Despite this, however, you may be forced to "push" if the picture has been taken in low light. Film can also be "pulled," reducing the ISO – for example, ISO 100 pulled one stop becomes ISO 50. Pulling reduces contrast and "flattens" the image.

Hand processing of E6 film is rare today. All E6 processing is done by machine to ensure quality control.

Home processing is still popular and is much easier and more successful if you have a proper darkroom rather than trying to work in a makeshift lab in the bathroom! Printing color or black and white yourself is the best and most satisfying way of learning the craft of photography. When you do your own processing you can imagine the photographic print in your hand as you take the picture. In most cities it is now possible to hire darkrooms by the day.

CHECKPOINTS

- Pushing E6 films warms the color. Cutting by more than one-and-a-half stops causes whites to become bluish. Some laboratories produce warmer results than others.
- Take a clip test (two or three frames from the front of the roll) and calculate the amount of push or cut required to balance the color. Send the remaining film back immediately. The color balance of chemicals may alter over time, although the laboratories do moniter the situation.
- Processing color negative film is not complicated but requires greater attention to time and temperature control than black and white film does. Half the fun of negative film is that the user can do his or her own processing and printing, and so exercise greater control over prints.
- Black and white processing is simple. It requires little equipment but lots of care. The effective speed of all black and white films can be altered by changing the development time. The contrast is also affected by the development time, the temperature of the developer, and the amount of agitation. But whether processing your own film or using a lab, there is no point pushing up the speed – and the grain and contrast – of a slow film if a faster film can be used for the picture in the first place.
- There are many developers on the market. A few of the most useful are: Ilford Hyfen for the sharpest results and fine grain on slow films; Agfa Rodinal for high quality at any speed – this is a one-shot developer that is thrown away after use; Aculux for the best possible grainy effect; and Acuspecial for best results with high-speed film. T-Max developers are good for other films as well as T-Max.

Paper

Many types of paper are now available, each with a particular property and characteristic that enhances a picture. This is what photographers refer to as "print quality."

Fiber-based black and white paper is produced by the major photographic manufacturers and by small companies making specialist papers for the fine art photographer. These papers are designed to be printed, fixed, and washed by hand. They come in many finishes, textures, tones, and contrasts and are graded 1 to 5 or variable contrast.

Resin-coated black and white papers give similar results to fiber-based, and are often preferred, although there is less choice. Resin-coated papers are designed for rapid processing, either by hand or machine. They take only 60 seconds from dry to dry, compared with 25 minutes for fiber-based prints.

Color paper. C-type color negative film is usually printed on color paper, either by machine or by hand. Color and contrast are easy to control.

R-type. A reversal paper designed to produce prints from transparencies. These papers tend to produce more of a contrast, as do transparencies, so choose pictures that work with the paper's characteristics. Results with the right transparency are good and cost-effective.

Cibachrome. A silver-dye batch process that produces excellent artwork prints from transparencies onto a tough plastic paper. Use a professional printer for the best results.

Dye transfer. This method can be used for making prints from negatives or transparencies, but is expensive and rarely used today. However, it is the finest of all the color printing processes.

Photocopy prints can be speedily obtained from transparencies or from another print. The finish is not photographic, looking more like a newspaper or magazine, but photocopies are cheap to produce and have a quality of their own.

Laser copies are scanned five times so the resulting image is more true to the original than a photocopy but still has the look of a magazine picture. These can be output to any size and are good for reference and for use in portfolios.

Inkjet prints are produced from a digital file, the paper and ink making a print that looks photographic. The superior iris process produces impressive prints. The home computer printer inks are not as permanent as true photographic prints, but new Lyson Inc inks are archival quality. Many types of papers and finishes are available, including inkjet paper specially for pictures taken with a digital camera.

Fuji Pictography produces impressive photorealistic prints using a dye transfer process from a wide range of digital image data. No chemicals or toner are needed and prints of up to 12 x 18 in (5 x 20 cm) at a resolution of 400 dpi can be made in two minutes. This is the print process of the future.

Advantix gives you a choice of three print sizes when you take the picture. The prints come back in a box – there is a lot of packaging – that includes a sheet of thumbnails of your pictures and the film in case you want to re-order. Apparently, this practice has confused some people, who try and reload the exposed film.

Transparency mounting by machine

An electric eye on the machine uses the black line between the frames as a guide to cut the film.

If a picture has a strong overall black background with an offcenterimage, there is a danger that the machine may center the image and cut the film in the wrong place. Further into the roll, pictures may be mounted with the frame line running down the middle, cutting the picture in two. To avoid this happening, mount it yourself.

There are machines which will print a limited amount of caption information on the slide mount.

Toning

Toning is for those who are fascinated by the craft of photography and the fine art aspects of a photographic print. Even an indifferent picture can be enhanced by successful toning and a good picture can be made into something really special.

Before toning, a print must be completely fixed and thoroughly washed to avoid stains and other faults. For sepia toning and any techniques that involve bleaching, prints should also be washed between bleach and toner. Copper and blue toning both leave a fine sediment on prints that becomes more obvious as they dry. Avoid this by sponging the face of prints during the final wash. Selenium can also leave a sediment and should be treated in the same way.

Sepia toning converts the silver image of an ordinary black and white print into brownish silver sulfide. The exact color depends on the paper and type of development used. Toning with sepia makes images very permanent, since silver sulfide is one of silver's most stable forms. The process involves bleaching, washing then toning. The bleach supplied with commercial sepia toners changes the silver image to silver bromide, which is then turned into silver sulfide by the toning solution.

Sodium sulfide was traditionally used in toners, but other sulfur-bearing compounds, without the 'bad egg' smell of sulphides, are now generally preferred. All sepia toners result in a small loss of image density which can be compensated for by overexposing at the printing stage.

Selenium toning partially converts the black silver grains to reddish silver selenide. It gives a purplish color on warm-tone papers, but there is no significant color change with cold or neutral-tone papers. Selenium toning does not give quite the same permanence as sepia, but it is often chosen for pictures that are to be archived, since it does not change the image color.

Blue toning works by depositing ferric ferrocyanide (Prussian blue) on to the silver image. It can give subtle or very

Blue toning is particularly suitable for portraits of men. It adds character and gravitas and flatters the skin tone.

Sepia toning on this picture of the Chapter House at Wells Cathedral, England, takes on the quality of the old stone and adds a pleasing depth and glow.

strong effects which are controlled by the dilution and the time of treatment. Prints are removed to the wash when the desired effect is seen.

Copper toning is similar to blue toning in that it deposits copper ferrocyanide onto the silver image, but while blue intensifies to some extent, copper gives a small reduction in image density. Short toning times produce a purple-brown color, which becomes more pinkish as toning progresses.

Gold toning plates the silver image with metallic gold and is also used for archiving, although it gives lower protection than either selenium or sepia. The gold is of a subtle blue color because of the finely divided state of the silver deposit, but, like selenium, it does not produce a color change on cold or neutral-tone papers. It may give a slight increase in shadow densities.

In general, the strongest blue tones are obtained with warm-toned images. Gold gives good yellow-orange to red tones on all papers if used after sepia toning.

Split toning occurs when toners and bleaches work most rapidly on a print's lightest tones, so that where it is bleached or incompletely toned, the lighter image tones are affected to a much greater degree than the darker ones. This happens with most toners and bleaches. With sepia, for example, if bleaching is stopped when

only the tones up to the lighter mid-tones have been fully bleached, only these will turn brown in the toning solution; shadows will remain black. If, after the solution, the print is transferred to another toner, this will act only on the darker tones, which still contain a proportion of silver, to give a two-color print. This works with many toners, but it is not very effective with a blue toner

or with selenium on warm-tone papers. Used after sepia, a blue toner tends to turn all image tones greenish, whether or not they still contain any silver, and selenium turns sepia tones reddish so that any split-tone effect is likely to be lost if it is also toning the shadows red. Gold is effective after partial sepia toning, giving pinkish highlight tones with bluish or neutral black shadows.

Filing and viewing

Devise an orderly filing system for your negatives and transparencies so that you can always find pictures easily. Feed new pictures into the system as soon as they are processed.

Number all the negative bags, keeping each film in a separate bag. Keep a record of the numbers in a notebook or on computer. Add brief descriptions of the shots on each roll of film.

Write as much information as you have on the bag and make a contact sheet of each film. Write the film number on the back of the paper before processing. A 36-exposure roll fits onto 10in × 8in (25cm × 20cm) paper if the film is cut into strips of five or six frames. File the negatives away consecutively in boxes or files, and keep the contacts separately in another file. The contacts are then available for easy reference. Do not allow the master file of contacts out of the house or studio at any time.

There are many designs of negative bag on the market. One of the best is a clear acetate divided sheet that takes a complete film in strips and has a caption panel at the top. The film can be contacted while in the sleeve and filed on a hanger in a filing cabinet.

This system is particularly useful if space is limited, but it is still advisable to keep contacts in a separate file, for two reasons. First, it takes an experienced picture editor or darkroom printer to read negatives; second, as any professional photographer will attest, it is useful to be able to look through the old contact file occasionally – you may discover good shots that had been overlooked.

Advantix film is returned with an index print of all the negatives which makes identification and re-ordering easy. Most processing houses will now provide an index print for ordinary 35mm film if you ask.

A negative folder is a simple and efficient way of storing your negatives. Sleeves for any size of film are available from good photographic stores. Don't pack the sleeves too tightly – the negatives need some air. If possible, file contact sheets opposite the negative sleeve. If you remove the contacts to send to anyone, photocopy the sheet first so you have a record.

An index print of all your negatives is automatically returned with Advantix film.

Pictures can also be scanned into a computer, and stored on disk or CD-Rom. The negatives need never be touched.

The best files for transparencies are the plastic sheets with pockets for holding 24 or 20 individual slides. There are two types. One has punch holes on the side for filing in a ring binder. The other has a large protective flap covering the front and a strip at the top that allows it to be hung directly in a filing cabinet. Such sleeves allow easy viewing of slides in series and provide quick access to the best shots. Keep rejects in boxes and, as with contacts, look at them occasionally. There will often be one or two pictures which, on a second look, seem worth rescuing from obscurity.

Viewing transparencies

The best way to view transparencies is on a light box or projected onto a screen (see p. 220). There are many excellent makes of light box on the market at a range of prices; but it is possible to construct a simple one for yourself, using opaque glass or white acrylic sheet and daylight fluorescent tubes.

A cheap light box, however, does not give a sufficiently accurate light for color judgment. Transparencies for reproduction should be viewed on a printer's light box, which provides controlled illumination. The light tubes are monitored and replaced after a fixed period.

Use a good eyeglass lens to look at transparencies on the light box, although ready-mounted slides can be viewed on battery or electric-powered hand viewers. The best lens for viewing transparencies is the Schneider magnifier. This high-quality lens allows the full 35mm frame to be viewed. There are many other types of viewer now available, but most let top light through onto the transparency, which diffuses the image.

When transparencies are returned from the processor, put them in the box the right way up. Draw diagonal lines across the top as a guide to restacking them.

A **transparency light** box should be fitted with colour-corrected fluorescent tubes. These give an even, overall light and do not overheat. The Schneider 4X wide angle loupe covers the whole 35mm frame. The Agfascop viewer is an essential aid to selecting slides.

Put the selected slides into acetate covers, file in plastic holders, and hang them in a cabinet.

Consecutive numbering stamps are useful for giving each slide the same number as the one in the notebook. Have another stamp to identify the slides with the photographer's name.

Projectors

The very best way to see and appreciate photographs is as large, high-quality reproductions in a well-printed book or magazine. Next best is to view them well-projected onto a large screen in a darkened room.

A transparency that looks insignificant on a light box may become much more interesting when projected and seen large. Detail and close-up shots usually look more dramatic when projected.

A slide does not begin to discolor until it has been projected many times. Do not project favorite pictures for too long in a projector that does not have a built-in cooling system: they might melt before your eyes – an interesting but distressing experience.

Black and white prints copied onto Fuji film become steely, which adds to the quality of the projected image.

The best sort of screen to project on is one that gives an even reflection all over, not just on the light path where a hot spot is created. Modern super-white emulsion paints have a reflective ingredient in them and are suitable for painting an interior wall for use as a screen. Conventional screens have a dark border; this could be painted onto the wall to help contain the projected image.

The Kodak Carousel has not altered in its basic design for many years. This projector is one of the most popular for audio-visual programmes, some of which run continuously for many days. The Carousel is also used for large studio back projections, and has a cooling unit to prevent the slides from melting.

Most major advertising agencies, conference centers, and educational institutions use Carousels. The projector is supplied with a remote unit which controls the focus and picture change – both forward and backward. There is a

Kodak Carousel

The Carousel magazine can only be changed while the machine is switched on. Turn the counter to 0 before attempting to remove it. Make sure the spring clip is in place at all times.

Back projection unit/light box

range of lenses to choose from. Carousels are available worldwide and can run off all types of electricity supply.

The Carousel tray holds 80 or 140 slides. To empty the tray of pictures, turn it upside down, allowing the slides to fall into the lid. With a slight twist, open it and run a finger around the tray, stacking the slides into blocks. This is much easier than taking the slides out individually.

The Kodak stack loader is a projection unit similar to the Carousel, but with automatic focus. It will take the circular Carousel tray, as well as the stack-loading magazine. The slides are put into the leader as a block, making it useful for editing material straight from the laboratory. This model is only made to run off 110V electricity.

The Leitz Pradovit projector has a similar design to that used by Rollei, Agfa, and several other manufacturers. They use trays holding either 36 or 50 transparencies, which are cheap and good for storing slides when not in use.

Back projection units are loaded with the slides the right way up and the emulsion facing the screen – the opposite way to a conventional projector. As with the Leitz, the transparencies are fed into the projector in straight trays.

This type of unit is useful when editing transparencies and for tabletop presentations as the viewing room does not have to be blacked out. As with all back projection units, the texture of the fresnel screen is visible when viewed from an angle.

Size of lens and distance between projector and screen image needed to achieve approximate width of screen image

Width of screen	40ins 1.02m		50ins 1.27m		1.52m 60in		1.83m 72in		2.44m 96ins		3.05m 120in		144ins 3.66m	
image:														
Focal length of lens:	Distance between screen and projector to give above screen sizes													
	ft.	m.	ft.	m.	ft.	m.	ft.	m	ft.	m.	ft.	m.	m.	ft.
60mm	6	(1.83)	7	(2.13)	9½	(2.9)	10½	(3.2)	14	(4.27)	17½	(5.33)	21	(6.4)
85mm	8½	(2.59)	10½	(3.2)	13	(3.96)	15	(4.57)	20	(6.1)	25	(7.62)	30	(9.14)
100mm	10	(3.05)	12½	(3.8)	15	(4.57)	18	(5.49)	23½	(7.16)	30	(9.14)	35	(10.67)
150mm	15	(4.57)	19	(5.8)	22½	(6.86)	27	(8.23)	35	(10.67)	45	(13.72)	53	(16.15)
180mm	18	(5.49)	23	(7.01)	27	(8.23)	32	(9.75)	42	(12.8)	53	(16.15)	64	(19.51)
250mm	25	(7.63)	32	(9.75)	37	(11.28)	45	(13.72)	59	(17.98)	75	(22.86)	88	(26.82)

Kodak stack loader

Leitz Pradovit

PRADOVIT C 1500

Copying

Bowen's copy stand. The camera screws onto an extension arm which brings it directly over the center of the artwork. It can also be moved up and down the column. Even lighting is ensured by the four adjustable lights. The complete unit can be made secure by screwing the bracket at the top of the column to a wall. This eliminates camera shake on long exposures.

Despite all the scanning technology, there is still a place for the photographic copying of images such as paintings or other non-scannable items. A precise task which requires care and concentration, copying is a good technique to master. You can use a copy stand to hold the camera or simply fix the item on a wall or a stand such as an easel.

If working with a copy stand, use a spirit level to ensure that the flat artwork and the camera are perfectly square, then mount the camera directly over the center of the original.

Position lights on each side of the camera, at the same height and at 45° to the painting. If the lights are too close to the artwork, they will create reflections on the surface. They must be balanced to give exactly the same exposure from each side. A good method of checking the position of the lights when setting up is to place a matchbox or pencil in the middle of the artwork and move the lights until the shadow is exactly the same on each side. To be sure of achieving correct exposure take the reading off a gray card.

Reproducing the color balance of the original is critical. Shots taken on color negative film can be corrected at print stage. Place a color scale and a gray scale, obtainable at photographic shops, at one side of the artwork. The printers can then match these scales to their own to achieve correct balance. Color and gray

scales can also be used with transparency film to achieve the correct balance on the reshoot.

If the object being copied has a reflective surface, it must be placed facing a black wall or card, or the reflection of the camera and photographer will appear in the picture. The camera must also be wrapped with black cloth and the photographer should dress in black.

Use a yellow filter with black and white film to make yellowish stains disappear. Faded images can often be revived with yellow (which increases contrast by lightening light areas and darkening the darks) or a blue filter, which also increases contrast. The yellow filter works better on sepia-toned pictures and the blue on more black and white pictures. Faded edges can be corrected in the darkroom by giving them more exposure than the rest of the print.

A copy was made of this painting for the owner to send to a museum for authentication. The glass was removed and the painting fixed on a stand that was made absolutely vertical. The painting was then photographed in daylight on color negative film and bracketed.

Artwork can be copied straight off a wall, as long as the camera is parallel with it. Place a spirit level on top of the camera to check that it is level. Use a pencil or matchbox, *right*, to judge the light level. Make sure the density of shadow is the same on both sides.

Mounts and frames

A mounted transparency is much easier to handle than a loose piece of film and can be stamped with identifying marks. Up to five lines of text can be put onto the mount to identify the picture. Process-paid film is returned to the customer cut and mounted. Kodachrome comes in cardboard mounts; Agfa and many commercial labs use plastic. Film processed by a commercial laboratory usually comes back unmounted but can be mounted at extra cost.

Professionals who shoot many rolls of film on an assignment usually prefer to select manually, cut the best frames from a strip, mount them, and then store the rest. Always use the mounts the same way around, with the emulsion side on the same side of the mount. The emulsion side of Ektachrome film is the less shiny side.

Frames

A huge variety of picture frames is now available, ranging from simple perspex to decorative antique examples. Most are suitable for photographs, but it is essential to marry the right picture to the right frame. Small, stand-up frames have always been popular for family pictures,

Photographs do not need ornate frames – the simple aluminum style, *left*, is readily available and suits most images. Stores offering a selection of do-it-yourself frames, mounting boards, and a quick framing service have proliferated and are now a feature of most shopping malls.

A flip chart, *left*, is a simple yet effective way of displaying family pictures. Have one on your desk and turn to a different photograph every day.

but try enlarging your favorite pictures and putting them up on the wall. Select the best from your holiday photographs and display those too; an ordinary small print often comes to life when enlarged.

Such pictures do not need complex framing – a simple aluminum frame complements most images. Always use mounts. Framing shops supply the board and will cut mounts to size for you. And don't feel that once a picture is framed it has to stay there for ever. Get other prints of the same size and ring the changes.

Framed pictures usually look more effective when grouped on the wall.

Don't just hang them square but arrange them in pleasing shapes; try your arrangement out on the floor until you get it right. Make sure the lighting is good. Don't hang glass-fronted pictures opposite a window unless non-reflective glass is fitted to the frame.

As well as framing individual prints, try grouping small prints in a frame. Cut a window in a mount for each picture or simply use a collection of machine prints like a collage. A selection of pictures of a wonderful holiday or even from different stages of someone's life can make the most wonderful gift.

Frames for displaying a group of images allow you to make interesting juxtapositions, *left*. Use your own pictures or group postcards of work from different photographers or from different times. Framed photographs are now seen much more as art, worthy of a place on the walls of homes and public places, like hotels and restaurants.

To make a successful collage, *above*, of a family event such as a holiday, you should think about the look you want when taking the pictures. Aim for variety – close ups, big pictures, and small pictures. When you take the film for processing, ask for two sets of prints – one to cut up for the collage and one to keep. Use a sticky-back frame made specially for the purpose or fix the pictures to a board and get a print of the whole thing when it is complete.

Presentation

The potential of photography is only fully realized when finished pictures are presented for others to see – in an album, on a wall as a print, or projected onto a screen. There is no point in taking great pictures that are then stored out of sight or hung haphazardly. Make a conscious effort and think of this as the show business aspect of photography.

A slide show

Before planning a slide show, album, or exhibition, edit the photographs carefully. Selecting pictures requires a different attitude to that needed when taking the photographs. Do not think about how difficult it was to get the pictures or how pleasant the holiday was. Forget the emotional attachment to the pictures and try to select them on their merits.

There is a great difference between choosing one picture to do a specific job and selecting a set to be shown together. Much of the dramatic impact of a selection of shots depends on the juxtaposition of one picture with another. The effect of two sympathetic images added together can be greater than the sum of the two separate pictures. Deliberately jarring images can be placed together to jolt or unsettle the viewer. Experiment with the choice of images to create displays representative of personal taste.

The same disciplines apply whether the photographs are intended to create a mood of anger, joy, nostalgia, eroticism, or fantasy; or just tell a simple story about a holiday, wedding, or sales conference.

Making a portfolio

Professionals make a portfolio of their best pictures to show potential clients examples of their work. Lots of people can take the same kinds of pictures so a portfolio should show your particular skills and individuality.

The portfolio will usually contain laminated copies of book and magazine pages showing published photographs, as well as prints, and transparencies mounted on cards. Laminations are made commercially by sandwiching a print between two pieces of clear plastic and applying heat. The lamination protects the print from damage and also brightens the color under a gloss finish. It is a good method to use when a print is likely to be handled frequently.

Many photographers now also put their portfolio on to a web site. Clients can gain access to their work quickly and decide whether to take a closer look.

For an amateur, keeping a portfolio of current photographs is a helpful way to trace improvements in technique. It gives an end product to all the effort as well as keeping the best work readily available.

A print box is the best way to store and transport loose prints. Looking at prints is still the simplest and most satisfying way of assessing pictures.

A tear-sheet book of spiral-bound clear plastic pages stays looking slick and professional, even though it gets a lot of wear.

Think carefully about how you present your portfolio. Bear the following points in mind:

• Place all the images in the folder the same way around

• Keep the portfolio simple. Don't include too much – most people don't want to look at more than about 30 pictures at a time.

• Include examples of any work which has been published, samples that are relevant to that client, and photographs that are your own personal favorites or characteristic of your work.

• Mount everything cleanly, with one image per page as a general rule. If images are related, as in a sequence set, for example, they could be mounted together.

• A presentation pack should not be so big that it is difficult to find enough desk space to lay it on.

• Keep the viewing of transparencies simple. If art directors can get an overall view of transparencies, they can then pick out those that interest them for closer study. Alternatively, mount them singly so they can be looked at individually.

Dupe your best 35mm transparencies up to 5 × 4 in cm (12.5 × 10) or 10 × 8 in (25 × 20 cm) to make them easier to view.

Web sites allow clients to get an instant taste of a photographer's work without having to send for his or her portfolio.

A CD can hold a large number of pictures and is an easy way of sending your work to potential clients.

Applications

Most of the billions of photographs taken every year are shot on holiday. Processing houses report that their best business is done in the summer months and just after Christmas. But it is a great pity that so much equipment and enthusiasm is not applied during the rest of the year. Photography can add so much to the enjoyment of other pursuits; it can be helpful in a business, give insights into a hobby, or be merely used to record a full and happy life.

People absorbed in their children, their jobs or their hobbies, using cameras to record information and results, can acquire unique collections of pictures. Their *primary* interests are the crucial factor. I know someone who has made a point of photographing different types of grass when traveling round the world on business. Wherever he goes he looks for subjects – desert grasses, grass crops, decorative grasses – and he now has thousands of pictures.

You don't have to be an expert on a subject to take a great photograph relating to it. The camera can be the catalyst between you and your subject, and enthusiasm is often more important than knowledge.

Almost every hobby or business has its own specialist magazines, which usually welcome pictures that may be of interest to fellow enthusiasts. Send your pictures in. If the magazine uses them they may want to see more. No editor will ignore good, relevant photographs. The publication may only be a small trade paper with a limited budget, but getting pictures published is always a thrill.

The number of professions, trades, or interests to which photography can be applied is endless. People in creative areas, such as architects or designers, should be well aware of the potential of the camera, but those in other walks of life can also find photography a useful tool. People who have to travel during the course of their business can find a camera an invaluable notebook, especially if used in conjunction with a pocket cassette recorder. Realtors rely on pictures to create initial interest when selling houses. A good photograph of a building makes a positive impression and attracts more attention from customers than a poor, unsharp snapshot. Teachers and lecturers can use photographs, possibly made up into slide shows, to add interest to their classes.

Executives of global companies can carry a Canon Elph in a briefcase to photograph new investments. If you are selling your house, you can have pictures on the Internet within hours. A farmer can keep a useful record of his fields and crops by photographing them at the same time each year.

Digital photography can be particularly useful, allowing people instant access to the same material, no matter what the distance or time difference. For example, an architect can use his or her digital camera to record the progress of a building project. If a problem arises he or she takes pictures and e-mails them to the main office, using a laptop computer and mobile phone. The architects on site can then discuss the problem with head office, both with the same pictures in front of them.

Web sites

Good sales people in photostores often know a great deal about what they sell, but nowadays, it can be more convenient for a photographer to use the Internet. It is often easier to query something with the manufacturer and ask direct questions via e-mail rather than go through the approved agents. There are more than 100,000 sites associated with photography, and the number is increasing all the time.

You can check prices and availability and even order items directly, paying by credit card. You can talk to photographers on the other side of the world, be inspired by looking at picture sites, or even sell prints of your work – all from the comfort of your chair. Many photographers now have a portfolio on their own web sites. A client can call up the site, view the photographer's work, and decide to make a commission, all in a matter of moments.

CAMERAS
Canon
 www.canon.co.uk
 www.usa.canon.com
Contax
 www.contaxcameras.com
Hasselblad (UK)
 www.hasselblad.co.uk
Leica
 www.leica-camera.com
Minolta
 www.minoltausa.com
Nikon
 www.nikon.co.uk
Nikon Electronic Imaging Division
 www.kit.co.jp/nikon/eid
Olympus
 www.olympusamerica.com
Pentax
 www.pentax.com

FILM
Agfa
 www.agfa.com
 www.agfa.co.uk
Fuji
 www.fujifilm.com
Ilford
 www.ilford.com

Kodak
 www.kodak.com
Polaroid
 www.polaroid.com

ACCESSORIES
Bags
Lowepro
 www.lowepro.com
Tamrac
 www.tamrac.com
Domke
 www.fargo-ent.com/domke/index.html

Meters
Sekonic
 www.sekonic.com

Lenses
Sigma
 www.sigmaphoto.com
Tamron
 www.tamron.com

Filters
Lee Filters
 www.leefilters.com

Tripods
Manfrotto
 www.bogenphoto.com

Lighting
Broncolor
 www.sinarbron.com
California Sunbounce
 www.sunbounce.com
Calumet
 www.calumetphoto.com
Chimera
 www.chimeralighting.com
Dyna-lite
 www.dynalite.com
Elinchrom
 www.elinchrom.com
Optex
 www.optexint.com/optex
Sunpack
 http://www.tocad.com
Vivitar
 www.vivitarcorp.com

STORES
B & H, New York
 www.bhphotovideo.com

Grays of Westminster, England
www.graysofwestminster.co.uk
Lens & Repro
www.lensrepro.com
Netphotostore
www.netphotostore.com
Ocean Optics Underwater Photography
www.oceanoptics.co.uk
Pix Equipment Rentals
www.pixcamera.com

ASSOCIATIONS/TRAINING
Association of Photographers
www.aophoto.co.uk
Brooks Institute of Photography
www.brooks.edu
Digital Cameras, Digital Tips
www.imaging-resource.com/ARTS1.HTM
The Maine Photographic Workshops
www.meworkshops.com
New York Institute of Photography
www.nyip.com
Santa Fe Workshops
www.sfworkshop.com

PHOTOGRAPHERS/AGENCIES
24 hours in Cyberspace
www.cyber24.com
Ansel Adams Gallery Home Page
www.adamsgallery.com
Corbis
www.corbis.gallery.com/main.html
Digital Journalist
www.digitaljournalist.org
Getty Images
www.getty-images.com/getrycoms/index.html
Kodak Professional
www.kodak.com/go/professional
Professional Photographers of America
www.ppa–world.org
Robert Farber Photographic Gallery
www.farber.com

LABORATORIES
A and I
www.Aandl.com
BWC Miami Beach
www.bwc.net
Joe's Basement
www.joesbasement.co.uk
K & M Camera
www.kmcamera.com
Metro London
www.metroimaging.co.uk

GALLERIES
Hulton Getty
www.getty/hulton/home.html
Museum of Modern Art
www.moma.org
National Museum of Photography
www.nmsi.ac.uk/nmpft
National Portrait Gallery
www.npg.org.uk
Special Photographers' Gallery
www.specialphoto.co.uk
UCR California Museum of Photography
www.cmp.UCR.edu

MAGAZINES/PUBLISHERS
British Journal of Photography
www.bjphoto.co.uk
Contact
www.contact-uk.com
Focal News
www.bh.com
Life Magazine
www.pathfinder.com/life
National Geographic
www.nationalgeographic.com/photography
Photo District News
www.pdn-pix.com
Popular Photography
www.funnet.com/magazines/pmags/popularphoto.html

COMPUTERS/SOFTWARE
Adobe Photoshop
www.adobe.com
Adobe Photoshop Information Page
www.adobe.com/prodindex/photoshop/main.html
Adobe Photoshop Discussion List
www.sc.edu/deis/photoshp/
Apple
www.apple.com
Epson
www.epson.com
Hewlett Packard
www.photosmart.com
Live Picture
www.livepicture.com
Microsoft
www.microsoft.com
Quantel Paintbox
www.quantel.com
Scitex
www.scitex.com

Recommended books

Photographers are often described as having a "great eye." This is simply the ability to see and isolate great pictures – whether by capturing magical action moments or juxtaposing objects against a studio background. The top photographers have the uncommon in common – a personal vision.

It is an enormous help to study the work of leading photographers when educating the eye. Do not just sit back and applaud them, however. Try to understand why a particular shot was taken, where the light was coming from, the lens and type of film used. Question and study every aspect of the picture.

This list of books is not definitive, but includes those that we have found most stimulating and helpful.

GENERAL

Adams, Ansel *Images* 1923–1974
 (USA) New York Graphic Society
Angel, Heather *The Book of Close-up Photography*
 (UK) Ebury Press
 (USA) Alfred A. Knopf Inc
Brandt, Bill *Shadow of Light*
 (UK) Gordon Fraser
 (USA) Da Capo Press
Eisenstaedt, Alfred *Eisenstaedt's Album*
 (UK) Thames & Hudson
 (USA) Viking Penguin
Feininger, Andreas *The Complete Colour Photographer*
 (UK) Thames & Hudson
 (USA) Prentice-Hall
Haas, Ernst *In America*
 (UK) Thames & Hudson
 (USA) Viking Penguin
Kane, Art *The Persuasive Image*
 (UK) Thames & Hudson
 (USA) Alskog
Kertesz, André *Sixty Years of Photography*
 (UK) Thames & Hudson
 (USA) Viking Penguin
Lartigue, Henri *Diary of a Century*
 (UK) Penguin Books
 (USA) Viking Penguin
Link, O. Winston *Steam, Steel and Stars*
 (UK and USA) Harry N. Abrams
Michals, Duane *The Photographic Illusion*
 (UK) Thames & Hudson
 (USA) Alskog
Newton, Helmut *Worlds in a Small Room*
 (USA) Viking Press
Ricciardi, Mirella *Vanishing Africa*
 (UK) Collins
 (USA) Holt, Rinehart & Winston
Rockwell, Norman *Norman Rockwell's America*
 (USA) Harry N. Abrams
Sieff, Jeanloup *40 Years of Photography*
 (USA) Evergreen
Sontag, Susan *On Photography*
 (UK) Penguin Books
 (USA) Farrar, Straus & Giroux
Watson, Albert *Cyclops*
 (UK) Pavilion
Weston, Edward *50 Years*
 (UK) McGraw Hill Books
 (USA) Aperture
A Day in the Life of China
 (UK) Merehurst Press
 (USA) Collins
A Day in the Life of Spain
 (UK and USA) Collins
The Image Bank: Visual Ideas for the Creative Photographer
 (UK) Phaidon Press
 (USA) Amphoto
The Best of Life
 (UK and USA) Time-Life Books

PHOTOJOURNALISM/REPORTAGE

Brassai *The Secret Paris of the 30s*
 (UK) Thames & Hudson
 (USA) Viking Penguin
Cartier-Bresson, Henri *The World of Cartier-Bresson*
 (UK) Gordon Fraser
 (USA) Viking Penguin
Erwitt, Elliott *Photographs and Anti-Photographs*
 (UK) Thames & Hudson
 (USA) Viking Penguin
Frank, Robert *The Americans*
 (USA) Aperture
Lange, Dorothea *Dorothea Lange*
 (USA) Museum of Modern Art
Loengard, John *Pictures under Discussion*
 (UK and USA) Amphoto
Mark, Mary Ellen, and Leibovitz, Annie
 Photo-journalism: The Woman's Perspective
 (UK) Thames & Hudson

(USA) Alskog

Salgado, Sebastiao *Workers*
 (UK) Phaidon
 (USA) Aperture

Smith, Eugene *Let Truth be the Prejudice*
 (UK and USA) Aperture
 Great Photographic Essays from Life
 (UK) Life Books
 (USA) New York Graphic Society
 In Our Time: The World as seen by Magnum Photographers
 (UK) Andre Deutsch
 (USA) American Federation of Arts

PORTRAITS

Avedon, Richard *Avedon Photographs*
 (UK) Thames & Hudson
 (USA) Farrar, Straus & Giroux

Bown, Jane *The Gentle Eye*
 (UK) The Observer

Davidson, Bruce *East 100th Street*
 (USA) Harvard University Press

Horst *Sixty Years of Photography*
 (UK) Thames & Hudson
 (USA) Rizzoli International

Kobal, John *Hollywood Glamour Portraits*
 (USA) Dover

Leibovitz, Annie *Rolling Stone: The Photographs*
 (USA) Simon & Schuster

Mapplethorpe, Robert *Some Women*
 (USA) Secker & Warburg

Skrebneski *Beautiful Women*
 (USA) New York Graphic Society

WAR

Burrows, Larry *Compassionate Photographer*
 (USA) Time-Life Books

Capa, Robert *Images of War*
 (UK) Paul Hamlyn
 (USA) Grossman

Duncan, David Douglas *War Without Heroes*
 (USA) Harper & Row

McCullin, Don *Sleeping with Ghosts*
 (UK) Jonathan Cape
 (USA) Random House

Nachtwey, James *Deeds of War*
 (UK and USA) Thames & Hudson

NATURE

Beard, Peter H. *The End of the Game*
 (UK) Collins

(USA) Viking Penguin

Dalton, Steven *Split Seconds*
 (UK) Dent

Erwitt, Elliot *Son of Bitch*
 (UK) Thames & Hudson
 (USA) Grossman

Shaw, John *John Shaw's Focus on Nature*
 (UK) HarperCollins
 (USA) Amphoto

Van Lawick, Hugo *Savage Paradise—Victims of the Serengeti*
 (UK) Collins
 (USA) William Morrow

NUDES

Brandt, Bill *Nudes 1945–1980*
 (UK) Gordon Fraser
 (USA) New York Graphic Society

Robert Farber *Classic Farber Nudes*
 (USA) Amphoto

Hamilton, David *The Best of David Hamilton*
 (UK) Collins
 (USA) William Morrow

Newton, Helmut *White Women*
 (UK) Quartet Books
 (USA) Stonehill

Weston, Edward *Nudes*
 (UK) Gordon Fraser
 (USA) Aperture

SPORT

Allsport *Visions of Sport*
 (UK) Pelham Books

Leifer, Neil *Sport*
 (USA) Abrams

Zimmerman & Kaufmann *Photographing Sports*
 (UK) Thames & Hudson
 (USA) Alskog

TRAVEL

Singh, Raghubir *The Ganges*
 (USA) Perennial Press

Stanfield, James *The Eye of the Beholder*
 (UK and USA) National Geographic
 The Photographs
 (UK and USA) National Geographic

CHILDREN

Mason, Jerry *The Family of Children*
 (UK) Cape
 (USA) Ridge Press

Index

Index

The author would like to thank the following for their assistance in the preparation of this book.

Jinny Johnson

Jakki Moores, Simon
 Coleman, and Alistair
 Robins at Nikon UK

Steve Baker at Leeds
 Photovisual Ltd.

Morgan and Fraser at the
 Flash Center

Arran at Film Plus

Robin Bell

Mike Laye

Andy Goldsworthy

Ken, Howard, and John
 at Genesis

Martin Evening

Dr. Jonathan Botting
 MBBS, MRCGP,
 DRCOG, MSOM

Russell Cheyne

Sarah Bee

Hugo Burnand

Jackie Morris

Alan Newnham

Linda Dunk

Paul Grundy

Brian English

Graham Piggott

Pat Morrissey

Clare Sharp

Maria Davey

Joel Porter

Jessica Kavanagh

Clare Harington

Pictures in this book were either commissioned by, or subsequently used by, the following:

Allied Domecq

British Gas/BMP–Needham

Express Newspapers

Figaro

Pan Books

Redwood Publishing

The Telegraph

Thistle Hotels

Time-Life Books

Victoria and Albert Museum

Artwork credits

Bold page numbers: artwork from original photographs © Julian Calder

10 Arka; 12–13 reproduced by kind permission of the Nikon Corporation; 15 John Hutchinson; 32 John Hutchinson; 35 John Hutchinson; **39** Arka, John Hutchinson; **46** Arka; **58** Arka, Trevor Hill; **64** John Hutchinson; **65** Arka, Trevor Hill; **66** Trevor Hill, Jim Robins; **68** Trevor Hill, Jim Robins; **70–71** Arka; **72–73** Arka; **74–75** Arka; **77** John Hutchinson; **78–79** Arka, Trevor Hill; **80–81 Arka, Trevor Hill**; **82–83** Arka, Trevor Hill; **84–85** John Hutchinson; **86–87** John Hutchinson; **89** Arka, Trevor Hill, John Hutchinson; **90** Arka, John Hutchinson; **92–93** Arka, Trevor Hill; **126–27** Arka; **132** Arka; **133** John Hutchinson; **150** Arka; **154** Trevor Hill, Jim Robins; **163** Jim Robins; **200–1** Arka, Trevor Hill; **202–3** Arka, Trevor Hill; **207** John Hutchinson; **210** Arka; **216** Arka, John Hutchinson; **217** Arka; **219** John Hutchinson

Photograph credits

All photographs by Julian Calder except for the following:

John Garrett
25 (bottom), **28** (bottom), **48** (all pics), **49** (top,) **50** (top left and bottom right), **51** top, **54** (top and bottom), **56**, **94**, **106–107** (all pics), **111** (top), **126–27**, **134–35**, **138**, **152–53**, **154–55**, **160** (3 and 5), **161** (7 and 8), **162–63**, **164**, **168–69**, **188** (top), **212–3**

Yannis Behrakis/Reuters/Popperphoto **108–109**
Hugo Burnand **118–119**, **122** (left and middle)
Russell Cheyne **178–79**, **182–83**
Linda Dunk **144–45**
Paul Grundy **177** (top)
Pat Morrissey **146**
Alan Newnham **120**, **121** (bottom), **171** (bottom)
Image manipulation by Martin Evening
190–91, **192–93**, **194–95**, **196–97**, **198–99**

Gray card (18 percent tone)
Measure light off this tone to
obtain average exposure (see p.38).